Creating Lifelike Figures

IN POLYMER CLAY

Tools & Techniques for
Sculpting Realistic Figures

KATHERINE DEWEY

POTTER CRAFT

New York

Dedication

For Lillian and Leo...They know why.

Acknowledgments

Chase Fountain, a thoughtful and talented man, he photographed every step.

Kimberly Mackenzie, a gifted book designer and graphic artist, she juggled hundreds of images and thousands of words.

Keith Scroggins, Britt Myers, and Don Denney, each a craftsman whose knowledge and guidance made this book possible.

Hope Phillips, Jan Walcott, Jorge Sanchez of Polyform Products; Donna Kato and the Van Aken company; and Peter Dyne of Golding Handcrafts. Each fulfilled every request and answered every question

Cover design: Timothy Hsu
Interior design: Kim Mackenzie, San Antonio, Texas
Photography: Chase Fountain, Southern Exposure Photography, San Marcos, Texas

Copyright © 2008 by Katherine Dewey

Originally published by Potter Craft,
an imprint of the Crown Publishing Group,
a division of Random House, Inc., New York in 2008.
www.crownpublishing.com
www.pottercraft.com

POTTER CRAFT and colophon is a registered trademark of Random House, Inc.

ISBN-10: 0-8230-1503-3

ISBN-13: 978-0-8230-1503-0

Library of Congress Control Number: 2007939793

First Potter Craft edition

4 5 6 7 8 9 / 17 16 15 14 13 12 11

About the Author

Katherine Dewey has been an award winning, professional artist for 30 years. The author of *Creating Life-like Animals in Polymer Clay*, she is a regularly featured instructor and guest artist at polymer clay venues nationwide.

Born in Peoria, Illinois in 1944, Katherine was raised by parents who recognized her talent and introduced her to all of the arts. During her early college years she concentrated on the performing arts at the Pasadena Playhouse and Pasadena Junior College, Pasadena, California. When her family moved to Illinois, she began to explore the visual arts at Springfield College, the University of Illinois, Eastern Illinois University, and Parkland College. She studied graphic design, sculpture, and painting under several of the best artisans in the region, but took many geology, history, and biology courses in order to provide herself with a solid foundation for her work. In 1968, Katherine struck out on her own as a freelance artist. She painted elaborate signs, designed and illustrated brochures, rendered medical illustrations for a series of instructional slides, and constructed wildlife dioramas, built architectural models, and designed masks for business and theater.

Married in 1969, she and her husband spent the next 24 years traveling wherever his Air Force career took them. All the while, Katherine pursued and expanded her artistic horizons. She perfected her painting skills, broadened her experience, and acquired an increasingly rich collection of subject matter. When she and her family returned to Illinois in 1975, Katherine discovered polymer clay, a medium that set her free to express her ideas in three dimensions. She soon earned a reputation as an accomplished sculptor, and today is one of the leading and best known artists working in polymer clay. Her works have been displayed worldwide. Her teaching skills have made her a popular instructor in the art of sculpting in polymer clay. This is her second book.

Table of Contents

Introduction – Page 5

Part 1 – **A Medium for Everyone** – Page 6
Polymer Clay Fundamentals

Part 2 – **Figure Fundamentals** – Page 10
An Overview of Figurative Modeling

Part 3 – **Fundamental Tools** – Page 13
The Essential and Nonessential Tool Kit

Part 4 – **Face to Face** – Page 20
Modeling the Head and Face

Part 5 – **The Body in Question** – Page 46
Modeling the Torso

Part 6 – **A Leg to Stand On** – Page 70
Modeling the Leg & Foot

Part 7 – **A Show of Hands** – Page 86
Modeling the Hand & Arm

Part 8 – **Measure for Measure** – Page 102
Modeling in a Smaller Scale

Part 9 – **Costumes of Clay** – Page 116
Dressing the Sculpture in Polymer Clay

Part 10 – **Finishing Touches** – Page 130
Adding Details with Paint and Fiber

Resources – Page 143

Index – Page 144

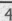

Introduction

I am an amateur at heart. I sculpt for the love of it. That's what the word "amateur" means—one who loves. I cannot resist creating new shapes in wet sand, new fallen snow, fresh cement, or cold mashed potatoes. I'm also a professional. Sculpting is my livelihood, and polymer clay is my favorite medium. No other clay is as colorful, versatile, or widely available. No other clay drives me to explore the possibilities. No other clay urges me to ask "What if?"

What if I wrote a book about the art of figure modeling in polymer clay? What if I wrote that book with the amateur in mind? The amateur, in the truest sense of the word, has a love of art and sculpture. The amateur is ready to take the first step into the artist's realm. This book is about that first step and those that follow. It will take you along a different path than other books on the subject of realistic figure modeling. Why? Because polymer clay is a thoroughly modern product, not bound by tradition. Nan Roche called it "the new clay." Why not use new methods?

Taken as a whole, the figure is complex. Why not break it down? Break everything down: proportions, body parts, armature, and clay. Break the body down part by part, and break the parts down form by form. Separate parts mean separate armatures, the bones of the sculpture. Break the clay down, too, into measured amounts—so much for each form, so much for each body part. Break it down and then put it back together again. Taken as parts of the whole, the complex figure becomes simple enough for the amateur. I am an amateur at heart.

PART ONE

A Medium for Everyone

Polymer clay is unique, a remarkable clay that requires no special tools, not even a kiln. Its wide availability has made it the first clay for amateurs and the the clay of choice for many professionals—sculptors who have designed one of a kind dolls, modeled figures for the toy and collectable industries, and created miniatures and masks for the movies. There is no other clay quite like it.

This man-made clay is a medium for the new millennium. Polymer clay is composed of fine PVC particles suspended in a liquid called a plasticiser. The plasticiser gives the clay its flexibility. Fillers, such as natural earth clays and chalks, add bulk. Pigments add color. Baking the clay at the right temperature (between 200 and 275º F) fuses all of the ingredients into a hard plastic.

Polymer Clays are low temperature clays, sensitive to heat, some more so than others. The warmth of your hands or the heat of a summer day can make them softer. Too much heat (above 90º F) over too long a time will

Clays from all over the world illustrate a fraction of the colors available. Most companies manufacture both small blocks and large bricks, and most offer a range of colors, including pastels, flesh blends and specialty clays. While brands differ in subtle ways, all share one important trait—they urge the artist to explore the possibilities.

partially bake the clay, but don't assume firm clay has been partially baked, even if it crumbles. It may simply be old. As polymer clay ages, fillers absorb some of the plasticiser and the clay loses some of its pliability. Clay softeners such as Sculpey Diluent, Kato Liquid Conditioner, and Fimo Mix Quick can extend the life of these "advanced" clays, but often they just need to be kneaded. Once kneaded, they become pliable.

The Perfect Polymer Clay?

For the artist who sculpts, the perfect polymer clay blends easily. It's firm enough to hold its form, yet soft enough to model and drape. The perfect clay has a long working time, remains color faithful after baking, and resists breakage. That's the perfect clay for modeling, but, no brand has all of those qualities. The clays easiest to blend, Super Sculpey, Sculpey III and Prēmo, tend to scorch if baked too long. The most flexible clays after baking, Cernit and Modelene, are difficult to blend. The same is true for the firmest clay, Creal-Therm. The most color faithful clay, Kato, has a short working time. Because no clay has all of the qualities artists desire, artists adapt. They choose the clay that suits the way they work and work in ways that give them the control they need.

Cernit—A German clay prized by doll artists for its porcelain texture and durability, Cernit responds quickly to the heat of your hands, becoming very soft. Many artists mix this clay with a more blendable brand to improve its workability. Available in 27 colors.

Creal-Therm—A very firm clay, this Dutch product requires substantial kneading before it will blend. A very durable product if baked as the manufacturer directs. Available in 28 colors.

Du-Kit—A clay from New Zealand, Dukit has a nice firmness, smooth texture, and blends beautifully. Du-Kit has a long working time. After baking it remains flexible, making it a durable clay. Made in 25 colors

Fimo Classic—A German clay prized by jewelry designers for its firmness and color faithful qualities, Fimo is flexible after baking and resists cracking. Made in 24 colors.

Fimo Soft—As soft as its name implies, this sister to Fimo Classic is not as flexible as the original. Available in 48 colors, Fimo Soft also comes in Stone, Glitter, and translucent hues.

Kato Polyclay—Designed by Donna Kato, this clay handles extended baking times without changing color. A clay with a shorter working time than others, it requires additional kneading during the modeling process. After baking, this blendable clay is very flexible and resists cracking. Available in 17 colors.

Modelene—A clay from Australia, Modelene blends with ease, but has some of the heat sensitive qualities of Cernit. While it darkens slightly on baking, Modelene remains flexible afterwards. Available in 27 colors.

Super Sculpey—Made in America, this clay is ideal for the sculptor more concerned with form and texture rather than color. Available only in beige, Super Sculpey blends effortlessly, but can darken if baked too long.

Prēmo Sculpey—This clay blends effortlessly and has the longest working time available to the artist. Though it tends to darken when baked too long, it remains my favorite clay. Most of the figures in this book were made of Prēmo Sculpey. Available in 32 colors.

ProSculpt—Designed by a doll artist for doll artists, this clay is available in three colors—Caucasian Flesh, Ethnic Brown and Translucent White. A variety of realistic flesh blends are possible with this soft, blendable clay.

Specialty Clays—Specialty clays have unique qualities, and almost every company makes them. Fimo Stone, Cernit Stone, and Sculpey Granitex have tiny fibers. When mixed with other colors, they add visual softness to clay cloth. Cernit, Prēmo, Fimo, and Kato metallic and pearl clays shine like satins and silks. Translucent Liquid Sculpey (TLS) and Kato Sauce are liquid polymer clays. Translucent Liquid Sculpey (TLS), Kato Sauce, and Liquid Fimo are polymer clays in a liquid state. TLS has a matte finish, while Kato Sauce shines. Liquid Fimo is thin and clear as water before and after baking. Mix them with oil paints, mica powders, or dry pigments to create polymer paints; or use them as polymer varnish. Specialty clays add depth to the creative well.

Flesh Blends

Every brand makes a variety of flesh toned clays. Most are translucent and produce a realistic impression, but that same quality, translucence, can cause problems. The sheen of unbaked clay, especially translucent clay, makes it difficult to detect seam lines, fingerprints, tool marks. These flaws become noticeable after baking. Wet sanding, scraping, and wiping the surface with acetone will eliminate most fingerprints and tool marks, but not a phenomenon called "plaquing," a problem with translucent clays. The surface will feel smooth, but appear pocked with crescent-shaped blisters of trapped air. For these reasons, use a semi-opaque flesh tone. Aided by a bright light, you'll see tool marks, fingerprints, and unblended seams. After baking, glazing with acrylic paints or water mixable oils will create the illusion of translucent flesh.

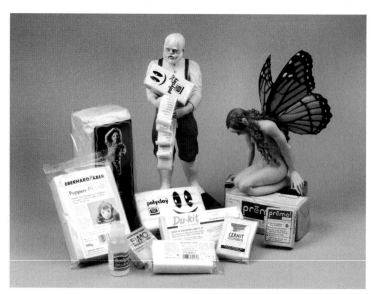

All of the major brands manufacture flesh tones ranging from deep cocoa browns to the pale porcelain pinks. Most companies make clay conditioners as well, additives such as Sculpey's Diluent or Fimo's MixQuick. Conditioners put new life into old, dry clay and help unbaked clay adhere to baked clay, a valuable technique for the figure modeler.

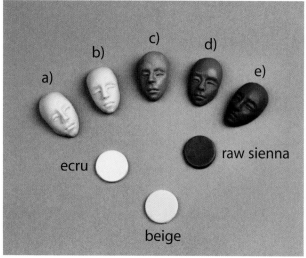

*Flawless flesh begins with a color that captures the ideal of the figure you want to model. These masks illustrate five possibilities, each a blend of translucent Beige and at least one opaque clay. **a)** Asian ancestry—6 parts Beige + 1 part Ecru. **b)** Northern European—8 parts Beige + 1 part Ecru. **c)** American Indian—8 parts Beige + 1 part Raw Sienna, ¼ part Ecru. **d)** African American Heritage— 4 parts Beige + 1 part Raw Sienna. **e)** African Ancestry—1 part Beige + 1 part Raw Sienna. Whatever brand of clay you select, don't let ready made flesh colors limit your creativity.*

TIP

If you're a beginner or new to polymer clay, get acquainted with the techniques by modeling one or two faces or figures in gray or green clay, or create the look of bronze with a blend of two parts black and one part copper. When using these colors, visual distractions—such as dirt in clay—won't bother you. With experience, you'll gain confidence and learn to work quickly. Working quickly is one of the keys to keeping pale, flesh-toned clays clean. The other key is firm, fit clay.

Fit Clay for a Fit Figure

Learning to judge the clay's fitness for modeling is the single most important lesson you can learn. Compared to clay fresh from the package, clay fit for modeling may feel "hard," but it will hold the shape you give it and remain blendable without cracking. Firm clay feels silkier, resists dirt and fingerprints.

GETTING INTO CONDITION

All polymer clays need conditioning. Begin by rolling the clay in your hands to form a long rod. Fold and twist, then roll another rod. Continue folding, twisting and rolling for about five minutes until the clay is uniformly pliable. Use this technique to blend colors, too. Once the color is uniform you know the clay is conditioned, but is it fit for modeling? Test it and find out.

PASSING THE FITNESS TEST

Test the clay's fitness for modeling. Roll the clay into a ball. Cut the ball in half and then put the halves back together. Blend the seams by stroking the surface with your thumb or finger. If you can create a smooth ball out of the two halves simply by blending the seams, it's fit. If the ball loses its shape, the clay's too soft. Make the clay firm and fit by "leaching" it.

MAKING SOFT CLAY FIRMER

Most polymer clays are too soft for the techniques described in this book. To make it firmer, roll it into thin sheets, sandwich the clay sheets between clean pieces of paper and place a weight on top. Let it rest for several hours. The paper will draw, or "leach," excess plasticiser from the clay. Do the fitness test. If it's still too soft, leach it again.

SAFETY FUNDAMENTALS

Before you begin, stop and read the label. Just as each clay has different traits, each clay has different instructions for use and different baking temperatures. Look for the AP Non Toxic Seal. Make sure the clay meets the Art & Creative Materials Institute's safety standards.

- The AP Non toxic label does not mean polymer clay is safe to eat; it means the clay is non toxic if used properly. Don't create food containers; resins in baked polymer clay are not fully inert and may leach into the food. For the same reason, if you work at the kitchen table, protect it from the clay. It might be an old and battered table, but it's also where you prepare food. If you use kitchen utensils as tools, don't return them to the kitchen. You're an artist now, and that garlic press, rolling pin, baking dish are all artist's tools. If you bake your sculptures in the same oven you use for cooking, clean it afterwards. It only takes a few minutes to wipe the walls and ceiling with a damp rag and mild degreaser.

- When a sculpture is in the oven, use the ventilator. Polymer clay releases fumes when baking, and the odor, while not unpleasant, may bother some. Use an accurate oven thermometer. Baking above 360° F will burn the clay and release irritating and hazardous fumes.

- Keep your work area clean. It will protect the clay from dust and fibers, the bane of every polymer artist. Keeping your work area clean means putting the clay away when you're finished—away from the kids, away from the pets. Store the clay and the tools away in a sealed container, and store it with the label. There's valuable information on that label.

- If your children want to play with the clay, play with them. Polymer Clay is not a toy. It's a creative medium. Treat it as one and your children will, too. Naturally, everyone washes their hands when they're finished.

<div style="text-align:center">

P A R T T W O

Figure Fundamentals

</div>

Before you begin, take a moment to learn about the modeling method described in this book. It's a modular method , one that focuses on the individual parts of the body and the simple shapes used to create those parts. It's also a measured method, one that assures you'll use the right amount of clay for each body part. Still, the techniques are flexible. You'll find you can make creative choices with confidence. Later, if you want to explore other techniques and other clays, you'll find you have the knowledge to apply what you've learned. Understanding begins here with the basics, the basics of proportion and the basic shapes.

A Method for Modeling

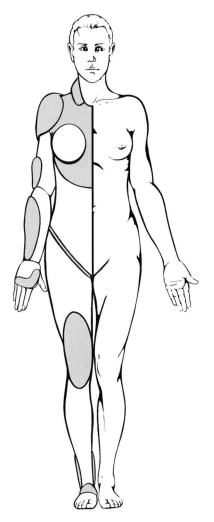

This unusual woman illustrates a method for modeling the figure. The left side of her body shows the simple shapes that create each body part. The areas colored in white represent fully rounded forms. The gray areas illustrate appliques that create the surface features of the body. There are patterns for modeling each body part. Drawn to scale, they illustrate the size, shape of each applique and body part.

TIPS FOR THE MODELER

• Stay in step. Take the time to measure the clay. Let your muscle memory and sense of scale develop naturally. Soon, you'll have the skills to combine steps, create short-cuts, and work without measuring the clay.

• Always blend seams with overlapping strokes and always from the applique onto the base piece.

• When you model the features of the face, position matching appliques in pairs.

• When you model the limbs, don't finish one leg or one arm. Model both sets of limbs at the same time.

• Tools are harder than your fingers. When you use tools, use them gently and with less pressure.

• Don't hold your work too tightly. Better to drop it on the floor than squeeze it out of shape.

• Check your work for symmetry. Study it from all angles. Use a mirror. When in doubt, measure the figure.

Mastering the Basic Shapes

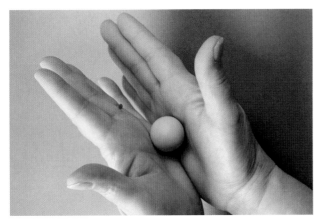

THE BALL

Every fundamental form begins with a smooth, seamless ball of clay. Use even pressure. Too much pressure with one hand will produce a bi-cone, similar to a toy top. If that happens, use your fingers to push it into a rounder shape, then re-roll gently.

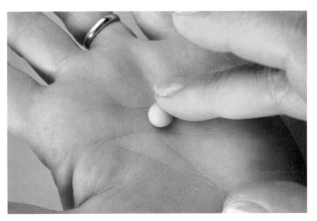

THE SMALL BALL

Use your finger to roll smaller balls in the hollow of your hand.

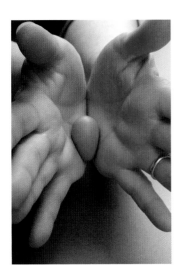

THE EGG

To form an egg, hold your palms together in a 'V' shape and roll a ball back and forth two or three times.

THE SMALL EGG

Shape a small egg by using you finger to roll a small ball back and forth in the hollow of your palm.

THE ROD

Shape rods of clay by rolling a ball of clay back and forth on a flat surface. Exert even pressure as you move your hands apart. For uniform rods, use a sheet of plexiglass or a ceramic tile instead of your hands.

THE TAPERED ROD

Both the arms and legs use the tapered rod. Roll a rod back and forth on the work surface with the heel of your hand set near the end of the rod. The more pressure you use, the more tapered the rod. Practice creating a gently tapered rod.

Measuring the Figure

Artists use certain features of the head and body as landmarks for creating a realistically proportioned figure, one with dimensions correct for its type. Like the landmarks of a map these features are prominent and fixed. The distance between one and another remains constant. These distances are the keys to mapping and modeling the figure, rules of proportion in every sense of the word. Using the length and width of the head as a measuring gauge gives you a standard for the rest of the figure.

MEASURED CLAY FOR A MEASURED FIGURE

Measuring the clay assures you'll use the right amount of clay for each body part. With each scale pattern, you'll find this diagram. It's called the Base Unit. The circle represents a ball of clay of a specific size. The line beneath the circle is the key to creating uniform Base Units from rods of clay.

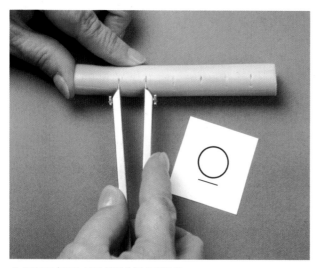

A METHOD OF MEASURING

Roll a rod of clay until it's the same diameter as the Base Unit. Set a divider to match the line beneath the circle. Press it against the rod leaving two marks in the clay. Continue marking the rod by pressing each mark into the previous mark. When you cut the rod, each slice will produce a ball of clay the same diameter as the Base Unit.

> **TIP**
>
> You'll need 65 to 90 Base Units to model a complete figure. Measure the clay ahead of time. Store the marked rods in a plastic bag and cut them as you need them.

> **NOTE**
>
> How much clay you use depends on the size or scale of the figure, whether you choose to create a male or female, whether the figure is slender, muscular or pudgy and the use of a foil core. It helps to have extra clay on hand if you need to correct problems or wish to make changes. These are the amounts of clay I prepare for slender to heavy figures in all the scales:
>
> ⅙th scale figure uses 18–24 ounces
> ⅛th scale uses 9–11 ounces
> 1/10th scale figure uses 6–8 ounces
> 1/12th scale uses 4–6 ounces

The Proportioned Figure

1 Head Width

1 Head Length

7 ½ Heads Tall

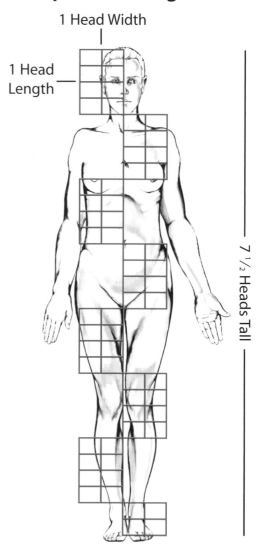

Measuring as you model is the key to a well proportioned sculpture. Measure the head and you can measure the body or the limbs by using the head a gauge. You'll find this book filled with maps to help you find your way. This is the first, a figure standing 7 ½ heads tall.

PART THREE

Fundamental Tools

You already own the most sophisticated pair of tools imaginable—your hands. But you will need other tools, tools that can reach in tight spaces or manipulate the clay in ways your fingers cannot. While polymer clay is readily available good, suitable modeling tools are not. Making your own tools solves that problem. Making your own tools also extends your knowledge of polymer clay and your abilities as an artist. As the artist in you grows, you'll gain an awareness of your needs as sculptor and have the skills to meet those needs by designing or adapting the right tool for the task at hand. It's a valuable skill, one every sculptor should have.

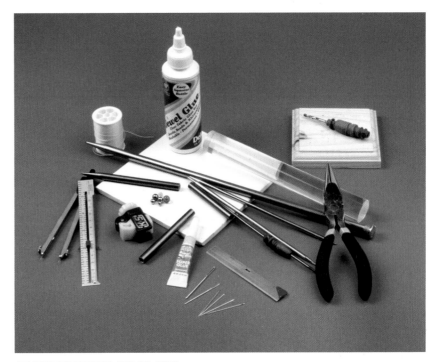

THE ESSENTIAL TOOL KIT

These are some of the essentials—tools for the modeler and toolmaker. The acrylic rod rolls smooth sheets of clay. The divider measures the clay and the sculpture. The blade and craft knife cut clay. The brush removes raw edges. Pliers and wire cutters bend and cut the armature wires, the bones of your sculptures. The wood plaque is a sculpting stand. The rest of the kit includes a tube cutter, vinyl and instant glue, thread and an assortment of knitting and sewing needles—supplies for making your own tools, fancy handles and all.

YOU'LL NEED THESE SUPPLIES TO MAKE YOUR OWN TOOLS:

- Knitting Needles: one pair of #11 ½ or #13 standard, aluminum knitting needles, one #7 and one #2 double ended aluminum knitting needle, two to four #7 or #8 aluminum knitting needles (optional)

- Sewing Needles: five medium sewing needles, one #18 or #20 tapestry needle, one #13 tapestry needle

- Tools for Making Tools: work surface, small ceramic tile; two needle nose pliers, button thread, ⅛ and ¹⁄₁₆ inch drill bits; ½" thick wood plaque, sharp long blade (a glass scraper or clay blade), tube cutter (available at hobby and craft stores), stove (for heating and bending needles), pasta machine or roller, large wooden craft ball (or round soup ladle), glass beads or ball bearings sizes 4mm, 6mm, 8mm

- Glues: vinyl glue, cyanoacrylate (instant) glue, heat resistant epoxy putty (optional)

- Polymer Clay: 12–16 ounces of a strong polymer clay (Prēmo, Fimo) any color or colors

Making Your Own Tools

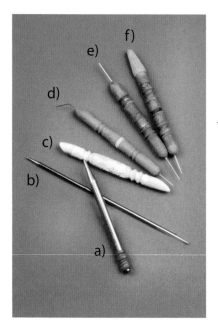

You'll need these tools to create the figures in this book: *a & b*) the large and medium knitting needle, *c*) the curved tip tool; *d*) the fine needle tool; *e*) the tapestry needle tool; and *f*) the hair stamp. Made of knitting, sewing, and tapestry needles, these tools create smooth seams and add fine details.

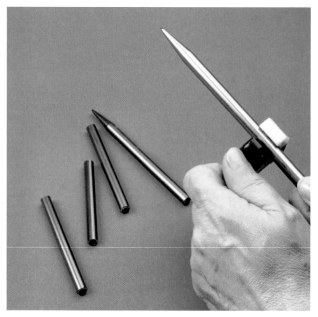

Step 1—*Standard aluminum knitting needles sizes 10 and larger are hollow. Cut the needles with a tube cutter. Two tools use the pointed end of the knitting needle: the large needle tool is 6 inches long, and the Hair Stamp is 4 inches long. Use the rest of the needles to make four strong handles at least 4 inches long.*

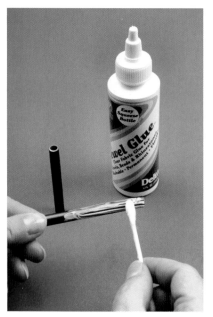

PREPARING THE HANDLES

Step 2—*Cover the handles for a better grip. Make the clay adhere by coating each handle with vinyl glue. Stand the handles on end to dry.*

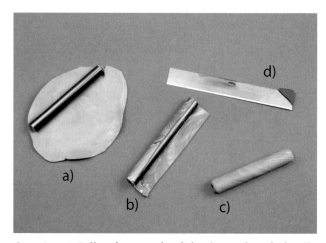

Step 3—*a) Roll a thin pancake of clay larger than the handle. b) Trim the clay into a rectangle as long the handle and a little more than three times as wide. c) Press firmly as you roll the tube on the clay sheet. d) Trim the excess clay and rub smooth.*

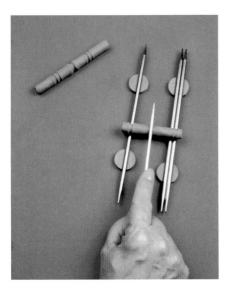

IMPROVING THE GRIP

Step 4—Improve the grip. Press 2 to 4 knitting needles parallel to each other in polymer clay to hold them steady. Set the clay covered handle on top perpendicular to the knitting needles. Use another needle to roll the handle back and forth over the knitting needles.

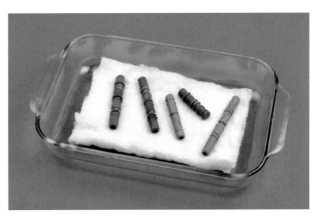

BAKING THE HANDLES

Step 5—Bake the handles on a cushion of cotton stuffing or batting for twenty minutes at the temperature recommended by the manufacturer of the clay you're using.

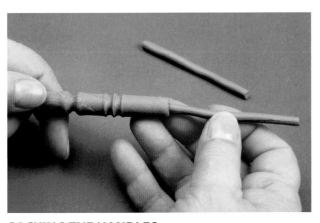

PACKING THE HANDLES

Step 6—Roll a rod of polymer clay into a long rod and fill each handle. Tamp it down and add more clay until the handle is full. Set the packed handles aside and prepare the tips.

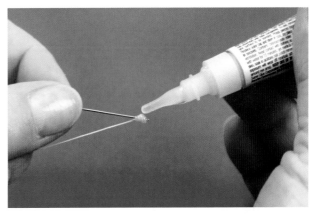

THE NEEDLE TOOLS — SECURING A NEEDLE

Step 1—To prevent needles from pulling loose, thread the needle with button thread and wrap the thread around the eye forming a knot. Add a drop of instant glue and trim the excess thread.

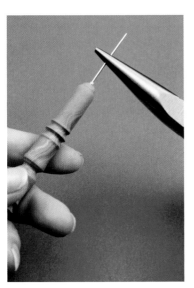

ADDING A NEEDLE

Step 2—To insert a needle, add another drop of instant glue to the knot and quickly insert the needle into the clay packed handle. Add more clay, pack firmly and rub smooth. Bake for twenty to thirty minutes.

NOTE

The Tapestry Needle Tool has a large #13 needle in one end and smaller #16 or 18 needle in the other. The Fine Needle Tool, also double ended, has a straight and bent needle. To bend a needle, hold it with a pliers over a flame heat until the needle turns cherry red. Bend it with a second pair of pliers while the needle is still hot.

The Curved Tip Tool

Step 1—*The Curved Tip tool has multiple uses: modeling the eye lids, the nose, marking finger and toe nails. It begins with a covered and baked handle. After packing the handle, use your finger or a large bead to create a dimple in each end of the tool. Make two small eggs each as wide as the diameter of the tool. One by one, press the large ends of each egg into the dimples at the ends of the tool. Blend the seams.*

SHAPING THE LARGE TIP

Step 2—*Bevel one end by pressing it against the work surface.*

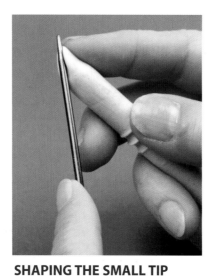

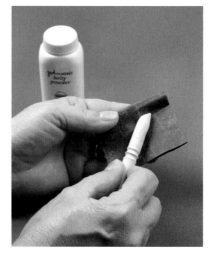

Step 3—*Moisten the beveled end and then press it against the shaft of the large knitting needle. The tip should resemble a wide, gently U-shaped gouge. Take care not to damage it while you shape the small curved tip.*

SHAPING THE SMALL TIP

Step 4—*Lightly stroke the other end of the tool to a point, moisten the clay and then press it against the tapered end of a #2 knitting needle. This tip should resemble a teardrop-shaped gouge, broader at the base then at the tip. With both tips finished, bake the Curved Tool on a cushion of cotton for 30 to 40 minutes.*

Step 5—*After baking, use emery paper and water to sand both tips. Make them smooth and the edges sharp. Rub the tips with talcum powder. Treat with powder on a regular basis.*

The Hair Tool

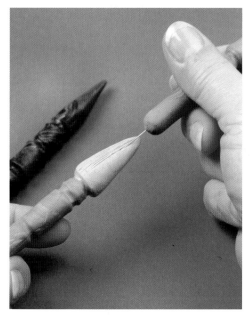

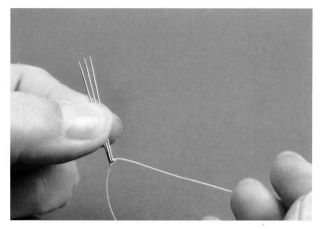

THE THREE NEEDLE COMB

Step 2—The other end of the hair tool holds a small "comb" made of three medium sewing needles that draw fine closely spaced lines in the clay where the stamp is impractical to use. Begin by threading all three needles together.

THE HAIR STAMP

Step 1—This 4-inch-long tool uses the pointed end of a large knitting needle as a foundation for a stamp. The two in this picture show the first steps of construction. The dark tool on the top left has been covered with a sheet of clay and baked for 20 minutes. The tip of the lighter tool has been capped with a thin, triangular sheet of fresh clay. Draw closely spaced lines in the cap radiating from base of the cap toward the point. Use the shaft of the needle to impress these lines, not the tip. It will leave a line the same width as the needle, creating a stamp. Take your time with this tool and it will save you hours of work. Bake for thirty minutes.

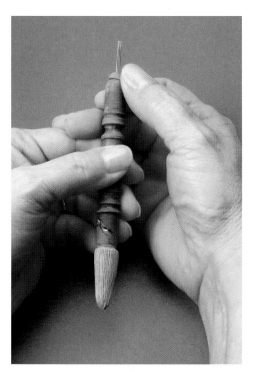

FINISHING THE HAIR TOOL

Step 3—Pack the open end of the hair tool with a rod of clay. Hold the needles in a pliers so they're aligned close together and secure the thread with instant glue. Trim the thread, add another drop of glue to the threaded end and quickly insert the comb into the packed clay. Secure with more clay and bake again for 20 minutes.

The Core Tool

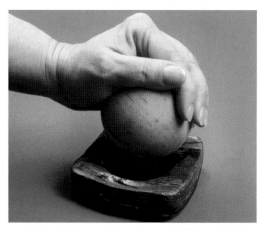

Bowl shaped, this tool uses almost a half pound of clay, but makes it possible to create smooth foil cores (skulls) for the head. It's 4 inches square and ¾ of an inch thick. Press a wet wood ball or round soup ladle into the clay to form a shallow bowl. Remove the ball or ladle and bake for 1 hour.

Making Tools for Life-Like Eyes

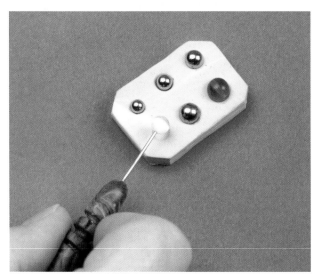

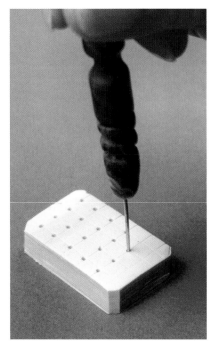

THE DRYING & BAKING STAND
For baking eyes and drying painted or varnished eyes, make a flat stand with a small block of clay. Use the small tapestry needle to poke holes into the block at regular intervals.

THE EYEBALL MOLD
The eye mold begins as a flat block of clay approximately 1" wide, 1 ½" long and a bit more than ¼" thick. Press ball bearings or glass beads ranging from 4mm to 8mm half way into the clay at even intervals. Bake the stand for 30 minutes with the beads and bearings in place. When cool, pop the beads and bearings out.

The Sculpting Stand

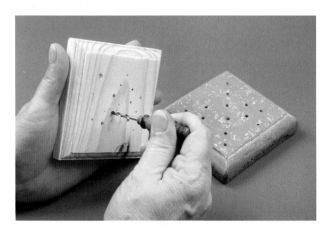

As your sculpture progresses, you'll need a sculpting stand for figures that stand. Drill at least a dozen holes at irregular intervals, using a ⅛ inch drill bit. The random nature of the holes will accommodate most your work. The gray stand on the right was coated with vinyl glue and then covered with thin sheets of polymer clay pressed firmly in place. After baking fro 20 minutes, the holes were drilled. While both stands work well, the clay covered stand's additional weight makes it more stable.

Tools for Strength

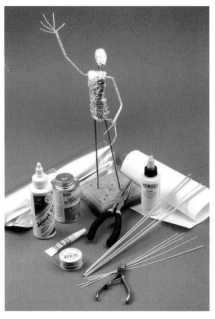

Inside every sculpture is an armature, a support structure of metal rods and aluminum foil. Brass rods, my favorite "bones," make for strong limbs and stiff spines. Use ⅛-inch diameter rods for large sculptures and ¹⁄₁₆-inch rods for smaller figures. Floral or beading wire replaces finger bones, and twisted together, becomes the support for arms. Cyanoacrylate glues, or instant glues, help hold the structure together. Vinyl glues such as Sobo, Gem Tac, and Aileen's Tacky Glue make the clay adhere to most any surface including buckram, a stiff cloth that's nice for supporting clay costumes. Clear PVC cement holds baked and raw clay components together securely. You'll also want pliers, wire cutters, and a ruler. To cut beading wire, a nail clipper works better than any wire cutter.

Baking Fundamentals

Your oven, a fundamental tool, may be a standard gas or electric oven, a smaller convection or toaster oven, never a microwave. Microwaves will boil the liquids in the clay, causing it to explode. I use my kitchen oven and clean it regularly, but many artists devote a smaller convection or toaster oven strictly to polymer clay use. What ever oven you select, use a timer, an oven thermometer and a ventilating fan. Dedicate a pan just for baking and always prop your work.

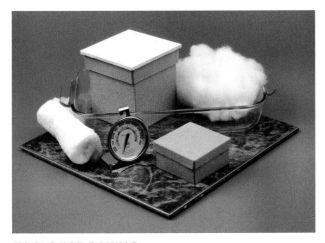

TOOLS FOR BAKING

The right baking surface and a good thermometer are essential. Glass bakeware cures the clay more evenly than metal. Smooth and portable, a ceramic tile serves as work and baking surface. Because the clay softens before it cures, sculptures need propping according to the pose. Small boxes serve as chairs for seated figures whose legs hang down. Cotton stuffing and batting provide soft support for figures too tall to stand in the oven.

Fundamental Finishes

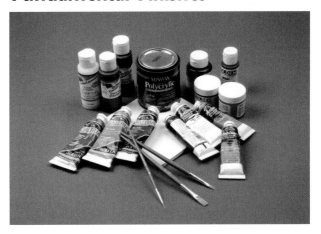

A daub of paint can turn your sculptures in colorful characters. You'll find two types of paint very useful—fast drying acrylics and slower drying water mixable oils. Use the acrylics for those sharp edged details, features such as eye brows or lips. Use water mixable oils for softly blended touches of color. Water-based wood finishes, such as Minwax's Water-based Polycrylic and Flecto's Diamond Elite will add shine where you want it—on the eyes, nails, lips, and hair. Apply these paints and varnishes with good synthetic brushes—a small 00 detail brush and a broader #4 or #6 flat or filbert and mix your paints on a small ceramic tile.

The Non-essentials

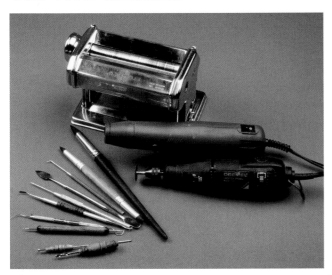

For me these tools have become indispensable, but for the new polymer clay artist they are something to acquire or make one or two at a time. The pasta machine rolls consistently thin, even sheets of clay—a must for the artist who designs costumes of clay. The rotary tool cuts, drills, grinds, and buffs a time saver that does as much around the house as in the studio. The heat gun cures thin layers of clay hard enough to continue working without having to stop and bake—nice for quick repairs and adjustments. The modeling tools, from top to bottom, include two rubber tipped clay shapers, three wax modeling tools, a dental spatula, a dental pick, a double ball stylus, and two homemade tools—a large ball stylus, actually a bodkin with the needle eye removed, and ⅛ inch drill bit set in aluminum tubing that's been covered with polymer clay.

Face to Face

Simple shapes and steps created these busts. For a brief time they were thin, earless beings with lidless eyes. Identical in form, each had the vague beginnings of a nose, mouth and chin, but little else. Flattened balls and rods of clay changed faint forms into people with distinct personalities. Simple shapes, simple steps—remember that and you'll do fine.

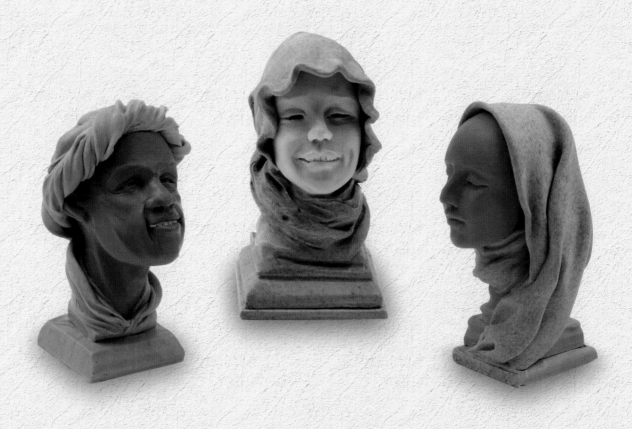

Understanding the Proportions of the Head and Face

You'll use the length and width of the head as a measuring gauge when you model the torso and the limbs. Learning the average head's proportions before you begin is your real first step.

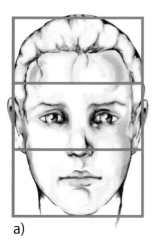
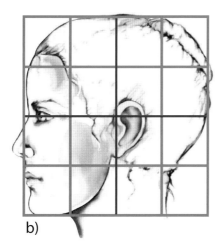

a)

b)

a) Face on, the head is egg shaped, ⅔ as wide as it is long. The forehead and crown occupy the upper third of the head; the eyes, brows, and bridge of the nose occupy the middle third. The base of the nose, mouth and chin occupy the lower third. b) The blue lines indicate vertical and horizontal midlines in this profile. The eyes lie on the horizontal midline. The jaw line divides the head into two parts, the face and the cranium. The ears are part of the cranium, not the face.

The Magic Squares

A single measurement, ½ the width of the face, will help you place the mouth, the nose, determine the eye width, establish the hairline and position the ears.

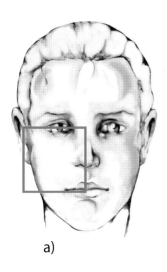
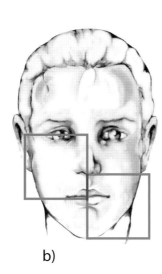
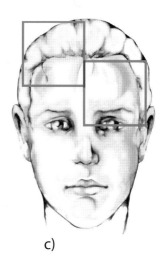

a)

b)

c)

a) Each side of this square equals ½ the width of the face at the mid-line. One-half the width of the face is also the distance between the eyes and the mouth. b) Join two squares so that the top of one square touches the mid-line and the other rests on the chin and magic happens. The base of the nose is ½ the mid-width above the chin. c) Add a second pair of squares with the bottom square resting on the mid line and you can map all of the features, including the hairline—½ the mid-width above the eyes. Note the distance between the mouth and the base of the nose is also the width of the eye, the distance between the eyes, and the distance from the eye to the side of the face.

A Pattern for Modeling the Head and Face

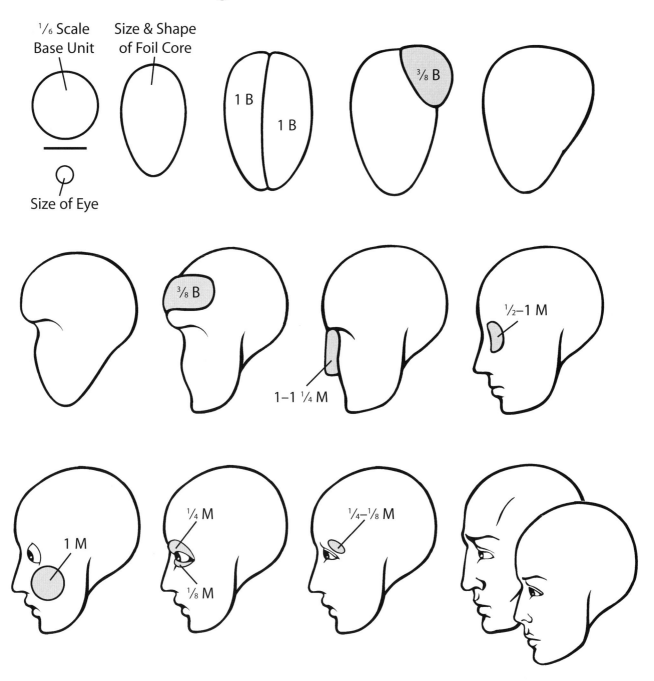

¹/₆ Scale Base Unit

Size & Shape of Foil Core

Size of Eye

1 B
1 B

³/₈ B

³/₈ B

1–1 ¹/₄ M

¹/₂–1 M

1 M

¹/₄ M

¹/₈ M

¹/₄–¹/₈ M

*This is a pattern for modeling the head in the ¹/₆ scale. Note the circle marked ¹/₆ **Scale Base Unit.** It represents a quarter ounce ball of clay, ²¹/₃₂ of an inch in diameter. The line beneath the circle will help you measure the clay using the method explained on page 12. Note, too, the shape of the foil core. It will help the clay hold its form as you follow the steps. The gray areas indicate appliques that build up the features. If you want to work in a smaller scale, you'll find tips and patterns for working in the next chapter, but the steps and techniques illustrating how to model and blend are here.*

B = Base Unit
M = Modeling Unit

YOU'LL NEED THESE TOOLS

- Five Base Units of Flesh Blend Clay (page 8)

- Work surface

- Straight blade for cutting clay

- Gauge for measuring (a divider, compass, calipers, or sewing gauge)

- Craft knife

- Fine Needle Tool (page 15)

- Tapestry Needle Tool (page 15)

- Large and medium aluminum knitting needles

- Curved Tip Tool (page 16)

- Craft grippers or hemostat

- Pencil with firm, new eraser

- Medium weight aluminum foil

- Ruler

- Core Mold (page 17)

- Stiff metal rod at least 2 inches long and $\frac{1}{16}$ inch in diameter.

- Wire cutters or needle nose pliers that cut

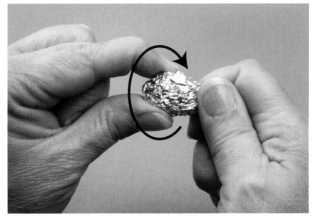

Step 2—Crumple the "knot" loosely and then more tightly. Turn the knot in one direction as you crumple. Pinch one end more firmly than the other to create the egg shape.

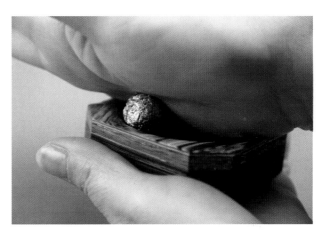

Step 3—Place the foil egg in the core mold, small end down. Use the palm of your hand to roll it back and forth rapidly. It should be the same size and shape as the foil core in the diagram.

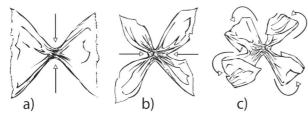

a) b) c)

CRAFTING THE ARMATURE

Step 1—To help the head keep its shape, make an egg-shaped armature from a 9 inch by 6 ½ inch sheet of medium weight aluminum foil. *a)* Gather two sides to the center to form a bow tie. *b)* Gather the opposite sides together to make a butterfly. *c)* Crumple the wing tips toward the center, one pair on the top and one pair on the bottom. It should resemble a loose knot.

TIP

While you're making that core, make more. Don't just model one head. Model three or four at the same time. You'll find your technique improving because you've repeated the same steps in rapid succession.

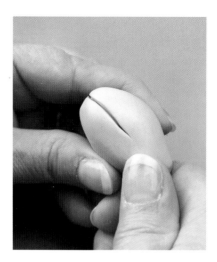

Step 5—*Use your thumb to blend the seams with overlapping strokes. To create a smoothly curved egg free of finger marks, twist the hollow of your hand back and forth against the egg. You'll use this technique often to keep the back and sides of the head smooth.*

SHAPING THE BASIC SKULL

Step 4—*Combine two Base Units and form an egg. Cut the egg in half lengthwise and flatten each half. Cover the foil core.*

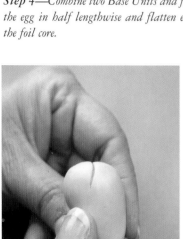

Step 6—*Roll ¾ of a ball of clay into a ball and cut it in half to make two domes. Place one dome just below the crown to form the back of the head. Blend the seams with your thumb, stroking clay from the applique onto the head.*

Step 7—*Use the large knitting needle to press a groove into the clay just below the mid-line of the face.*

Step 8—*Use your thumb to stroke the lower portion of the face making it longer and lower than the brow. Finish by lightly pinching the chin between your index fingers.*

Step 9—*Roll the remaining dome into a rod. Flatten to form a strip a bit longer than the head is wide. Place the strip on the forehead between the brow line and the crown of the head. Blend the side seams first, the crown, and then toward the brow line.*

SHAPING THE JAW

Step 10—*Define the jaw line with the large knitting needle. Place the shaft of the needle at the side of the head halfway between the forehead and the back of the head. Press gently as you pivot the needle to the other side of the head forming a groove. Use your fingers to stroke the clay smooth on each side of the groove.*

Step 11—*Flatten the base of the jaw by lightly pressing the base of the head down against the work surface. Push the head slightly forward as you flatten the jaw.*

Step 12—*To shape the sides of the face, place the knuckle of your index finger beneath the jaw and stroke down on the sides of the face with your thumb. If one side is longer than the other, lightly press the base of the jaw against the work surface.*

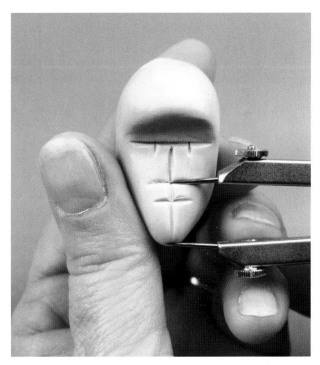

Step 13—*Follow these steps to map and mark the landmarks of the face: 1) Score the vertical and horizontal mid-lines. 2) Set your gauge to equal the distance from side of the face to the center line. 3) Score a line for the mouth ½ the mid-width below the mid-line. 4) Score a line for the nose ½ the mid-width above the chin. 5) Measure the distance between the mouth and nose—that's the eye width.*

TIP

Before you mark the face, check its dimensions. The head should now be ⅔ as wide as it is long, approximately 1 inch wide at the mid brow and 1 ½ inches long from crown to chin. If the length of head is too long compared to its width, press the base of the jaw against the work surface. If it's too short, lightly stroke down on the front and both sides of the face.

ABOUT MODELING UNITS

A Modeling Unit is ¹⁄₁₆ of a Base Unit. Some features of the face—the eyelids for example—use fractions of the Modeling Unit, portions as small as ¹⁄₁₂₈ of a Base Unit. That's hard to measure. Instead, start by cutting a Base Unit into quarters. Roll each quarter into a ball and flatten slightly. Cut each into four equal sections—these sections are ¹⁄₁₆ of a Base Unit or Modeling Units. Cut them into smaller portions as you need them. The average head uses 9 Modeling Units.

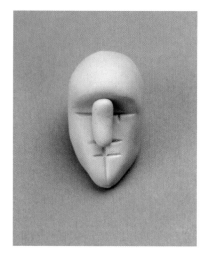

THE BASIC NOSE

Step 14—Build up the nose with a short rod of clay. Use 1 Modeling Unit to make a woman's nose. Use 1 ¼ units for a man's nose. Place the rod on the centerline from the brow line to just above the lower lip. (See the note about Modeling Units.)

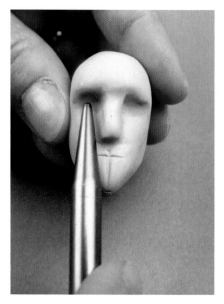

Step 15—Use the large knitting needle as a roller to blend the seams at the top, sides, and base of the nose. Finish blending with the sides of the nose your finger. Correct the brow line with a gentle rubbing and replace any lost guide lines.

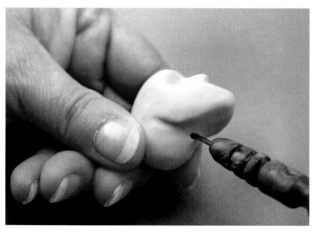

Step 16—Pierce the base of the head with the large tapestry needle. Insert a stiff metal rod, or use a tapestry needle tool as a temporary spine and add the rod later. It will support the head while you block in and model the rest of the features.

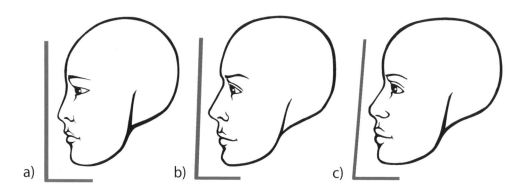

a) b) c)

SETTING THE FACIAL ANGLE

a) In faces of Asian heritage the chin is in line with the forehead, known as a vertical facial angle. b) Faces of Caucasian heritage have a vertical to near vertical angle. c) Faces expressing an African ancestry should have a slightly tilted facial angle. Use these drawings as a guide.

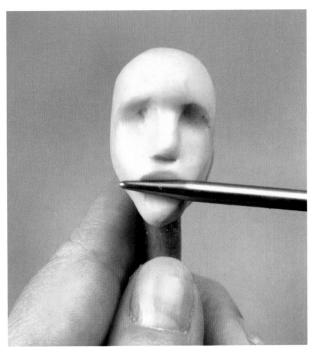

FACES OF AFRICAN HERITAGE

When you model a face of African heritage, set a slightly tilted facial angle by building up the chin and mouth with a flattened disc made of ½ Modeling Unit. Blend and then mark the position of the mouth.

BLOCKING THE UPPER LIP

Step 17—Place the medium knitting needle a little more than halfway between nose and the tip of the chin. Push up gently to the mouth mark to block in the upper lip.

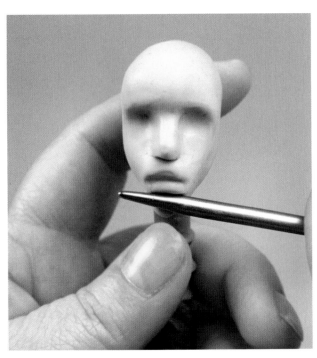

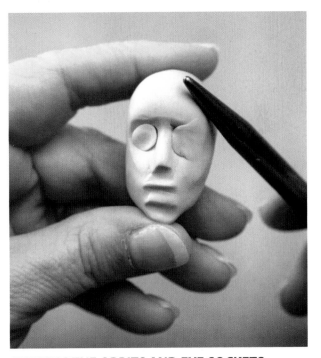

BLOCKING THE LOWER LIP

Step 18—Set the medium knitting needle a little more than halfway between the upper lip and the tip of chin. Push up. Reshape the base of the jaw and chin if necessary.

SHAPING THE ORBITS AND EYE SOCKETS

Step 19—Build up the eye sockets and orbit, the bony part of the skull around the sockets. Place a small, flat disc on each side of the bridge of the nose just below the brow line. Use ½ a Modeling Unit for each disc on a woman's face. Use 1 Modeling Unit for each disc on a man's face. Blend by using the large knitting needle as a roller, and then finish smoothing with your finger. This added clay helps form the brows and builds up the cheekbones.

Creating Life-like Eyes in Polymer Clay

You can use manufactured glass or acrylic eyes, but glass eyes are expensive and acrylic eyes may crack during baking. And, too, eyes fashioned for dolls sometimes exaggerate the size of the iris. Here's a brush free method for making painted, polymer clay eyes durable enough for modeling. They take little time to make, but they do need varnish, and the varnish should cure for several hours. Cured varnish is forgiving; you won't damage the eye as you work. You'll need the eye mold and stand described on page 18 in Part Three.

Always make extra eyes. Nothing is more frustrating than dropping a tiny eyeball, where it's lost in thick carpeting or bounced into oblivion.

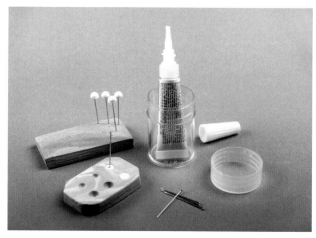

MAKING THE EYEBALLS

Step 20—Roll the eyeball clay into small balls; dip in water and then press firmly into the eye mold that is 4mm in diameter. The clay should be even with the top of the mold. Dip the head of a straight pin into instant glue, and then press it into the center of the eyeball. Wait a ten seconds for the glue to set before using the pin as a handle to lift the eyeball out of the mold. Set the pin in the baking stand. Bake the eyes for 20 to 30 minutes at 265° F and let cool in the stand.

TO MAKE LIFE-LIKE EYES YOU'LL NEED:

• The eye mold and stand (page 18)

• A small amount of light colored clay

• Shallow dish with water

• Cyanoacrylate (instant) glue

• A small jar lid

• Straight pins

• Acrylic gloss varnish (page 19)

• Acrylic paints: White, Black; Cobalt or Ultramarine Blue; Raw Umber and Raw Sienna; or Sap Green and Cadmium Yellow Medium

• Paint brush (for mixing, not painting)

• Small steel crochet hook

• Paint tray or jar lids

• Water

• Paper towel or clean rag

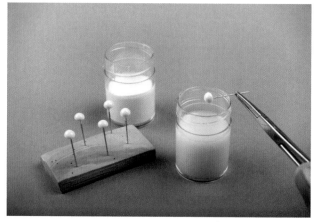

Step 21—Use the pin as a handle to dip the eyes into white acrylic paint. Locking tweezers or hemostats are perfect for holding the pin. Let the eyes dry in the stand about 30 minutes. Dip into gloss varnish, tapping the pin to remove any excess varnish. Let dry for 1 hour.

NOTE

The eye width encompasses the corners of the eyes, a feature that's part of the lids. 4mm is a good size for a ⅙ scale head, but you can use an eyeball as large as 5mm and set it slightly deeper.

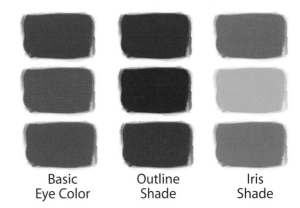

A Palette for Painting Eyes

Basic Eye Color	Outline Shade	Iris Shade

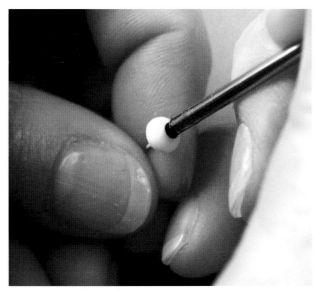

FROM WHITE TO PUPIL

*These eyes illustrate the painting technique. They also illustrate the size of the iris—⅓ to ½ the eye width. **a)** The varnished eyeball with its smooth easy to stamp surface. **b)** The dark outline for this blue eye is blend of black and blue. **c)** The tinted iris is a lighter shade of blue. **d)** The darker pupil is a blend of black and the outline shade.*

MIXING THE PAINT

Step 22—Choose a Basic Eye Color—Blue, Brown or Green. The outline shade is the basic color darkened with a touch of black. The iris shade is a lighter hue of the basic color. For Blue eyes, add White or Cerulean Blue. For Brown and Green eyes, add Raw Sienna, Yellow, or Yellow Ochre to the basic color. Add more Black to the Outline Shade to paint the pupil. Use just enough water to make the paint the consistency of cream.

PAINTING THE IRIS

Step 23—Use the handle of a steel crochet hook as a stamp to paint the iris. Dip the handle into the paint just enough to coat the tip. Stamp the center of the eyeball with the darker outline color. After the outline color dries, dip the handle of the crochet hook into the lighter iris hue, just enough to catch a bead of paint. Touch the bead of paint (not the handle itself) to the outline paint. The paint should fill the original circle but leave some of the outline visible.

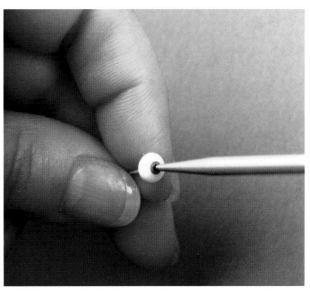

PAINTING THE PUPIL

Step 24—After the iris hue dries, use the point of a medium knitting needle to paint the pupil. Dip the needle point into a puddle of pupil color and then just touch the point to the center of the iris. After the pupil dries, dip the eye in varnish. Tap to remove any excess and let cure for 1 to 2 hours or more.

It takes a bit of practice to set the focus. Sometimes, twisting an eyeball will bring both into alignment. Another solution: eyes that look to one side or the other. It adds a spark of awareness, and that's priceless.

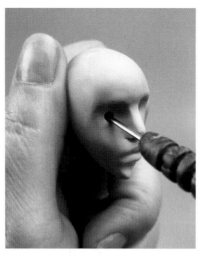

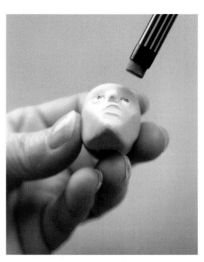

SETTING FOCUSED EYES

Step 25—*Mark the sockets one eye width from the center line. Pierce through the clay into the foil with the small tapestry needle. Use the large tapestry needle and a circular motion to widen the socket. Pierce again with the small tapestry needle to set the focus of the eyes. Pierce straight for eyes that look straight ahead or at slight angle for eyes that look to one side or the other.*

Step 26—*Cut the straight pin close to the eyeball. Set the eyes in their sockets. Make certain both look in the same direction before using the pencil eraser to firmly push the eyes in place. Look at the eyes from the chin up to make sure they're level.*

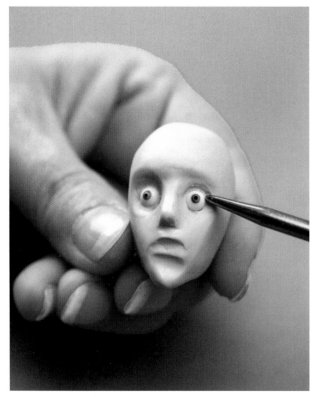

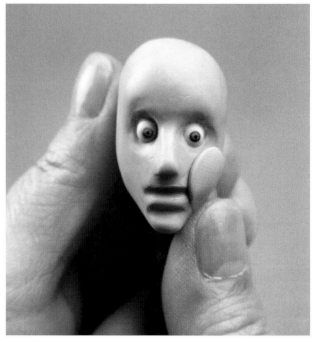

Step 27—*Use the medium knitting needle to "draw" a smooth, evenly defined border around each eye.*

FINISHING THE BASIC FACE

Step 28—*Add and blend a flattened ball made of 1 Modeling Unit placed on each cheek. Blend the jaw area with your fingers first. Use a large knitting needle as a roller near the nose mouth and eyes. Soften and smooth with your fingers.*

Understanding the Skull beneath the Skin

Modeling Ethnicity

You've just made the basic face. Bug-eyed and laughable, it's the beginning of a thousand faces made by just as many choices. Understanding some of the ethnic distinctions will help you make those choices. The facial angle described on page 26 is one example, an ethnic distinction seen in the skull beneath the skin. You may wish to represent others.

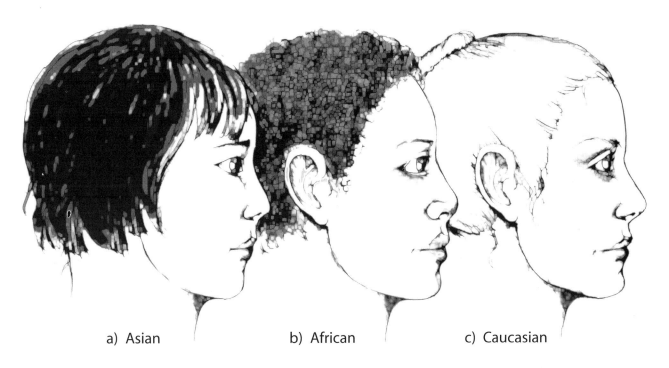

a) Asian b) African c) Caucasian

a) Asian: Traits most often seen in people of Asian ancestry may include an arched crown and the vertical profile described on page 26. A vertical and blunt chin enhances the effect made by broad and prominent cheekbones, features that reflect more light and add width to the face. A short nasal bridge makes the nose appear more delicately sculpted. Lack of shadows from the nose make the almond-shaped eyes look wide set. The eyebrows tend to be straight, rather than arched or round.

b) African: People of African heritage may have a slightly flatter crown, rounder at the back of the head, and the tilted profile described on page 26. Prominent cheekbones and a short nasal bridge produce a wider, flatter and more softly modeled nose, and the rounded rectangular eyes may seem wide set. The face typical of African descent has a rich layer of skin and muscle over smooth bones. The effect is a round, smooth forehead, full cheeks and fuller lips above a vertical, blunt chin. The eyebrows are often rounded, rather than arched or straight.

c) Caucasian: A round crown, flattened at the back shapes the skull of a person of Caucasian ancestry. The slightly tilted forehead, prominent brow ridge, equally prominent chin, and receding cheekbones make the face appear narrow. A long, high nasal bridge produces a sharply modeled nose that can make the eyes seem more closely set. The eyebrows tend to be arched, rather than round or straight.

Refining the Shape of the Face

Adding appliques to the cheeks or jaw will make the basic face fuller, or rounder, or stronger. Appliques also strengthen the perception of ancestry and gender.

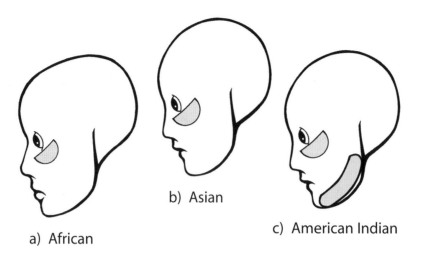

b) Asian

a) African

c) American Indian

These drawings show you the size and shape of appliques that enhance heritage by building up the cheekbones and the jaw. **a)** *Build up each cheekbone on a face of African descent with ¼ of a Modeling Unit. Roll ½ Modeling Unit into a ball, flatten and cut in half to form this applique.* **b)** *& **c)** For the broader, more prominent cheekbones of Asian or American Indian ancestry, roll ¾ of Modeling Unit into a ball, flatten and cut in half.* **c)** *Widen the jaw on faces of American Indian ancestry with a strip made of ½ a Modeling Unit.*

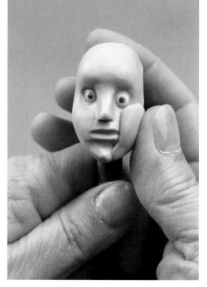

BUILDING UP THE CHEEKBONES

You'll find the large knitting needle is the best tool for blending this applique that builds up the cheekbones. Use the needle as a roller and finish by rubbing smooth with your finger. Refer to the pattern for the ethnicity of the figure you're modeling.

MODELING A STRONG JAW

Build up the cheekbones before you add this applique to create a strong jaw, a trait often seen in faces of American Indian descent. Use your thumb or fingers to blend this applique, a strip made of ½ of a Modeling Unit.

MODELING THE PLUMP FACE

If you want to model a fat face, use more clay. An egg-shaped applique of 3 Modeling Units makes for a naturally fat face with plump cheeks, jowls and chin.

Refining the Features

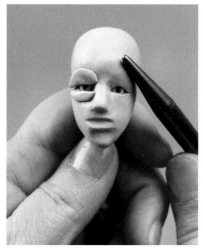

MODELING THE EYES AND LIDS

Step 29—Model the eye lids with ¼ of a Modeling Unit for each upper lid and ⅛ for each lower lid. Roll into elongated eggs. Flatten and press in place. Use the large knitting needle as a roller to blend the seams.

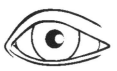 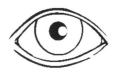 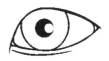

a) Caucasian b) African c) Asian

ANCESTRAL EYES

*These drawings show three distinct eye shapes, each an echo of ancestry. **a)** The triangular Caucasian socket produces a triangular eye with the apex of the triangle slightly to the inside. The lid is prominent. **b)** The African eye mirrors a rectangular socket, making for a larger, more exposed, evenly-shaped eye. Thicker skin on the orbit may partially conceal the lid. **c)** The almond eye of the Asian people reflects the oval shape of the socket. The epicanthal fold conceals the lid and creates an upward angle.*

 a) positive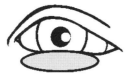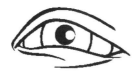

 b) negative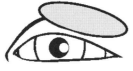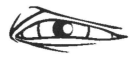

EXPRESSIVE EYES

*Heredity shapes our eyes, but emotions exert their own influences. To describe eyes that express emotions as well as ethnicity add appliques. **a)** When we smile, grin, laugh, and sing, the elevator muscles, a group named for their ability to lift the mouth, affect the shape of the eyes as well. These muscles attach at the cheekbones and at the orbit. When they contract they push against the lower lid. A small oval made of 1/32 to 1/16 of a Modeling Unit blended beneath the eye creates the influence these muscles have. **b)** Negative emotions tend to make us furrow our brows, concealing part of the lid. Add a flattened oval made of 1/16 to ⅛ of a Modeling Unit. Place it just above the eye and blend to create this effect.*

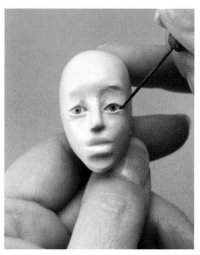

Step 30—Use the small tapestry needle to describe the shape of the eye. Rest the tip of the needle lightly on the eyeball as you draw the opening. Tracing and retrace the upper lid until smooth. Do the same for the lower lid. Define the corners of the eyes by pushing the point of the small tapestry needle into the corners.

TIP

Pick up tiny appliques with the tool you'll use for blending. You'll be able to see what you're doing. Just touch the tool to the clay. If the clay sticks to the work surface, loosen it with a blade and then pick it up with the tool.

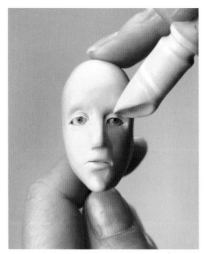

MODELING THE EYELIDS

Step 31—*Set the large curve tool on the upper lid above the middle of the eyeball and pivot first to the inside corner of the eye and then to the outside corner. If you wish, use the fine needle to mark a lid-line as a guide for setting the tool in place.*

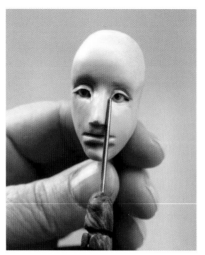

Step 32—*Refine the shape of the lid with the large tapestry needle to reflect ancestry and enhance the corners of the eyes.*

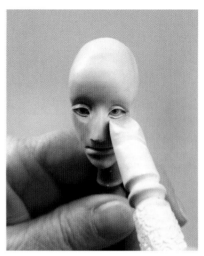

Step 33—*Press the large curved tip tool just below the lower lid and pivot, first to the inside corner and then to the outside.*

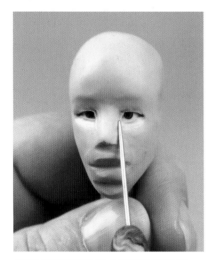

CREATING THE ASIAN FOLD

In people of Asian, and sometimes American Indian or African descent, a fold in the skin hides the upper eyelid. Suggest presence of the upper lid and the epicanthal fold concealing it by drawing a fine crease at the inner corner of the eye.

TIP

If the eyelids seem too thick, use the medium knitting needle as a roller and move it gently across the lid. Trim away excess clay with a craft knife and re-define the shape of the lid at the same time.

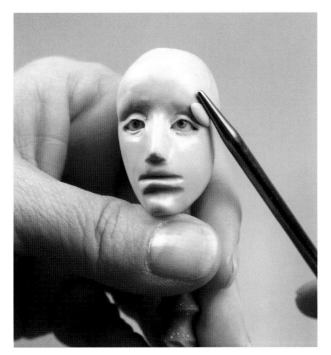

MODELING THE EYEBROWS

Step 34—Add a flattened oval made of ⅛ of a Modeling Unit just above the outer corner of the eye and below the eyebrow. Blend using the medium knitting needle as a roller.

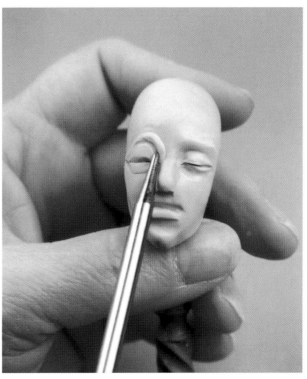

MODELING THE CLOSED EYE

Model the closed eye over a prebaked eyeball. Position the appliques and then use the curved tip tool to mark the crease of the upper lid. Soften the crease with the large knitting needle and blend the appliques. Pay attention to the corners of the eyes as well as the natural curve. Re-define the lid lines with the small tapestry needle.

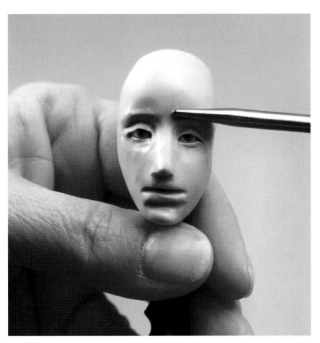

Step 35—Roll the medium or large knitting needle up from the crease of the lid toward the brow line. Work directly above the eye and then at an angle toward the outer corner of the eye. Finish by rolling the needle down from the mid forehead down toward the brow line.

TIP

Model normally-shaped brows first. Then, when you raise or lower them to express a particular emotion, you'll better understand the technique and know when to stop and avoid exaggeration.

Modeling the Mouth

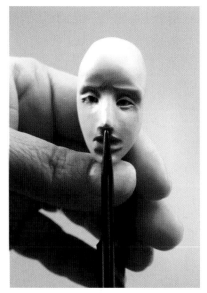

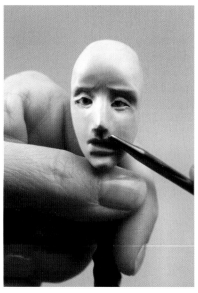

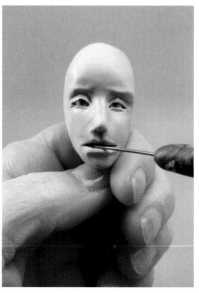

SHAPING THE PHILTRIM

Step 36—Press the tapered end of the medium knitting needle just below the center of the nose to form the philtrim, the groove that shapes the cupid's bow.

SHAPING THE UPPER LIP

Step 37—Set the medium knitting needle just above the lip and to one side of the philtrim. Lightly roll the needle down to the one corner of the mouth. Repeat this step on the other side. Make the lips larger by lightly drawing on the lip with the large knitting needle. Work from from the center to the corners of the mouth.

SETTING THE LIP LINE

Step 38—Hold the small tapestry needle at a slight angle with the point at one corner of the mouth and rock the press down. The point of the needle will create the corner of the mouth while the shaft of the needle will mark half of the lip line. Repeat this step at the opposite corner.

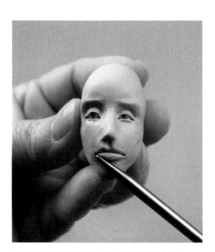

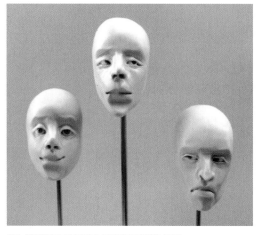

MODELING THE LOWER LIP

Step 39—Gently close the mouth using the same method you used to block in the lower lip. Refine the shape by pressing the needle at a slight angle on each side of the lower lip. Use the needle as a roller or your thumb to remove any grooves at the sides of the mouth.

PLAYING WITH EXPRESSION

An expressive mouth starts when you set the lip line. Accent the corners of the mouth and then draw the lip line. Curve the corners up for a smile. Draw straight across for a classic mouth, or pull the corners down for a frown. When you block the lower lip, it will follow the line you've described.

TIP

When we smile the elevator muscles make the cheeks appear fuller. Consider building up the cheeks with small round appliques made of ⅛ of a Modeling Unit if you model a smiling face.

Modeling the Nose

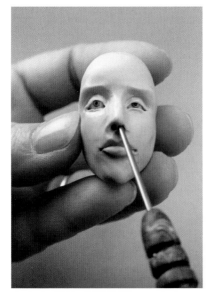

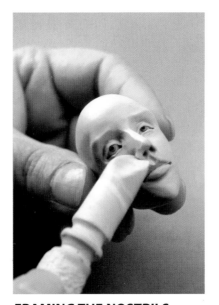

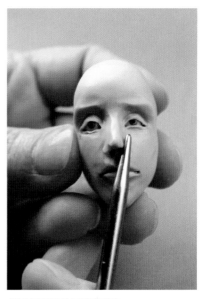

Step 40—Pierce the nostrils with the large tapestry needle. Move the needle lightly to the side and then up to create the tall, narrow nostrils for a person of Caucasian or Asian ancestry. Move the needle in a small circle to widen the nostrils for a face of African ancestry.

FRAMING THE NOSTRILS
Step 41—Use the large curved tip tool to create a curved groove on each side of the base of the nose. The flesh that frames the nostrils is called the ala. The groove is the alar cleft.

REFINING THE TIP
Step 42—Press lightly on each side of the tip of the nose with the medium knitting needle. Hold the needle at an angle for a more pointed nose.

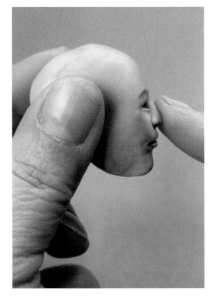

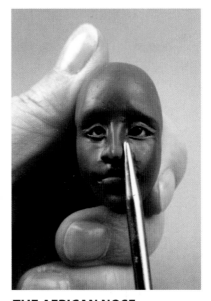

THE ASIAN NOSE
For a face of Asian ancestry, gently press the nose against the face to soften the profile.

THE AFRICAN NOSE
A face of African descent should have oval nostrils. Create the oval shape by pressing down against the top of each ala with the large knitting needle.

Changing the Nose to Fit the Face

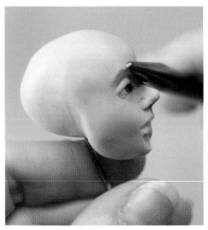 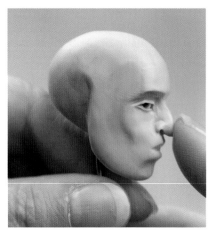 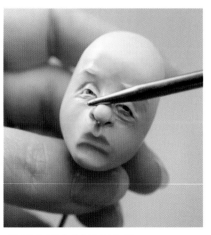

THE SNUBBED NOSE

Change the very straight nose to snubbed nose by pushing up at the tip with your finger. Reduce the bridge by rolling the large knitting needle toward the brow.

THE AQUILINE NOSE

Create a hooked nose by stroking the tip down with your finger. Pressure from the large knitting needle at the top of the bridge and just above the tip will create a bump that enhances the effect.

THE BULBOUS NOSE

Use the large knitting needle as a roller to enlarge the tip of the nose by rolling downward. Pivot the medium knitting needle all the way around the tip of the nose to create the bulb.

Modeling The Cheekbones and the Chin

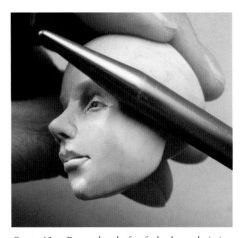 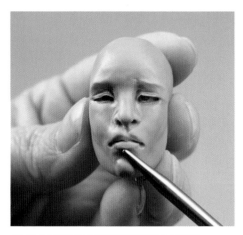

Step 43—Press the shaft of the large knitting needle against each side of the face at the center line. This step builds up the zygomatic bone, the arched bone at the side of the face that provides leverage for the jaw muscles.

SHAPING THE FEMININE CHIN

Step 44—Line up the medium knitting needle with the sides of the nose and then pivot the needle across the chin, creating a gentle arc. Soften the arc with your finger. Postpone this step on a man's face until you've made changes to the brows, mouth and jaws. To understand those changes, read the text.

Defining Gender

Though you may have used the amount of clay recommended for modeling a man's face, that face may still have some feminine qualities. You need to make adjustments, push the clay around a bit to emphasize a masculine gender. Before you do take a moment to understand what it is about a man's face that makes him so different from a woman. With that understanding, you'll have the confidence to make the necessary changes to your sculpture.

All women have something of the child still in them. Her bones are small and smooth. Her chin is pointed, her jaw round and narrow. Her forehead appears vertical and often round because of her small brow ridge. Her eyes, too, may seem round, soft, and large because of the smoothness of the bones. These are childlike features that remain as a girl becomes a woman. A man's skull is more robust with a ruggedness of bone that supports larger muscles and thicker skin. This bone and muscle growth gives an angularity to the features, including the eyes.

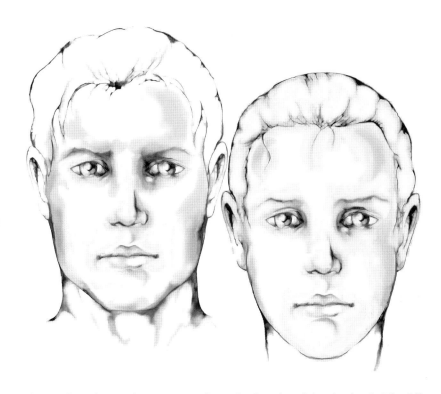

These two have the same features, yet one face is clearly male and the other female. The difference lies in the bones. A man's skull has thicker, rougher bones than a woman's, giving him a more prominent nose and brows, a square chin and wider jaw. The woman's narrower jaw and rounder face makes her eyes appear larger. Her pointed chin makes the mouth look fuller. While both possess the same nose, his is slightly larger.

TIP

Whatever the gender of the sculpture you're creating, the basic techniques remain the same. When modeling a woman's face, work gently and your work will show the smooth skull beneath the skin. Even though you've formed the foundation of a man's nose and eyes sockets, work with the same light touch. Those not quite masculine features will become a foundation for the changes that create a man's face. When you make those changes, be bold. Adopt an angular attitude. Straighten the curvature in the eyes, the nose, the mouth and the chin. Use strong strokes to model a man's head, beginning with the brows.

Modeling the Male of the Species

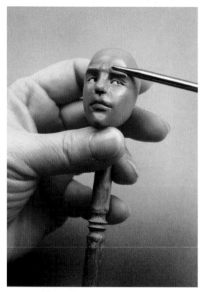

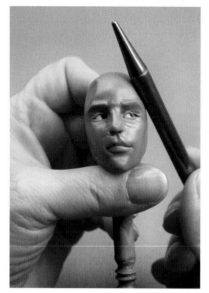

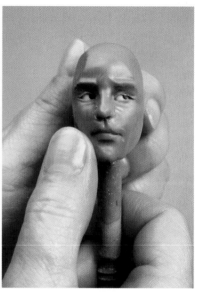

THE BROWS

Change a feminine face into one that is clearly masculine. Begin with the brows by using more pressure as you roll the medium knitting upward. Don't forget to roll the medium knitting down from the forehead toward the eye brows to position them properly. The more pressure you apply, the more prominent the brows.

ENHANCING THE TEMPORAL MUSCLE

Use pressure and a slight rolling motion at the sides of the forehead to suggest the temporal muscle. Larger in man, this muscle stabilizes the jaw.

SOFTENING THE CORNERS OF THE MOUTH

Use your thumb or finger to blur the edges of the bottom lip near the corners of the mouth and draw more clay toward the jaw.

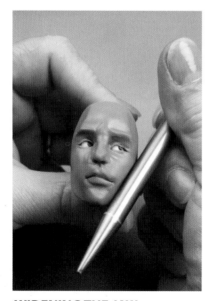

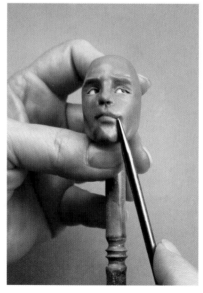

WIDENING THE JAW

Create a more sculpted cheekbone and widen the jaw further by pressing the shaft of a large knitting needle against the side of the face. Rolling the needle down toward the jaw at a slight angle for the best effect.

SHAPING THE MASCULINE CHIN

Line up the shaft of the medium knitting needle at the corners of the mouth before you pivot the needle across the chin. Finish by flattening the base of the chin a bit, making it more square.

Modeling The More Expressive Mouth

On the adult face, with the features so widely spaced, you have room to make changes easily and in any order. You know how to make changes that alter the shape of the nose. It's time to open the mouth, show a bit of tooth and express delight with the grin and the laugh.

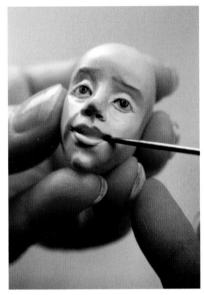

THE GRIN

Step A—*Turn a smile into a grin. Place the point of the large tapestry needle in the corner of the mouth. Pivot the needle back across the lip line. Repeat on the opposite side of the mouth. This step opens the mouth.*

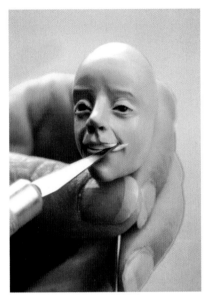

Step B—*Use the tapered end of the medium knitting needle to place a tiny rod of white clay in the open mouth. Press it flat with the same motion you used to open the mouth. Cut away any excess white clay and form a straight line at the bottom of the teeth with a craft knife.*

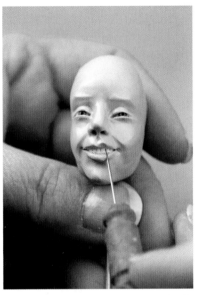

Step C—*Mark 6 to 8 teeth with the shaft of the fine needle. Begin in the center. Don't worry if you mark the bottom lip.*

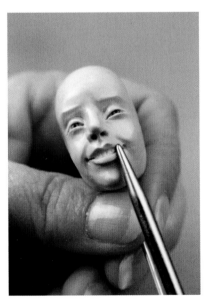

Step D—*Rolling the medium knitting needle across the bottom lip will erase any needle marks.*

NOTE

When the grin took shape, those wide eyes no longer fit the face. Tiny rods of clay, blended on the lower lids solved that problem.

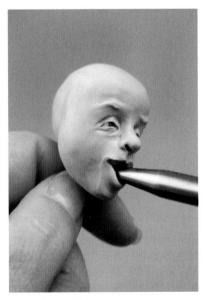

THE WIDE OPEN MOUTH

Pierce the center of the mouth with the tapestry needle. Move it in a circle to begin opening the mouth and then use a large knitting needle to open the mouth as wide as you wish.

A Timely Touch

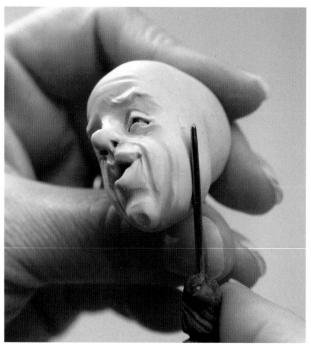

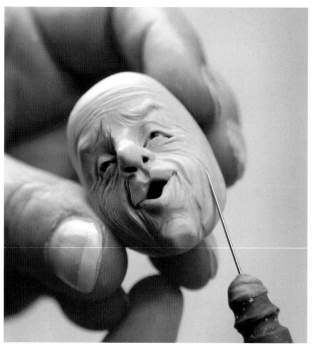

SOFT LINES AND WRINKLES

As we grow older, our skin loses its elasticity, our muscle loses tone, and our body loses fat. Soft Lines or wrinkles occur first. Use the shaft of the medium or small knitting needle to press these timely touches into the skin on the sides of the face, the jowls, and forehead.

FINE LINES

Use the small and large tapestry needles to create the more prominent laugh lines around the mouth and worry lines across the forehead and bridge of the nose. Use the shaft of the fine needle for the more delicate wrinkles.

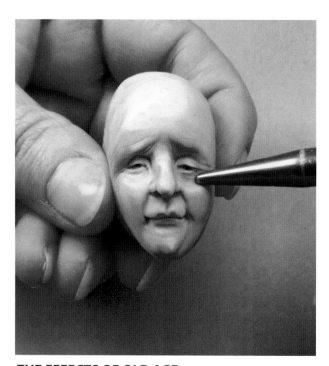

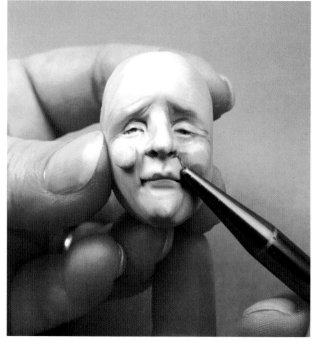

THE EFFECTS OF OLD AGE

Step A—In very old age, loss of fat effects the appearance. Eyes, once cushioned by pads of fat, sink slightly. Set the eyes a deeper. Use the tip of the medium knitting needle to describe the socket beneath the eye.

Step B—Accentuate each cheekbone with a small disc of clay. Use ⅛ of a Modeling Unit for each. Blend with a large or medium knitting needle. Push the chin towards the nose to show the effect of lost teeth.

Modeling the Neck

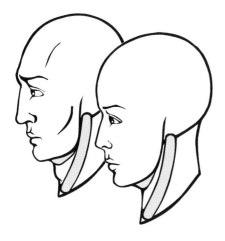

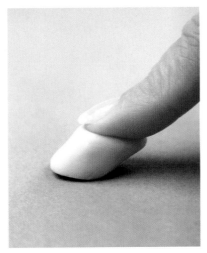

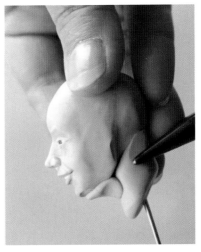

Man or woman, young or old, the pattern for modeling the neck is the same.

Step 45—Roll a ball of clay from 1 Base Unit for an average figure, 1 ½ units for a fat figure, into a rod with a diameter of ¾ the length of the head. Press one end at an angle against the work surface. Turn lengthwise and flatten the other end at an angle.

Step 46—Pierce the neck with the small tapestry needle. Thread the neck onto the rod until it fits snugly against the base of the head. Shape a flat triangle and fill out the base of the jaw. Use 2–3 Modeling Units for the base of a woman's jaw, 3–4 for a man's, 5–6 for a heavy jaw. Blend from the neck onto the head, from the base of the jaw onto the neck and then onto the jaw.

Refining the Neck and Jaw

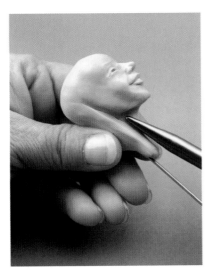

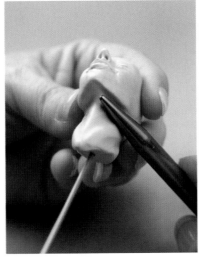

Step 47—A powerful muscle connects the upper jaw to the breastbone and collar bones. Create this muscle by adding a flat rod to each side of the neck. Use two Modeling Units for each rod. Place each at an angle beginning just behind the jaw and sloping toward what will be the pit of the neck. Blend the seams by stroking with your finger or use the medium knitting needle as a roller.

Step 48—Use pressure from the large knitting needle to model the underside of the jaw. If it's a man's head, move the needle to the side slightly to make the jaw wider. Gently pinch the mid throat to form the Adam's Apple.

Adding the Ears

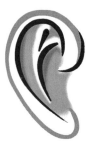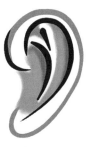

Step 49—It only takes a few strokes with the large knitting needle to model the ear, but it helps to have a pattern for modeling. The black lines in this illustration indicate the tool strokes you make to create the folds and curves in a pair of ears. You'll begin near the rim and work your way inward.

TIP

If you have trouble modeling ears that match, model one ear and set up a small mirror so that you can see its reflection. Use it as a reference for the second ear. The orientation will be the same.

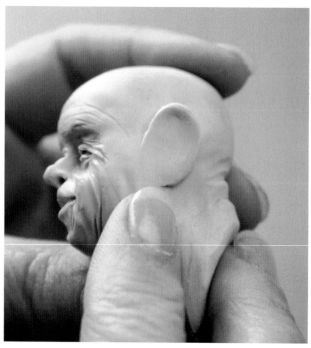

Step 50—Form two eggs, using ¾ of Modeling Unit for each. Flatten slightly with your finger, using a little pressure to form a shallow depression.

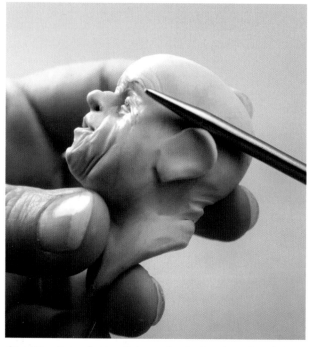

Step 51—Raise the rim of the ear by pivoting the medium knitting needle around the top, back, and base of the ear. Use the shaft of the needle to rub the seams smooth. Gently press the lobe end closer to the head.

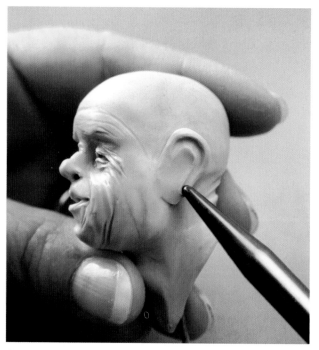

Step 52—Trace and retrace the shallow C-shaped groove near the rim of the ear with the large knitting needle. Use more pressure at the top of the ear and then taper off at the base of the "C".

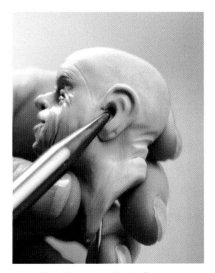

Step 53—Trace a smaller C-shaped opening with the large knitting needle. Gradually push toward the back of the ear to create the fold in the ear. If you raise a sharp edge, gently rub smooth with your finger.

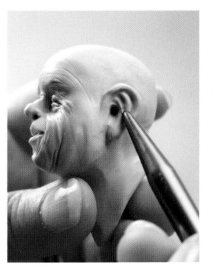

Step 54—Use the tip of the medium knitting needle to press the V-shaped grove near the top of the fold. The fold should now resemble a curved Y.

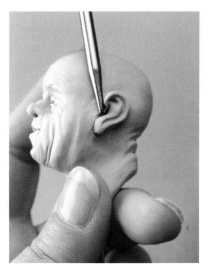

Step 55—Pivot the medium knitting needle around the crest and into the opening of the ear. This step raises the ear and pushes a bit clay toward the opening of the ear forming the pina.

In a New Light

On a different day in another light, I might see other possibilities and make other changes. The mood striking me might strike them. For the moment, these three and several others are almost finished. They need bodies and limbs, clothing and hair, blush on the cheeks and rouge on the lips.

TIP

After you've finished, set your work aside for day. Spend some time in the real world, observing real people. Now you're ready to look at your work in a new light—a bright and critical light. Look for balance and scale. Study it upside down and in a mirror. Get out your gauge and check for features that might be too large or too small. You'll find the rested clay cooler and firmer, but you can easily change the features. You'll find removing nicks, scratches, fingerprints, and flaws an easier task on cool clay.

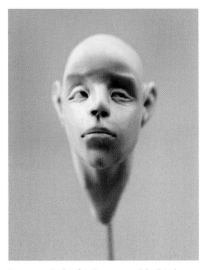

In a new light this brown-eyed lady's brows were too high and nostrils too large. It took light pressure above the brows to lower them. Pinching her nose to close her nostrils made all the difference in the world.

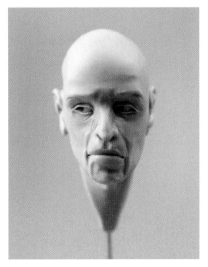

Pressure above the eyebrows with the large knitting needle made this man's brows larger and lower.

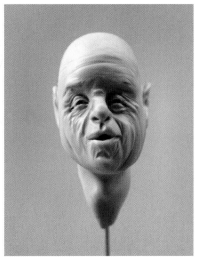

The fat fellow seemed just about right, but closing his mouth a bit added realism to his expression.

The Body in Question

The torso is the body in question, a marvel of muscle and tendon fastened to a foundation of bone. Hourglass in shape, compact foil cores provided the foundations for these torsos. A layer of clay, built up with appliques, provided the means for modeling the muscles. Tool strokes did the rest.

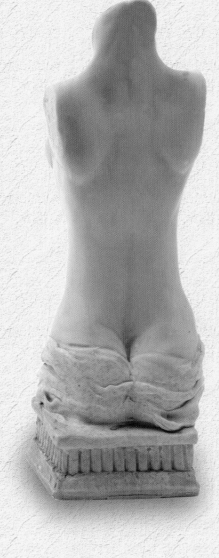

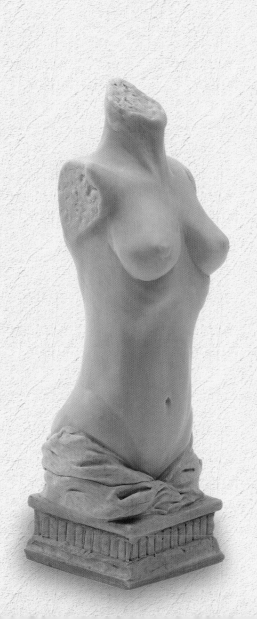

Mapping the Torso

The same robust growth seen in a man's skull exists in his torso. His ribcage, made of larger bones than a woman's, adds breadth to the shoulders, and produces a slight angle in the collar bones. The pelvic girdle, more closed and upright than a woman's, makes for narrower hips and a flatter abdomen. Smaller, smoother bones comprise a woman's ribcage and shoulder girdle. Her collar bones lie horizontally because her ribcage is smaller. Her pelvic girdle, made to cradle a growing infant, adds width and roundness to the belly and hips.

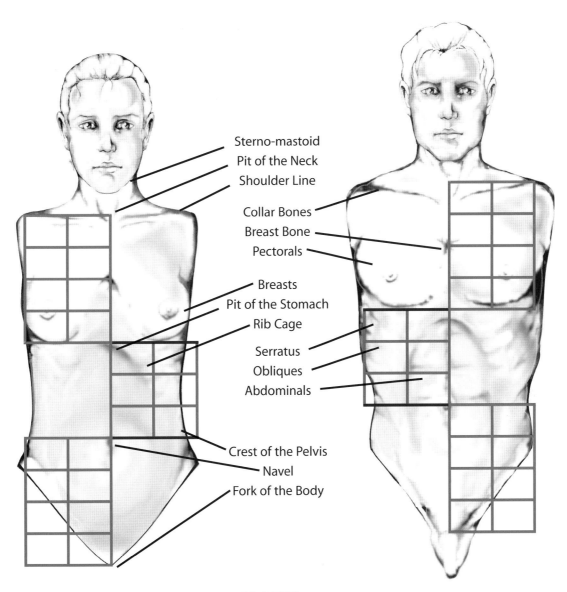

Sterno-mastoid
Pit of the Neck
Shoulder Line
Collar Bones
Breast Bone
Pectorals
Breasts
Pit of the Stomach
Rib Cage
Serratus
Obliques
Abdominals
Crest of the Pelvis
Navel
Fork of the Body

LANDMARKS OF THE CHEST AND ABDOMEN

These two figures have realistic proportions—a torso 2 ¾ head lengths long. The upper and lower torso are 1 head length long, joined by a mid section ¾ of a head length long. Their waistlines are roughly the same, a little more than 1 head length wide, but the similarities end there. A woman's chest is 1 ¼ head lengths wide and her hips slightly wider, about 1 ½ head lengths. A man has narrower hips and a broader chest, just the opposite of a woman. The figures you make should reflect similar proportions. Knowing the muscles and bones, even their common names, will make modeling them easier.

The Torso in Profile

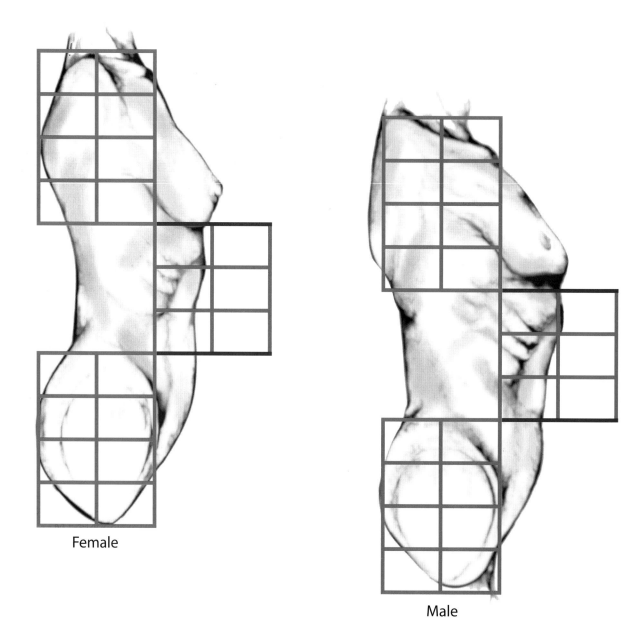

Female

Male

Seen from the side, you can see how the bones of the torso directly affect its shape. The man's broader chest reflects his larger ribcage. His upright pelvis makes for a straight back. A woman's tilted pelvis produces a greater arch. The grid illustrates the depth of the torso compared to its width—roughly ¾ the width all along its length.

Landmarks of the Back

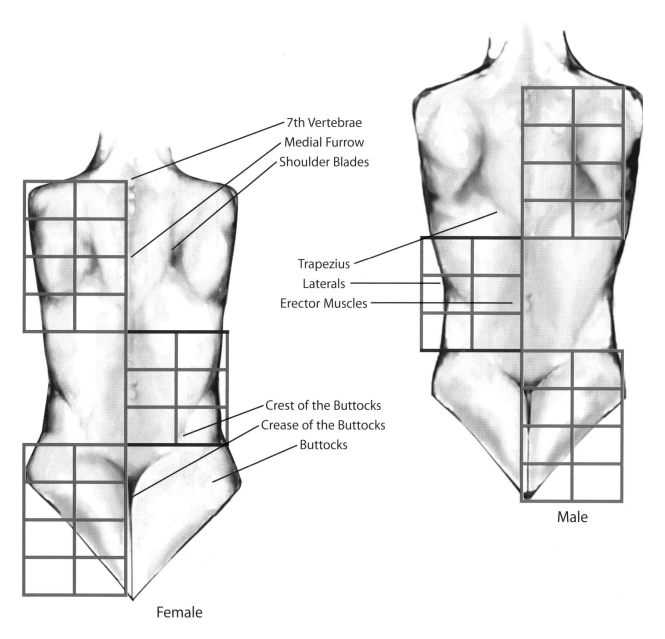

7th Vertebrae
Medial Furrow
Shoulder Blades

Trapezius
Laterals
Erector Muscles

Crest of the Buttocks
Crease of the Buttocks
Buttocks

Female

Male

The same grid is your reference modeling the landmarks of the back. The medial furrow, shoulder blades, the erector muscles, and the crest and crease of the buttocks are noticeable on every torso. Even a heavy torso may show the effect of the latissimus and the trapezius, muscles responsible for the V shape visible below the shoulder blades.

Building The Body
Crafting the Body Armature

With a baking time of 20 to 30 minutes for every quarter inch of clay, using a foil core for the body makes practical sense. A foil core with a body-like shape makes modeling sense. It gives strength and shape to the figure.

YOU'LL NEED THESE SUPPLIES

- Work surface
- Aluminum foil
- Twelve-inch ruler
- 20 to 25 Units of flesh blend clay
- Straight blade for cutting clay
- Gauge or dividers
- Large and small tapestry needle tool (Page 15)
- Large and medium aluminum knitting needles

Finishing Materials
- Two ⅛ inch diameter brass rods or coat hangers (5 ½ head lengths long)
- Sculpting Stand (page 18)
- Rubbing alcohol (91% is best)
- Clean paint brush—a #4 or #6 filbert is ideal
- Talcum powder
- Baking dish & fiberfill
- Medium and fine wet/dry sandpaper and water

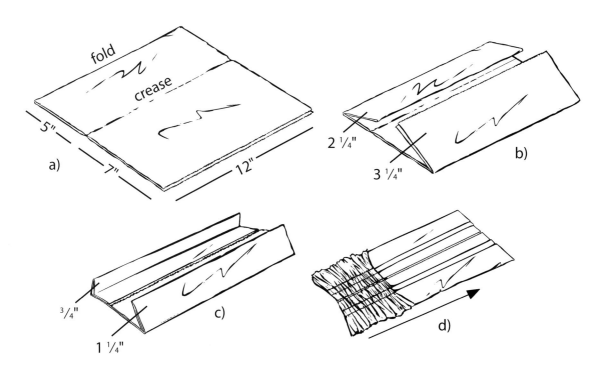

MAKING THE CENTRAL CORE

Step 1—These are the steps for making the central core: ***a****) Fold a 24-inch by 12-inch long sheet of foil in half to make it 12 inches square. Crease the foil parallel to the fold 5 inches from one end. This will be the waistline.* ***b****) Fold over 2 ¼ inches of the 5 inch wide hip section and 3 ¼ inches of the 7 inch chest section.* ***c****) Fold over ¾ of an inch on the shorter hip section and 1 ¼ inches on the longer chest section. If the folded sheet measures 12 inches by 4 ½ inches, you've done it just right.* ***d****) Gather perpendicular to the folds. The staggered layers of foil will create a core thicker at the ends—the chest and hips—and thinner at the waist.*

GATHERING THE FOIL

Step 2—For more control, make small, loose pleats before you gather the foil.

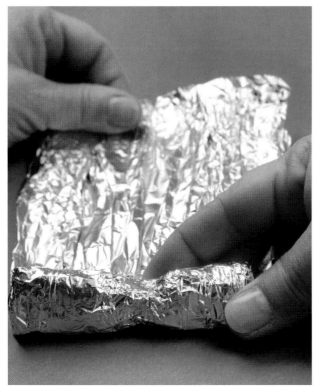

WRAPPING THE CENTRAL CORE

Step 4—Add bulk with three 12 x 12 inch sheets of foil. Gather each to a width of little more than 4 inches. Roll the core in the gathered sheets, one sheet at a time. Pull tightly. Stop now and then to pinch the foil at the waist. Make certain the wrapping is tight.

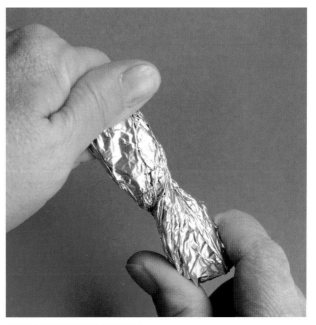

CREATING THE WAIST

Step 3—Pinch the waist to make it more compact. Twist once at the waist. It should resemble a lopsided bow tie a little more than 4 inches long.

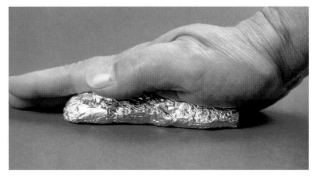

FLATTENING THE BACK

Step 5—Press the core against a hard surface with the palm of your hand. The softness of your palm will form a rounded front. The hard work surface will flatten the back.

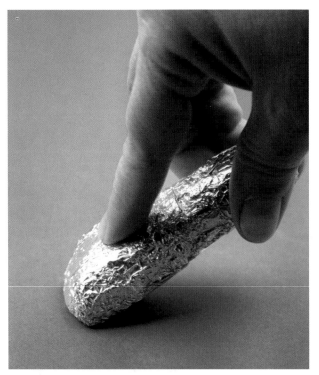

SHAPING THE SHOULDERS

Step 6—Bevel the shoulder line by pressing the chest against a hard surface. Do the same to the upper back.

TAPERING THE FORK

Step 7—Taper the hip joints by holding the core at an angle and pressing each bottom corner against a hard surface. Press hard and use a grinding motion to form smooth, sharply defined joints. This is the fork of the body.

ARCHING THE BACK

Step 8—Arch the back. If you plan to pose the body by bending or twisting it at the waist, flex the core several times and then arch the back. Modeling a straight body over a flexed core gives you the option to pose the body later.

Building the Basic Body

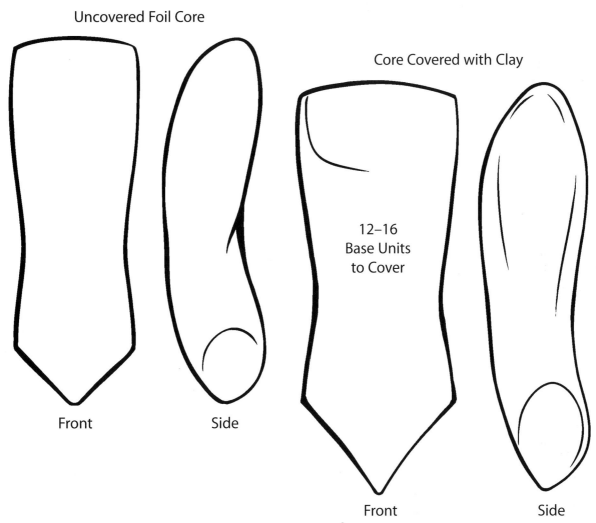

Uncovered Foil Core

Core Covered with Clay

12–16
Base Units
to Cover

Front

Side

Front

Side

SIZE & SHAPE OF FOIL CORE

The ⅙ scale body core should match this diagram for size and shape. It's just right for a figure 7 ½ head lengths tall, but a figure standing 6 ½ heads tall with shorter torso is just as realistic. So, too, is a figure standing 7 ¾ heads tall, with a torso of almost 3 head lengths long. If your foil core is compact and tightly wrapped, don't worry if it's a bit longer or shorter than the pattern. This is a diverse world where no body is perfect.

Step 11—*Cut the clay hourglass in half length wise. Flatten each half with the palm of your hand. Use a roller to make the two halves large enough to cover half of the core.*

Step 9—*Fill small crevices in the core with small amounts of clay. You shouldn't need more than one Base Unit.*

COVERING THE CORE WITH CLAY

Step 10—*Combine 12 Base Units for a slender body, 14 for an average body, and 16 for a stocky body. Roll the clay into a smooth, seamless ball. Form a rod ¾ the length of the core. Place the edge of your hand one-third of the way from the end of the rod and roll the rod back and forth until it's as long as the core. It should resemble an offset hourglass.*

Step 12—*Sandwich the core between the two sheets of clay. Press firmly, seal the seams and rub smooth.*

Step 13—*You'll find the roller helpful for creating a smooth body. The covered core should match the Basic Body Pattern.*

Building Up the Body

These appliques will build up the chest, upper back, buttocks, and correct the width of the shoulders and hips.

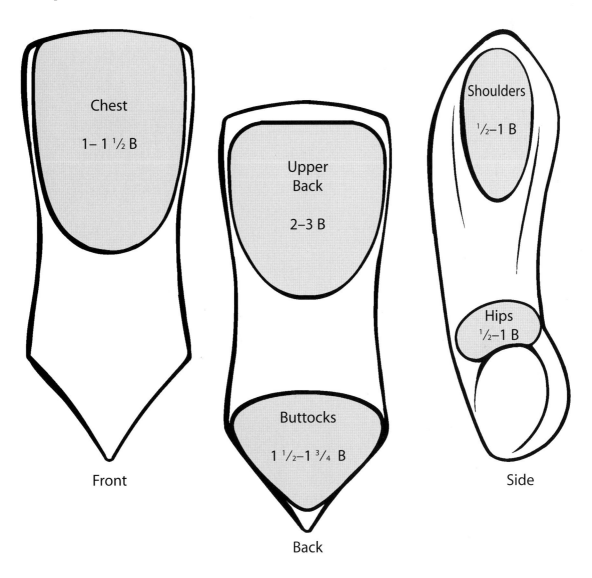

B = Base Unit

⅙ Scale
Base Unit

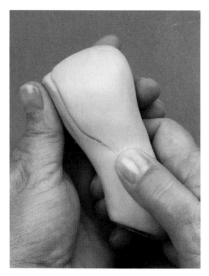

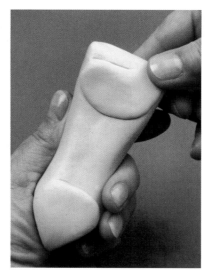

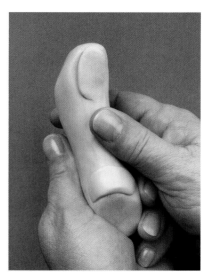

BUILDING UP THE CHEST

Step 14—Build up the chest with an oval pancake of clay. Use 1 Base Unit for a woman and 2 units for a man. Add ½ unit for a stockier figure of either gender. Roll the clay into a thick rod, and then flatten it with your palm until it matches the chest applique in the pattern. Blend the seams by rubbing from the applique onto the torso. Use a roller to create a smooth finish.

BUILDING UP THE BACK AND BUTTOCKS

Step 15—Add a flattened oval of clay to the upper and mid back. Use 2 Base Units for a woman and 2 ½ units for a man. Add ½ unit to make a stockier figure of either gender. Build up the buttocks with a flattened egg made of 1 ½ units for both the slender and average build. Add another ¼ unit for a stocky body. Blend the seams and then use a roller.

BUILDING UP THE HIPS AND SHOULDERS

*Step 16—Check the shoulder and hip width. Broaden a man's shoulders to 1 ½ head **lengths** wide with flattened eggs made of 1 Base Unit each. Use ½ of a Base Unit for a woman's smaller shoulders. They should be 2 head **widths**. Add girth to a man's hips with oval appliques made of ½ Base Unit. Use 1 unit each for a woman's hips.*

Modeling the Landmarks

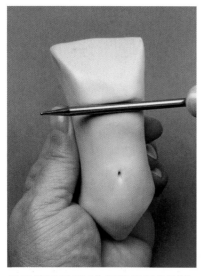

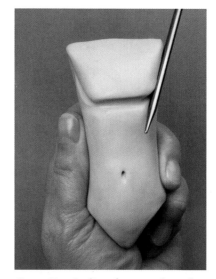

THE PECTORALS AND THE NAVEL

Step 17—Establish two landmarks, the base of the pectorals and the navel. Dimple the navel 1 head length above the fork of the body. Use the large knitting needle to press a horizontal groove into the clay a little more than 1 head length below the shoulder line. This is the base of the pectorals.

Step 18—Outline the pectorals with a groove on each side of the chest with the medium knitting needle. For each groove, set your needle on an invisible line connecting the shoulder to the navel and press. Round off the corners by pivoting the needle.

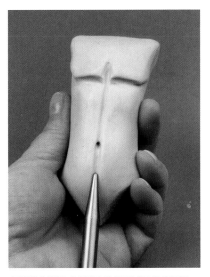

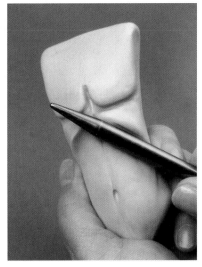

THE MID-LINE OF THE BODY

Step 19—Use a medium knitting needle to press a vertical groove extending from just above the fork almost to the pit of the neck. It's deeper where the muscles are more developed—just above the base of the pectorals and on the abdomen.

MODELING THE RIBCAGE

Step 20—Resembling an inverted U, the edge of the ribcage lies on two imaginary lines from the waistline line to the center of each breast. Set the large knitting needle parallel to that imaginary line and push toward the shoulders until the needle is almost on the line. Rub away any sharp edges with your finger.

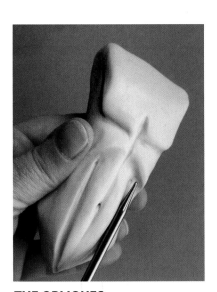

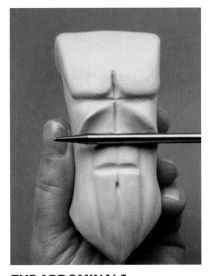

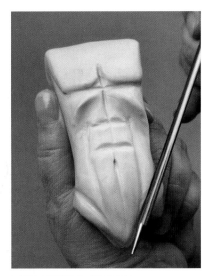

THE OBLIQUES

Step 21—The obliques, named for their slanting angle, flank the torso and frame the abdominals. One head width wide, the abdominals extend from the ribcage to the fork of the body, tapering below the navel. Create both muscle groups by pressing two gentle grooves with a medium knitting needle. Soften by stroking your finger up and down the groove. Use your finger instead of a tool on a woman's more softly modeled body, or on a slack and stocky body.

THE ABDOMINALS

Step 22—Tendonous bands cross the abdominals, adding strength by dividing the work. The first lies a little more than 1 eye width above the navel. The second lies ½ the mid-width above the first band. Use the shaft of the medium knitting needle to define the first and second bands in a well developed masculine torso The third band, just below the pectorals, is seldom visible. Use a large knitting needle and light pressure for a more rounded, yet well muscled woman's torso.

THE PELVIC GIRDLE

Step 23—Set the shaft of the medium knitting needle at the side of the body in line with the navel and then pivot the needle toward the fork of the body. This line echoes the angle of the pelvis and will help you model the buttocks.

Finishing Touches to the Chest and Ribcage

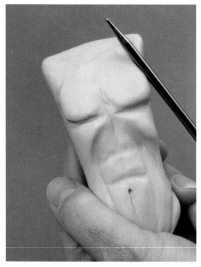

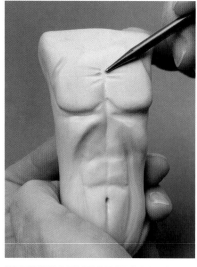

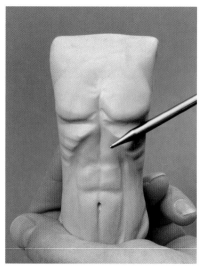

THE EDGE OF THE DELTOID

Step 24—*Rub the raw, rough edges of the chest and abdominals smooth. Form a small furrow at the sides of the chest with a medium knitting needle. This furrow, the leading edge of the deltoid muscle, will guide you when you add the arms to the body and model the shoulders.*

REFINING THE PECTORALS

Step 25—*On a well muscled, masculine body, the pectorals appear "knitted" together where they attach to the breastbone. Press three V-shaped grooves on each side of the mid-line, half way between the base of the chest muscles and the shoulder line. Use a moist finger to smooth the raw edges.*

THE VISIBLE RIBS

Step 26—*Suggest ribs by gently pressing three angled grooves on each side of the ribcage.*

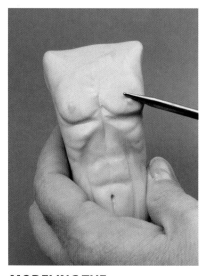

MODELING THE MASCULINE CHEST

Step 27—*The nipples lie 1 head length apart and 1 head length above the navel. Use tiny balls of clay to form the nipples, ¹⁄₁₆ of a Modeling Unit for each or less. Flatten slightly, press in place and blend the edges gently with the large knitting needle. Leave a small, round peak and lightly stipple around the edge.*

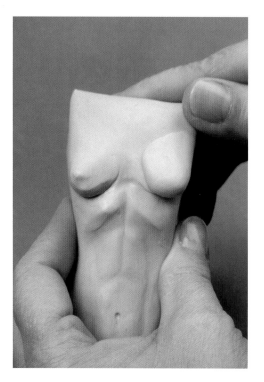

MODELING THE FEMININE BREAST

For a small breasted woman, roll ¼ of a Base Unit unit into a ball and cut in half (⅛ of a unit for each breast) and then press each half in place. For larger breasts, use twice as much clay. Blend the seams at the top of the breast first by stroking from the center of the breast onto the upper chest, and then towards the shoulders. Use the medium knitting needle, gentle pressure and a pivoting motion to seal and define the roundness at the base and sides of the breasts. Model the nipples using the same techniques you would use on a man's chest. They should point slightly upward and outward. Larger breasts have larger nipples.

Posing the Torso

We can shrug or hunch our shoulders, arch our backs, bend or twist at the waist. This is the average range of motion for the torso, easier to model with most of the work already finished.

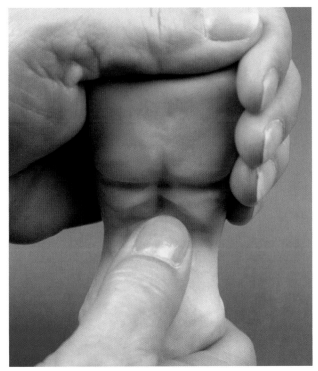

Step A—*To bend or twist the torso at the waist, cushion the back with the palm of one hand while you bend the torso forward, or turn it to one side. Clay at the waist may actually buckle, a problem easily fixed with gentle pressure.*

Step B—*Clay in the back may loosen or tear. Press the clay firmly against the foil core. Patch with small pieces of clay and blend Now, use the same tools and techniques described for modeling the straight back.*

Step C—*Press any buckled clay firmly against the foil core. Re-model the abdominal muscles if necessary, and add a few folds in the skin at the waist.*

Modeling the Back

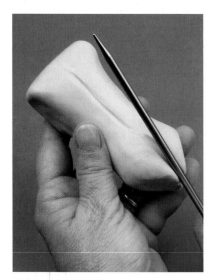

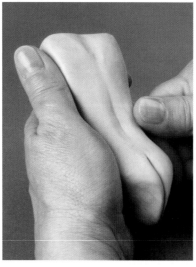

THE SPINE AND CREASE OF THE BUTTOCKS

Step 28—*Create a furrow along the midline of the back by stroking a grove down the spine with a medium knitting needle. To form the crease of the buttocks, press the shaft of the needle deep into the clay at the fork of the body. Pivot the needle from the fork toward the back, stopping ¾ of a head length above the fork.*

Step 29—*Rub the furrow smooth with your thumb by stroking away from the groove. Do the same to the edge of the buttocks. Use repeated finger strokes at the small of the back, 1 head length above the fork of the body, and at the shoulder line, where the erector muscles lie close to the surface. Squeeze the hip joints to close the crease of the buttocks.*

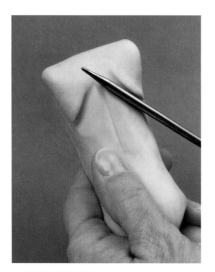

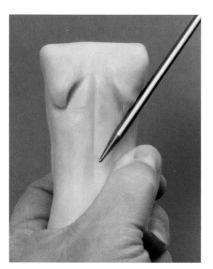

MODELING THE SHOULDER BLADES

Step 30—*Use gentle pressure and the shaft of the medium knitting needle to suggest the shoulder blades. Set the needle at an angle and push it toward an invisible line extending from the nape of the neck to the side of the body almost at its mid point. This is the same technique you used to create the rib cage.*

Step 31—*Give the shoulder blades a gently rounded V shape by pressing an angled groove running from the base of the shoulder blades to the shoulders. Rub the edges of the shoulder blades smooth.*

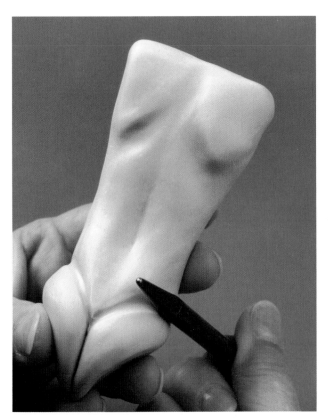

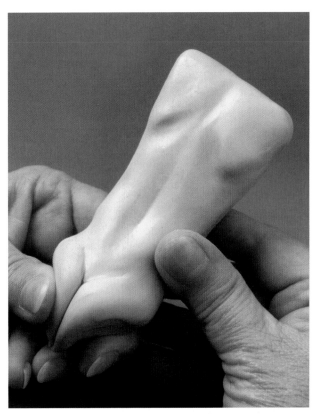

ROUNDING OUT THE BUTTOCKS

Step 32—*The crest of the buttocks is 1 head length above the fork of the body. Set the point of the large knitting needle at the crease of the buttocks and then pivot the needle back in a gentle arc toward the hip line. You may have to repeat this step.*

Step 33—*A wide V is centered at the crest of the buttocks. It's almost 1 head width wide. Rub the remainder of the buttocks smooth.*

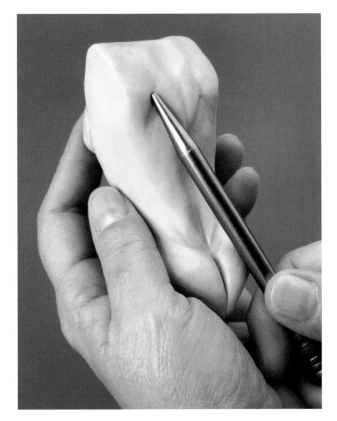

FINISHING TOUCHES TO THE BACK

Step 34—*The trapezius, named for its geometric shape, spreads like wings over the upper back, neck and shoulders. It creates the V shape seen beneath the shoulder blades. The latissimus dorsi, named for their size and position, originate at the pelvis and attach beneath the arm. Suggest the trapezius by pressing a light V into the upper back 1 head length below the shoulder line. Suggest the lattisimus with two angled furrows, one on each side of the back beginning above the buttocks and ending at the armpit. Use the large knitting needle for both. Soften all of the muscles, especially on a woman's body, with a gentle rubbing.*

Adding the Head to the Body

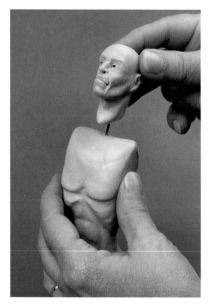

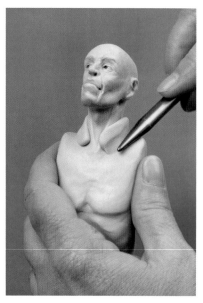

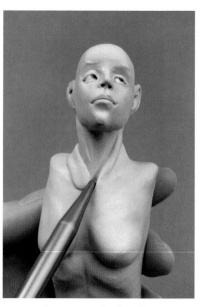

Step 35—*Pierce the torso at the center top with the large tapestry needle. Insert the rod till the neck sits firmly and blend seams.*

Step 36—*Secure the neck and build up the trapezius muscle with a flat collar clay made of ½ of a Base Unit if the figure is a man.*

Use ¼ of Base Unit for the collar to secure a woman's neck. Blend the seams and re-model the tendons of the neck as needed.

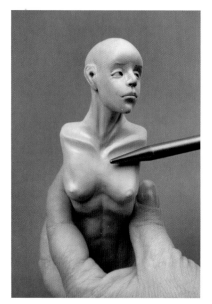

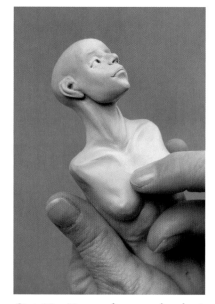

THE COLLAR BONES AND THE PIT OF THE NECK

Step 37—*Create the hollow in the neck above the collar bones with the shaft of the large knitting needle. Use the point of the needle to create the pit of the neck ½ the mid-width below the chin when the head is level. Use a rolling stroke from the chest upward toward the collar bones to empha-size the collar bones.*

Step 38—*Use your finger to soften the pit of the neck and the collar bones with gentle downward strokes.*

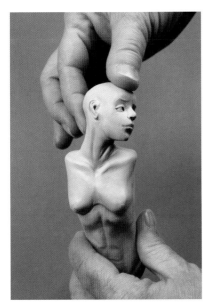

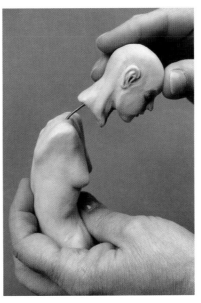

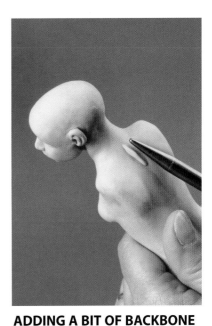

POSING THE HEAD

Step 39—You'll have no difficulty turning the head to one side or gently tilting it. The modeled muscles in the neck will also turn and stretch very naturally.

For the head that looks down, remove the armature rod from the head and neck, bend it and then place the rod in the body. When you ease the neck onto the bent rod, the clay will curve. Blend the seams and secure with a collar of clay, and then blend and model the collar bones and muscles. You can still turn the head from side to side slightly.

ADDING A BIT OF BACKBONE

Step 40—This is one of the last details. Add a bit of back bone with a small rod of clay. Blend the seams using a knitting needle as a roller. ⅛ of a Modeling Unit is just enough clay.

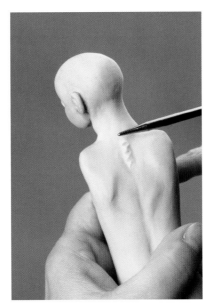

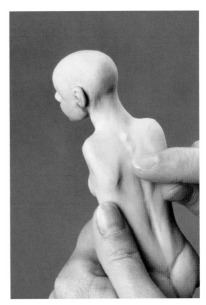

Step 4—Use the medium knitting needle to make two or three small grooves.

Step 42—Rub gently using a circular motion around each raised nodule, creating the appearance of the backbones.

The Heroic Torso

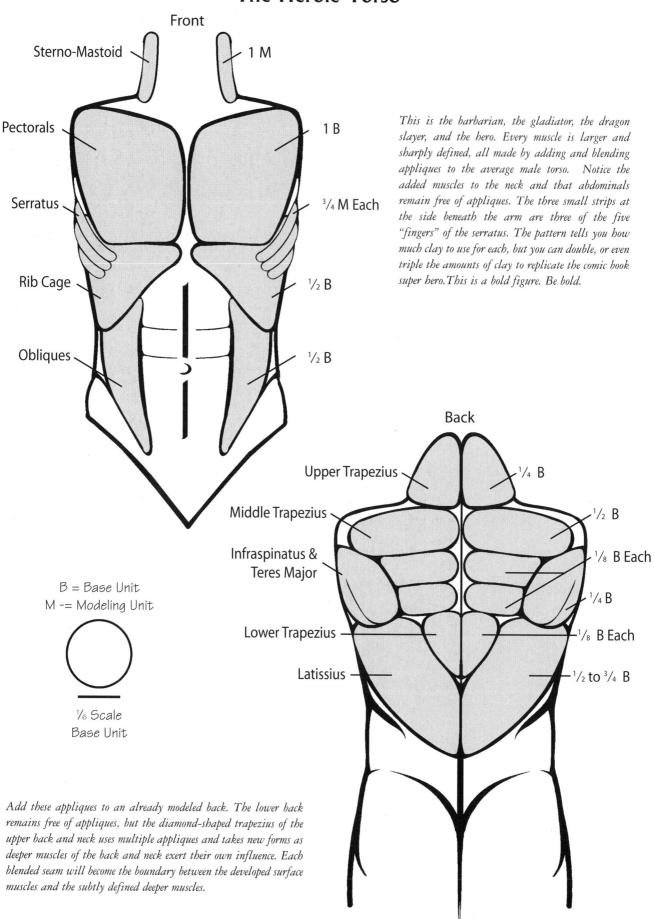

Front

- Sterno-Mastoid
- 1 M
- Pectorals
- 1 B
- Serratus
- ¾ M Each
- Rib Cage
- ½ B
- Obliques
- ½ B

This is the barbarian, the gladiator, the dragon slayer, and the hero. Every muscle is larger and sharply defined, all made by adding and blending appliques to the average male torso. Notice the added muscles to the neck and that abdominals remain free of appliques. The three small strips at the side beneath the arm are three of the five "fingers" of the serratus. The pattern tells you how much clay to use for each, but you can double, or even triple the amounts of clay to replicate the comic book super hero. This is a bold figure. Be bold.

B = Base Unit
M -= Modeling Unit

⅙ Scale
Base Unit

Back

- Upper Trapezius
- ¼ B
- Middle Trapezius
- ½ B
- Infraspinatus & Teres Major
- ⅛ B Each
- ¼ B
- Lower Trapezius
- ⅛ B Each
- Latissius
- ½ to ¾ B

Add these appliques to an already modeled back. The lower back remains free of appliques, but the diamond-shaped trapezius of the upper back and neck uses multiple appliques and takes new forms as deeper muscles of the back and neck exert their own influence. Each blended seam will become the boundary between the developed surface muscles and the subtly defined deeper muscles.

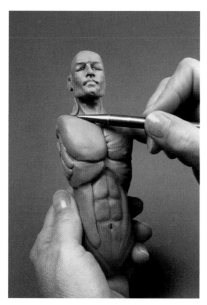

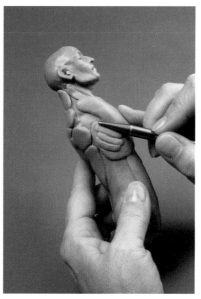

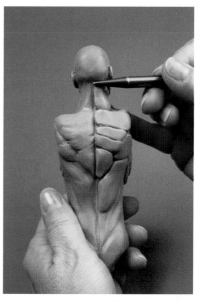

THE CHEST AND ABDOMEN

A—Follow the heroic pattern to build up the entire torso with appliques. Butt them against each other. Press down firmly. Use the large knitting needle to blend the edges of the appliques to the body and then to each other. Model the muscles in pairs or work on one side and use it as reference for the other side. Soften every tool stroke with your thumb or finger.

B—Note the additional fork of the sternocleidomastoid on the neck and the appliques that represent the serratus placed on top of the obliques. Use the diagram to position these muscles.

THE NECK AND BACK

C—With one side blended, you can see how appliques on the neck and the upper and mid back suggest the deeper muscles. Building up the midback, but leaving the lower back free of appliques helps to effect a trim waist.

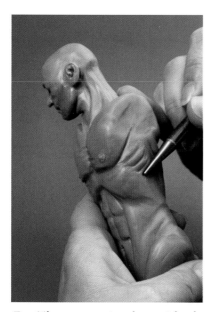

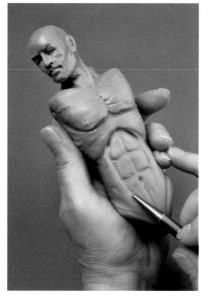

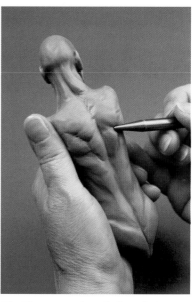

D—The serratus interlace with the obliques and the two appear braided together. Alternate finger and tool strokes to create this effect.

FINISHING TOUCHES TO THE HEROIC TORSO

E—With all of the seams blended, examine your work in a new light. Look for rough areas, such as these obliques. Roll or stroke them smooth. Check the torso for balance.

F—Use pressure from the large knitting to add emphasis where more than two muscle masses meet.

Modeling the Fat Body

SHAPING THE FAT CORE

Step A—*The fat body torso uses a simpler foil core.* *a) Fold a 24 x 12 inch sheet of foil in half making it 12 inches square, and then into thirds, making it 4 x 12 inches.* *b) Wrap the center of the rod with 12 x 12 inch sheet gathered to 12 x 2 inches. This will add extra fat to the middle of the body.* *c) Wrap again with two to four 12 x 12 sheets. Gather each sheet until it's the length of the central core and wrap the core with one gathered sheet at a time. Pinch the ends tightly as you wrap.*

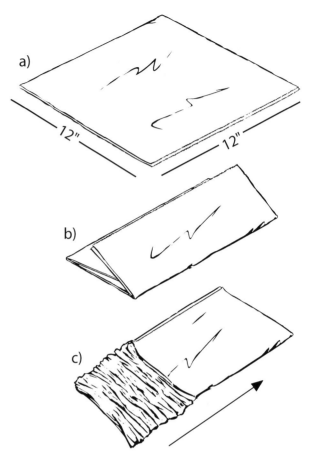

Fat Body Core

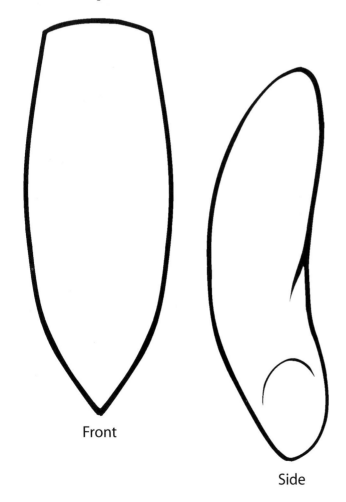

Front

Side

Step B—*Flatten the back, bevel the shoulders, form the hip joints, and create an arch using the techniques described on pages 51–52. It should match the size and shape of this pattern.*

Building Up the Fat Body

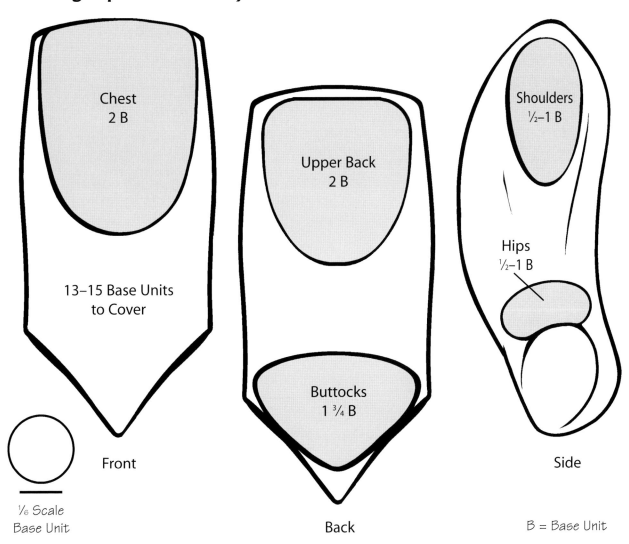

Chest
2 B

Upper Back
2 B

Shoulders
½–1 B

Hips
½–1 B

13–15 Base Units
to Cover

Buttocks
1 ¾ B

Front

⅙ Scale
Base Unit

Back

Side

B = Base Unit

Step C—Use 13–15 Base Units to cover the armature. Build up the chest, upper back and shoulders and hips, using the same amounts of clay as you would for an average torso. Add a bit more for the buttocks.

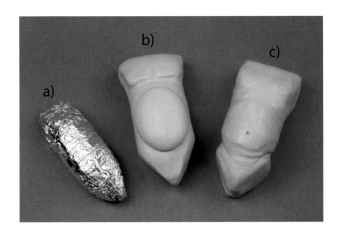

b)

c)

a)

Step D—a) The foil core, b) the basic fat body with an applique to fatten the belly in place c) and the modeled body use methods you already know. After building up the chest, back, buttocks, hips and shoulders, blend the seams. Model only the pectorals, the navel and the hip line. Don't model the abdominals or the mid-line, but do separate the breasts. Add and blend the belly fat with an oval applique made of 2–4 Base Units. Use the medium knitting needle to form rounded grooves in the clay, creating the illusion of a fat body whose weight causes the skin and underlying fat to drape in curves.

NOTE

Fat conceals. Landmarks such as the muscles of the neck, the collar bones, the shoulder blades, and the medial line should be softly modeled.

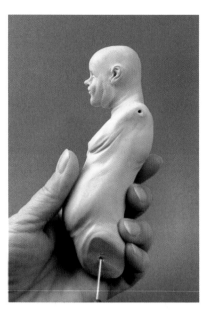

Step 43—Use the large tapestry needle to create starter sockets for the "bones" that will support the arms and legs. Pierce starter holes deep into the shoulder and the hip joints. Widen the hip sockets with a sturdy rod the same size as the armature rod you'll use to support the legs, or use a drill bit the same size as the armature rod. Widen the shoulder sockets to about ⅛ of and inch diameter, using either a #2 knitting needle, an armature rod, or drill bit.

NOTE

12 gauge coat hanger wire does work for the ⅙ scale standing figure, but ⅛" brass rods are stronger and less apt to bend. Smaller ¹⁄₁₆" brass rods are strong enough for the seated figure.

Preparing for the Next Step

As you've worked on your sculpture, you've used water to help your fingers glide over the clay, and mastered the skill of rolling surfaces smooth with a knitting needle. Two techniques, "burnishing" and "brushing down," will help erase fingerprints on large areas such as the fat man's belly, or soften tool marks in those hard to reach spots, such as the tendons in the Hero's neck

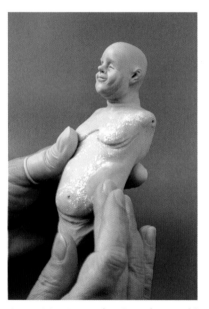

Step 44—"Burnishing" with a mild abrasive such as talcum powder or corn starch helps to remove mild imperfections. Wear a latex glove or finger cots (gloves for the fingers) on the hand you use to hold your work. Dust the figure and then burnish the surface with your thumb, finger, or palm of your hand. Take care near the nose, eyes, ears, and mouth.

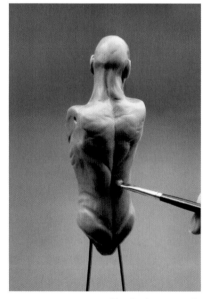

Step 45—Insert stiff rods deep into the hip sockets and stand the figure on the sculpting stand. "Brush down" the surface with 91% rubbing alcohol. Use a clean synthetic brush and let the alcohol do the work. Apply the alcohol so that it flows lightly, but doesn't drip. Don't use too much, or you'll dry out the clay. Wear gloves or finger cots. Let your sculpture rest an hour or more before touching it.

To Bake or Not to Bake

Adding limbs calls for a bit of manhandling. If the clay's very firm, you can simply let it rest and cool before you add the legs, or you can bake your sculpture now, a technique called "Series Baking." There are advantages to both choices. Working with a baked torso may feel awkward. Once it's baked, the pose is set, but mishandling won't damage well wrought muscles or fine features. Achieving a strong joint is easier with an unbaked torso, but mishandling while manhandling can damage a lot of hard work.

BAKING THE HEAD & TORSO

*If you decide to bake the figure at this point, follow the directions for the brand of clay you're using. The clay, thickest at the neck, determines the baking time, between 40 minutes to an hour. Use a glass pan or a large ceramic tile. Lay the figure on a cushion of cotton fiberfill or batting with an additional cushion beneath the neck and arch of the back. To protect from scorching cover the figure with 2 to 3 damp paper towels. Keep one eye on the thermostat and the other on the timer. A warm sculpture is a weak sculpture, one that can crack—**let it cool completely before handling it.***

HOT TIPS FOR THE COOL SCULPTOR

The figures in this book were baked many times. This technique, called "Series Baking," lets you build up a sculpture body part by body part, or layer by layer. Here are some tips for baking success:

• Use the baking temperature and time recommended by the manufacturer.

• Each time you bake a sculpture, or part of one, prop it. It may stand tall on the workbench, but not in the oven. Warm clay is vulnerable clay, soft and weak. Baked clay will soften, too.

• Let your sculpture cool in the oven for an hour or more and then let it cool to room temperature. Don't move it until the clay cools. Moving a warm sculpture leads to disaster—cracked necks, broken arms and fractured knees.

• If a sculpture does crack, stay cool, and let the sculpture cool. The glues you'll use to make repairs—instant glues for small cracks, polymer clay for large fractures, and PVC cement for major breaks—work best at room temperature.

• If the clay tends to darken or scorch, drape the sculpture with wet paper towels during the last half of the baking time.

• If part of a sculpture does scorch, take heart. Cut that dark clay away. Craft a new face, or new nose, or a new arm. I did.

A Leg to Stand On

The strongest bones, the most powerful muscles, and the most complex joints are in our lower limbs. We walk, run, leap and dance with astonishing agility. Work to suggest that combination of strength and joinery and you'll create the illusion of a figure with the same capacity for movement.

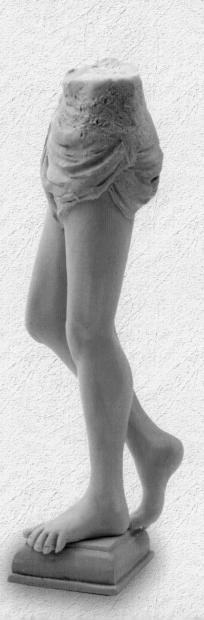

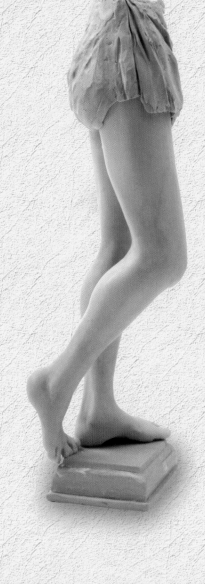

Landmarks of the Thigh, Leg, and Foot

Powerful muscles shape the lower limb. The Gluteals add roundness to the hips and buttocks while the Quadriceps add fullness to the thigh. The strap-like Sartorious enhances that fullness and visually divides the quadriceps from the hollow of the thigh. The Hamstrings create a flat, even appearance in the back while the Hamstring tendons frame the hollow of the knee. The knee joins the thigh to the leg. The inner margin of the tibia, the shinbone, is a visible landmark on the front of the leg. On the outside of the leg the thin fibula produces the gentle arc in the exterior muscles. On the back of the leg the Gastrocnemius, or calf, extends from the hollow of the knee to the midleg where it attaches to the Achilles tendon. The ankles, the heads of the fibula and tibia, divide the leg from the wedge-shaped foot. The dorsal arch, top of the foot, roundness of the heel and the toes are three of the landmarks within that form. The arch on the instep is another important landmark. The outside of the foot hugs the ground.

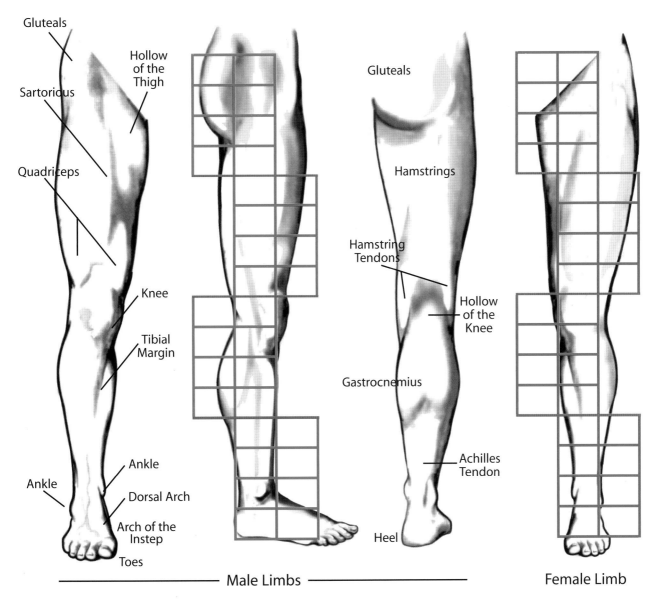

Male Limbs — Female Limb

The limb for a figure 7 ½ head lengths tall measures almost 4 ½ head lengths from the crest of the hip to the bottom of the foot, and 3 ¼ head lengths from the fork of the body. Though the woman's limb on the right has a smoother aspect and is broader at the thigh, the position of landmarks on her limb is the same as the three male limbs on the left. The base of the Buttocks lies in line with the fork of the body. The Sartorious crosses the inner thigh ¾ of a head length from the fork. The midpoint of the limb is just above the knee, and the base of the calf (the gastrocnemius) lies 1 head length below the midpoint, with the heel 1 head length below the calf. How sharply you choose to define the muscles depends on the body type you want to depict.

Building Legs and Feet of Clay

Again, you'll combine simple shapes to create complex forms. Again, you'll use armatures to make those forms strong—a stiff metal rod will replace the bones in each limb. Instead of foil you'll use clay cores. Easier to craft than foil cores, baked clay cores reduce the baking time of a partially or completely finished sculpture. Without a core, the thickest component of the limb, needs to bake 2 hours. That much time in the oven can scorch one of the best polymer modeling clays. Smaller elements in a sculpture—noses, ears, and toes—will darken. More importantly, these cores help you to model limbs that match.

Patterns for Building the Lower Limbs

Thigh Core Pattern - 9 Base Units

Leg Core Pattern - 5 Base Units

THE BAKED CLAY CORE

Once baked and threaded onto the metal bones, the clay cores made according to these patterns will give you a sturdy and poseable foundation for modeling. Both cores begin as elongated bi-cones, rod tapered at each end. Cutting each master core in half at a 45 degree angle will create two matching thigh and two matching leg cores.

NOTE

Even if you choose to costume your figure with loose-fitting trousers or a long gown, those garments deserve a figure that stands on realistically modeled limbs. Don't skip ahead. Stay in step and learn to model the bare limb. The well-dressed limb will follow soon enough.

YOU'LL NEED THESE SUPPLIES

- Work surface
- 40 Base Units of clay
- Straight blade for cutting clay
- Gauge or dividers
- Large and small tapestry needle tool (page 15)
- Large and medium aluminum knitting needles
- Curved Tip Tool (page 16)
- Craft knife
- Standing figure armature: two ⅛ inch brass rods 5 ½ head lengths long
- Seated figure armature: two ¹⁄₁₆ inch brass rods 4 ½ head lengths long
- Four temporary rods same diameter as armature rods 3 head lengths long
- Sculpting stand (page 18)
- Large baking dish or ceramic tile & Fiberfill

Pattern for the Limb

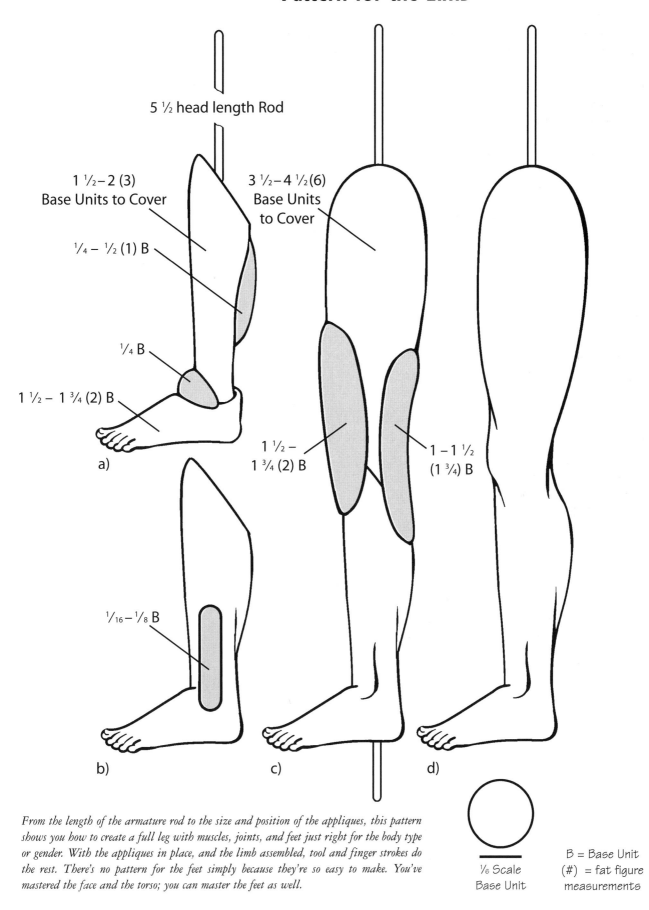

5 ½ head length Rod

1 ½ – 2 (3)
Base Units to Cover

3 ½ – 4 ½ (6)
Base Units
to Cover

¼ – ½ (1) B

¼ B

1 ½ – 1 ¾ (2) B

a)

1 ½ –
1 ¾ (2) B

1 – 1 ½
(1 ¾) B

¹⁄₁₆ – ⅛ B

b)

c)

d)

From the length of the armature rod to the size and position of the appliques, this pattern shows you how to create a full leg with muscles, joints, and feet just right for the body type or gender. With the appliques in place, and the limb assembled, tool and finger strokes do the rest. There's no pattern for the feet simply because they're so easy to make. You've mastered the face and the torso; you can master the feet as well.

⅙ Scale
Base Unit

B = Base Unit
(#) = fat figure
measurements

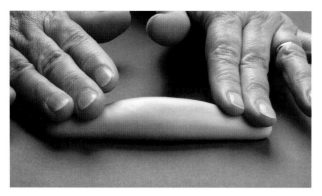

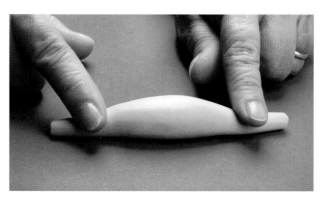

THE THIGH CORE

Step 1—*Combine 9 Base Units into a smooth, seamless ball of clay. Roll into a thick rod about head length long. Place your palms at the ends and continue rolling, applying pressure with your palms to taper the ends. It should be similar to the pattern on page 72, a bi-cone almost 3 ½ head lengths long.*

THE LEG CORE

Step 2—*Use 5 Base Units to form the leg cores. Use your fingers and more pressure near the ends to create a shape matching the pattern, a more tapered bi-cone 3 ½ head lengths long.*

TIPS

• For very strong legs for the standing figure, use an epoxy putty for the leg and thigh cores. ½ teaspoon of putty equals the Base Unit in volume. Blend the putty according to directions and let it set up for an hour or two. Use water or petroleum jelly to keep the putty from sticking to your hands and your tools and when you customize the thigh cores. Following the core directions for modeling, but before baking, thread both the thigh and leg cores onto each of the armature rods and gently bond together. Let cure over night for greater strength.

• If you have trouble rolling a core that's evenly tapered, you're using more pressure with one hand than the other. Let the hand that caused the problem correct the problem—flip the core lengthwise and continue rolling.

Step 3—*Use the pattern guide on page 72 to cut each master thigh and leg core in half at a 45 degree angle.*

PIERCING THE CORES

Step 4—*Use a slender, stiff rod or long needle to pierce each core. Spin your tool like a drill, and work to keep it centered. After piercing the cores, thread each onto a temporary rod the same diameter as the armature rod you'll use in the finished figure, ⅛ inch thick for a standing figure and 1/16 of an inch thick for a seated figure.*

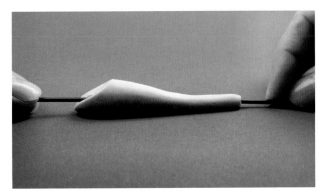

ALIGNING THE SHINBONE

Step 5—Hold the leg core by the knee with the knee face down and stroke it at the ankle until the core is the right length, 1 ½ head lengths for an average or lean figure, 1 ¼ head lengths or less for a plump figure. Gently press the front of each leg core against the work surface to flatten it slightly, and then round out the front by rolling it back and forth one or two times. This step corrects the length, thins the ankles, and aligns the shinbone close to the surface.

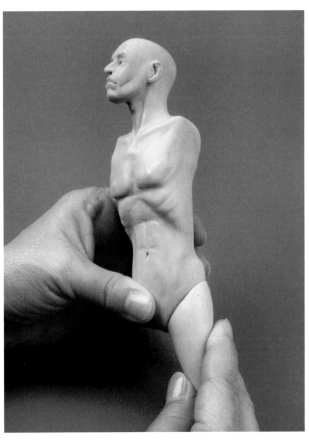

THIGHS THAT FIT THE TORSO

Step 6—Insure a good fit of the thigh to the body. With the thigh core on the temporary rod, insert the rod into socket in the torso. Lightly press the thigh against the hip joint to insure it fits the body. Brush the hip joint with water or powder to keep the core from sticking. This position, in line with the body, suits a standing pose.

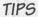

TIPS

Once the cores are on the rod, tailor them to suit the stature of your sculpture, not the pattern. For average or lean figures, stretch or compress the thigh cores to equal the distance from the fork of the body to the base of the pectorals, or 1 ¾ head lengths. You may have made a taller or shorter figure, and crafting cores that suit the stature is more important than following the pattern exactly. For fat figures a thigh shorter than normal, 1 ½ head lengths, will emphasize the body's plump appearance.

BAKING THE CORES

Step 7—Bake all four cores on a cushion of fiberfill in a glass pan according to package instructions. The clay will be thickest in the thigh cores and that thickness determines the baking time, depending on the clay, from 1 to 1 ½ hours. While these cores bake, model the feet.

Feet of Clay

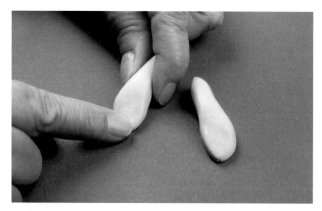

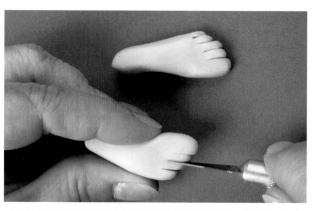

SHAPING THE BASIC FOOT

Step 8—*Work step by step to create a pair of feet, not one at a time. Use 1 ½ Base Units for each woman's foot, 1 ¾ Base Units for each man's foot, and 1 ¾ to 2 Base Units for the fat foot. To shape each foot, roll the clay to form an elongated egg about ¾ of head length. Hold the egg by the small end, the heel, as you stroke the other end, the toes, to flatten them. This will lengthen the foot to a little more than 1 head length.*

ORIENTING THE FEET AND MARKING THE TOES

Step 9—*Curve each foot inward, forming a right and left foot, and the cut three evenly spaced "toes" with a craft knife. Split the two outer toes with the knife to make four smaller toes and one big toe on each foot.*

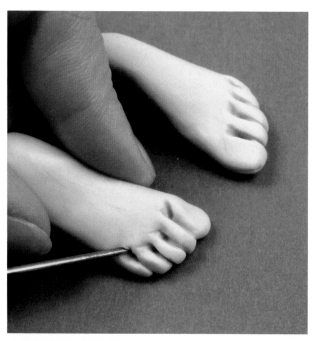

REFINING THE WEBBING

Step 10—*Use the large tapestry needle to round out the toes and enhance the cleft, or webbing, between each toe.*

REFINING THE TOES

Step 11—*On the bottom of the foot, press two angled grooves into the clay—one below the small toes. Curl the small toes over the needle after you create this groove.*

Step 12—Place the second groove below the big toe.

FORMING THE ARCH

Step 13—Create the arch on the instep with the large tapestry needle. Roll it back and forth a bit to form a smooth and realistic arch.

DETAILING THE SOLE

Step 14—With some poses, the bottom of the foot is visible. For a kneeling or seated figure, add this step: Separate each toe with the small tapestry needle and then use the large medium knitting needle to press a small indentation between each toe.

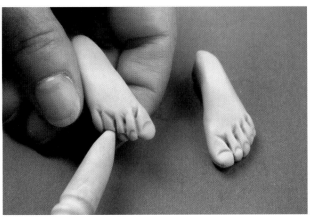

MARKING THE NAILS

Step 15—Use the large curved tip to imprint the base of the nail on the big toe and the small curved tip to imprint the nails on the small toes.

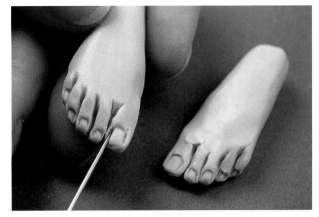

FINISHING THE NAILS

Step 16—Define the sides of the nails with the small tapestry needle.

COVERING THE CORES WITH CLAY

Step 17—Remove the temporary rods and cover each core with an oval sheet of clay. Form the clay into a shape resembling the core. Flatten with a roller until it's 3 times as wide and a bit longer than the core. Use 4 ½ Base Units to cover each male thigh, 3 ½ units for each female thigh, and 6 Base Units for each fat thigh. Use 2 Base Units to cover up each male leg, and 1 ½ Base Units to cover each female leg. Use 3 Base Units for each fat leg. Cover each core completely.

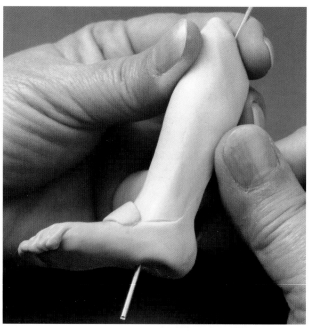

MODELING THE LEG AND ATTACHING THE FOOT

Step 18—Set the covered thighs aside while you assemble the leg and foot. Press the base of the leg into the clay foot. Thread the armature rod into the leg and pierce the foot. Secure the foot and build up the dorsal arch with an oval applique made of ¼ of a Base Unit. Blend the seams by first stroking clay from the heel up onto the leg and from the sides of the foot onto the leg. Blend the applique by stroking from the applique up onto the shin and down onto the foot. Rub smooth with your finger and re-model the arch on the instep if necessary.

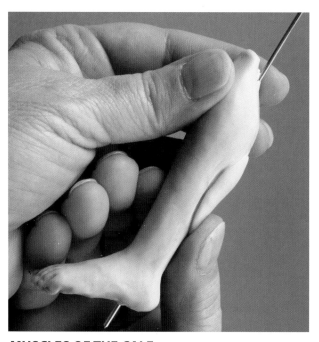

MUSCLES OF THE CALF

Step 19— Build up the muscles of the calf, the Gastrocnemius, with an oval applique. Use ¼ of a Base Unit on a female leg, ½ a Base Unit on a male leg, and ¾ to 1 unit on a fat leg. Blend from the applique onto the leg.

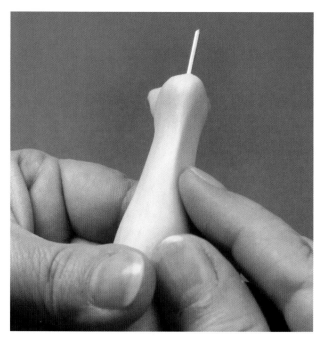

THE ACHILLES TENDON

Step 20—Stroke upward on each side of the back of the leg. Begin your strokes just above the heel. This step creates the Achilles tendon and adds more clay to the muscles of the calf. Stroke more firmly on the inside of the leg; the inner belly of the gastrocnemius is slightly higher. If the tendon moves to one side, center it with a finger stroke on the other side.

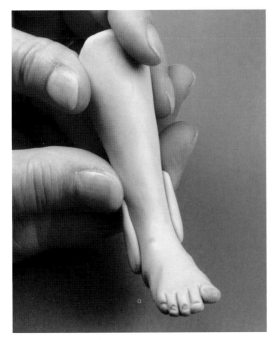

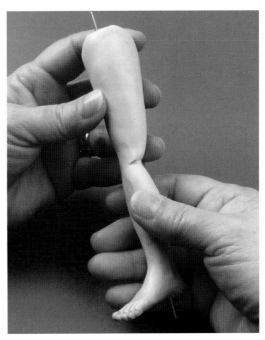

A WELL-TURNED ANKLE

Step 21—Use one slightly flattened rod of clay for each ankle. Use ¹⁄₁₆ of a Base Unit for a woman's ankles and ¹⁄₈ for a man's ankles. The base of inner ankle lies just above the top of the foot and the outer ankle lies just below. Blend the side and top seams stroking upward with your fingers.

ASSEMBLING THE LIMB AND MODELING THE THIGH

Step 22—Thread the covered thigh onto the armature rod with the crest of the thigh on the outside. Push firmly to weld the two parts of the leg together. The knee should overlap the base of the thigh. Blend the seams.

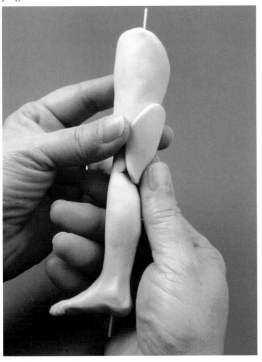

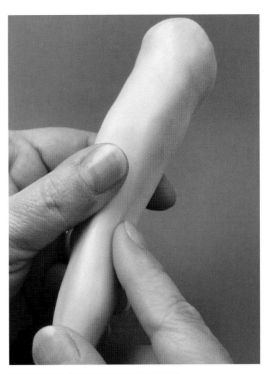

BUILDING UP THE HAMSTRINGS

Step 23—Secure the joint and build up the Hamstrings with an oval applique. Use 1 Base Unit on a woman's limb, 1 ½ Base Units on a man's limb, and 1 ¾ on a fat limb. Press firmly in position so that it covers the hollow of the knee. Blend the seams from the applique up onto the thigh and down onto the calf and then the sides.

THE HOLLOW OF THE KNEE

Step 24—Stroke the back of the knee joint downwards to create the tendons and the hollow of the knee. Use repeated strokes rather than one firm stroke. Finish by lightly pinching the tendons toward each other.

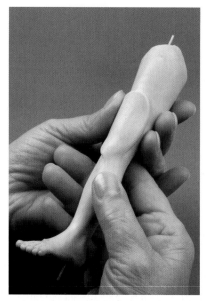

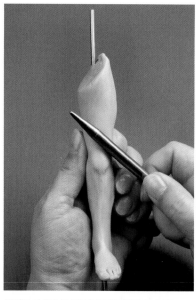

THE QUADRICEPS AND THE KNEE

Step 25—*Build up the knee and Quadriceps with an oval applique. Use 1 ½ Base Units for a woman's leg, 1 ¾ Base Units for a man's leg, 1 ¼ to 2 for the heavy leg. Blend the bottom seams carefully so as not to lose the base of the knee. Blend the seams by stroking from the applique onto the thigh. When finished, stroke along the edge of the applique on the outer thigh. This softly modeled groove is the illio-tibial band.*

THE QUADRICEPS TENDON

Step 26—*Suggest the Quadriceps tendon with light pressure from the large knitting needle on the inside and outside of the limb just above the knee. On a woman's more softly modeled limb and on the fat limb, use your little finger to do this step.*

THE KNEECAP

Step 27—*Suggest the kneecap's triangular shape with pressure from the large knitting needle. Soften the knee details with your finger*

THE SARTORIOUS

Step 28—*¾ of a head length from the top of the inner thigh, use the shaft of the large knitting needle to press a diagonal groove extending from the inner thigh to the hip, fading at the hip. This is the strap-like Sartorious. Soften it with a finger stroke.*

THE TIBIAL MARGIN

Step 29—*Stroke the inside of the leg from just above the inner ankle to the base of the kneecap. Use enough pressure to raise a slight ridge, the visible edge or margin of the tibia.*

The Heroic Limb

Like the heroic torso, the muscles on the heroic limb stand proud and well defined. This pattern will help you place appliques on the already modeled leg to produce muscles befitting a hero's stature. Each fraction is that part of a Base Unit.

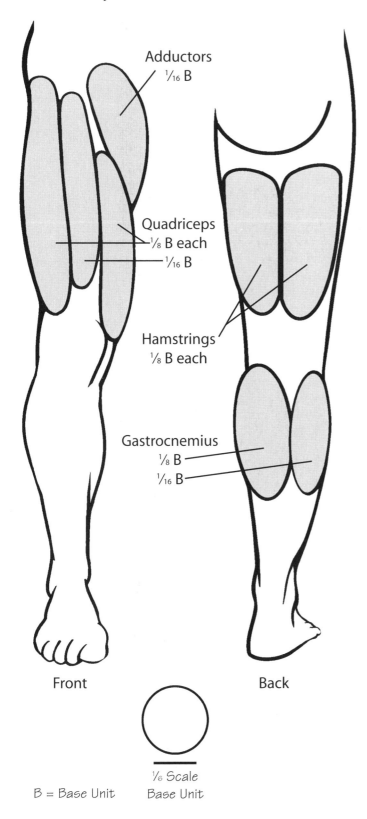

Adductors
$\frac{1}{16}$ B

Quadriceps
$\frac{1}{8}$ B each
$\frac{1}{16}$ B

Hamstrings
$\frac{1}{8}$ B each

Gastrocnemius
$\frac{1}{8}$ B
$\frac{1}{16}$ B

Front

Back

$\frac{1}{6}$ Scale
Base Unit

B = Base Unit

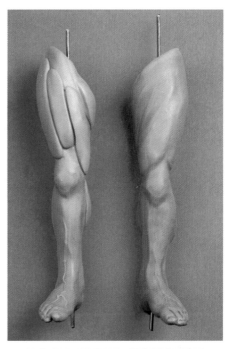

BUILDING UP THE HEROIC LIMB

Step A—Press all of the appliques firmly in place. Stroke along the seams with your finger to blend, concealing the seams yet leaving the muscles well defined.

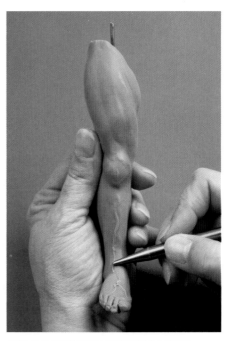

DETAILING THE HEROIC LIMB

Step B—Roll hair thin rods of clay and press in place. The veins curve in and out like an old river, branching at the mid-foot toward the big and little toes. Drag the tip of the large knitting along the edge of the veins to blend. Finish with a soft brush and alcohol.

At Last ... Legs to Stand On

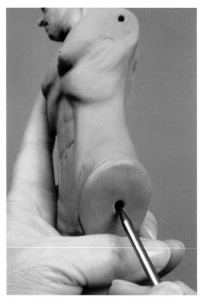

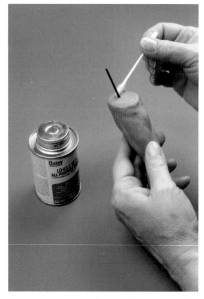

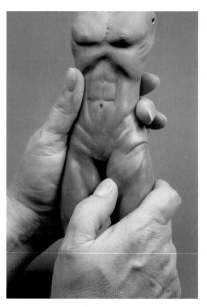

ATTACHING THE LIMBS

Step 30—Attach and finish modeling each limb one at a time. Begin by covering each hip joint with an oval applique made of ⅛ to ¼ of a Base Unit. Press firmly in place. You should have no trouble seeing the pierced sockets where the armature rod inserts into the body. Pierce the socket again.

Step 31—Open the windows! Or, take the legs and the torso outside for this step. The best method for securing limbs to a torso this size, it works with both baked or un-baked clay—apply a small amount of clear PVC cement to the center of the hip joint with a cotton swab.

Step 32—Quickly attach the limb by inserting the armature rod deep into the body, at least 1 head length, and press the limb firmly in place. Hold the limb firmly against the torso for five to ten minutes and then blend the seams.

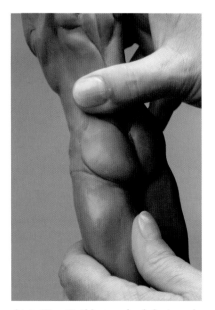

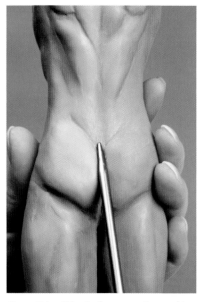

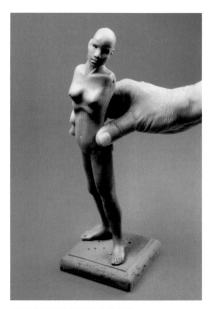

Step 33—Build up each of the buttocks with a half circle applique made of ½ Base Unit. Use ¾ of a Base Unit on a woman's buttocks and 1 unit on a fat figure.

Step 34—Blend the seams by stroking from the applique onto the back and thigh, but take care not to lose the fold at the base of the buttocks, nor the crease.

SETTING THE POSE

Step 34—Set the pose. Hold the figure by the hips and insert the armature rods into two holes in the temporary base. After determining your figure stands vertically, push down gently. It will now stand level. Let the figure stand for several hours, insuring the glue dries completely and the joints are strong.

The Seated Figure

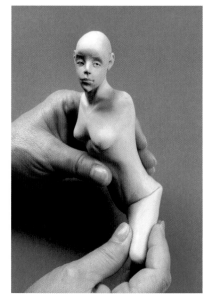

Step A—*Pressing the core in this horizontal position will suit more than one pose—sitting or kneeling back on one's heels. Dust the hip joint with corn starch or powder. Hold the core in position against the joint with your fingers and then with your palm coax the leg into the right position. The core should overlap the joint at the inguinal line, the line at the groin. The leg cores don't require customizing, but they do need to be the right length with the shinbone aligned. Carefully pierce all the cores, thread onto armature sized wire without disturbing their shapes and bake.*

THE BENT LIMB

Step B—*Model the straight leg, following all of the steps that suggest the muscles and joints, and then bend the leg at the knee. The knee will lose its shape and the clay may even tear. Repair the misshapen knee by stroking clay from the knee down toward the shin and back onto the thigh. Repair the torn knee with a small rod of clay made of $\frac{1}{16}$ of a Base Unit and blend.*

> **NOTE**
>
> The seated pose is a supported pose with the body resting on the buttocks and thighs. For that reason, you can use a lighter weight metal rod in the limbs. $\frac{1}{16}$ inch brass rods are ideal. They're sturdy, easy to bend, and available at most hobby shops. The rod doesn't need to extend deep into the body or beyond the sole of the foot, but it should extend into the foot. Don't forget to model the bottom of the foot with as much care as you model the top.

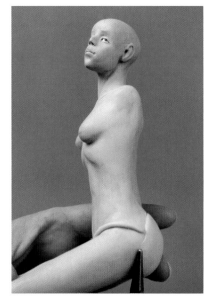

Step C—*Attach the legs using the same techniques you would use to secure a standing leg. Build up the buttocks with oval appliques as if it were a standing figure. Use $\frac{1}{2}$ Base Unit for a male figure, $\frac{1}{4}$ of a Base Unit for a female figure, 1 Base Unit on the fat figure. Add flattened rods made of $\frac{1}{8}$ of a Base Unit along the inguinal line. Blend the seams.*

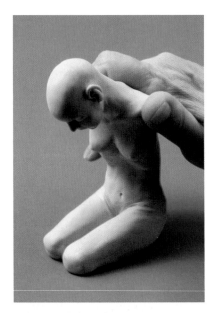

MODELING THE THIGH TO SUIT THE POSE

Step A—*To model the thighs, cover the thigh cores using the same oval wrapping technique, but use these amounts: 4 ¾ Base Units to cover each female thigh core and 6 units to cover each male thigh core. Rub the clay smooth and attach the thighs to the torso. Secure and model the buttocks, using the same techniques as if for a seated figure. Build up the buttocks with oval appliques of 1 to 1 ¼ Base Units each, 1 for a man and 1 ¼ for a woman. Model the inguinal fold with flattened rods made of ⅛. Flatten the backs of the thighs by pressing the figure down against the work surface. This will widen the exterior thighs .*

SITTING BACK ON ONE'S HEELS

With a pose so compact and self supporting, you don't need metal rods, but you will have to make some changes to model this pose realistically. Do insure the thigh cores to fit the pose using the same technique you would use for a sitting figure. The thigh is smooth and uniform; there are no appliques, but you'll use extra clay when you cover the thigh core.

MODELING THE LEG TO SUIT THE POSE

Step B—*Cover the leg cores using 2 ½ Base Units for each female leg, and 3 ½ Base Units for each male leg. This is a thicker wrap, but there are no appliques. Blend the seams. Stroke the clay from the base of the leg up onto the calf. Model the finished foot for this pose, attach and secure with an oval applique made of ¼ of a Base Unit. Remember, the leg is compressed by the weight of the body and the thigh — don't build up the Gastrocnemius on the back of the calf, build it up on the outer calf with an oval applique made of ¼ of a Base Unit and blend. Model the ankles, using strips made of ¹⁄₁₆ of a Base Unit for each ankle.*

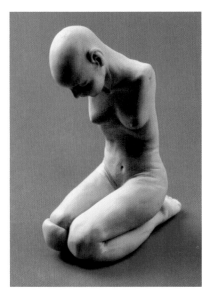

Step D—*Press the modeled lower legs against the base of the thighs. Fill the gap at the knee joint with wedges made of ½ Base Unit each, a then blend and model the knee.*

Step C—*Pose the foot and flatten the shin.*

Too Tall for the Oven?

Baking Techniques for the Standing and Sitting Figure

Too tall to stand in most ovens, the 12 inch tall hero will bake laying on a cushion of fiberfill. Laying down distributes the weight more evenly and prevents cracking at the joints. A sturdy cardboard box provides a temporary chair for the seated lady. The dark brown lady illustrates another seated pose and how to bake her. In all of these figures, the clay in the foot is the thickest unbaked component, almost a half inch thick. These figures will bake for 40 to 50 minutes and cool for 2–4 hours before they're moved. A blanket of damp paper towels laid in place halfway through the baking time will prevent scorching.

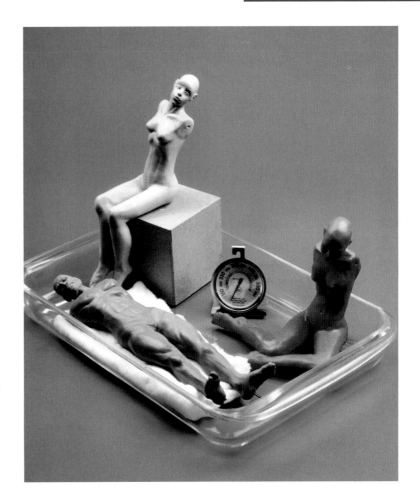

NOTE

Remember, in the oven and fresh from the oven, strong sculptures are vulnerable sculptures. Polymer clay, baked or unbaked, expands and softens with heat. In the oven and while it cools, your sculpture needs adequate propping against the effects of gravity, especially at the neck, hips, knees, and ankles. For figures this size and weight, almost a pound, the clay in the limbs can and will crack if the figure bakes in a standing position. Compressed by its own weight, the softened clay will slide down the smooth armature rods in the legs. That's why laying the figure down is so important.

A Show of Hands

Our arms and hands have set us apart. Other creatures possess more powerful limbs, arms that are pound for pound far stronger. Other creatures possess hands, other primates an opposable thumb, but no creature has changed the world as we have. Offset by an arm of adequate strength is the human hand capable of the delicate maneuver. Because of that balance of adequacy and delicacy, we possess an unparalleled dexterity. Celebrate that distinction with wire and clay.

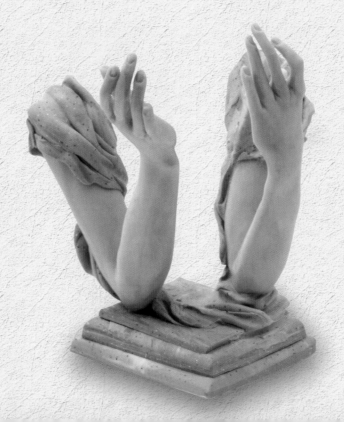

Mapping the Landmarks of the Hand and Arm

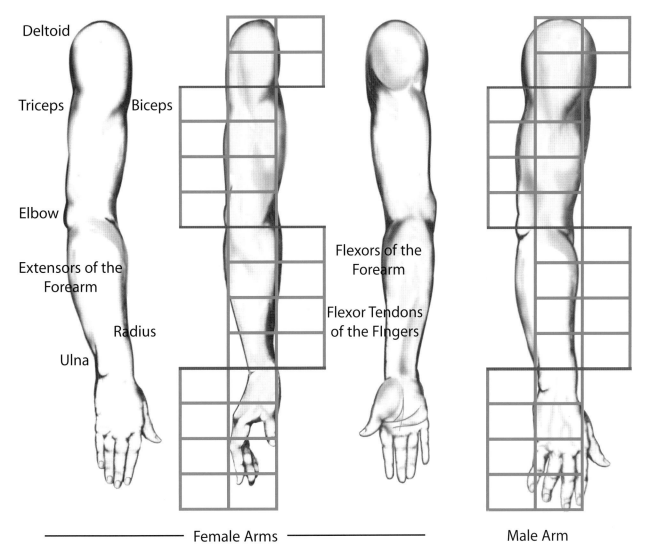

Deltoid

Triceps Biceps

Elbow

Extensors of the
Forearm

Radius

Ulna

Flexors of the
Forearm

Flexor Tendons
of the Fingers

Female Arms Male Arm

Three views of the female arm on the left and one of the male arm on the right show you how similar, and yet singular the two are. From shoulder to finger tip a woman's arm is 3 ¼ head lengths long, while a man's arm is longer, almost 3 ½ head lengths. In both, the distance from the armpit to the elbow is 1 head length, and 1 head length from the elbow to just above the wrist bone. From the wrist bone to the tip of the middle finger, a man's hand is 1 head length long and woman's ¾ of a head length. The fingers are slightly less than half the length of the hand itself.

YOU'LL NEED THESE SUPPLIES

- Work surface
- 10–12 Base Units of clay
- Straight blade for cutting clay
- Gauge or dividers
- Large and small tapestry needle tool (page 15)
- Large and medium aluminum knitting needles
- Curved Tip Tool (page 16)
- Blade

- Wire cutters or nail clippers
- Ten cloth-covered florist wires
- Vinyl glue
- Small ceramic tile
- Sculpting Stand (page 18)
- Large baking dish or ceramic tile & cotton fiber or batting

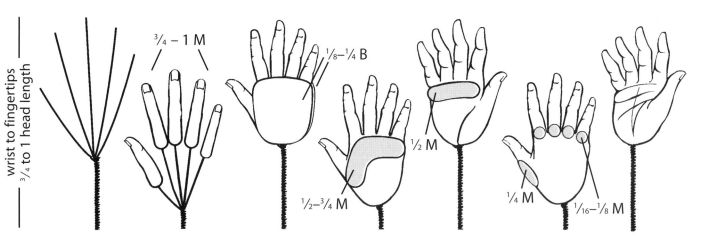

wrist to fingertips
¾ to 1 head length

¾ – 1 M

⅛–¼ B

½ M

½–¾ M

¼ M

¹⁄₁₆–⅛ M

BUILDING THE HAND

Use this pattern as a guide for modeling the hand, beginning with the armature and ending with a finished hand and a bit of palmistry. Notice that you model the fingers first, and then build the hand, and then the arm. This is a woman's hand—the wrist is ¾ of a head length from the fingertips. In a man's hand, the wrist is 1 head length from the fingertips.

Armature Techniques

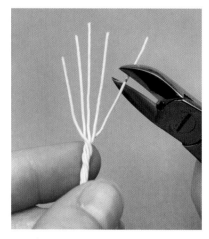

THE BASIC ARMATURE

Step 1—This is the basic armature use white, cloth-covered florist wire. For each arm, cut five wires 4 ½ head lengths long. Mark the wrist, 1 head length from one end and twist the wires together through to the other end. Trim the fingers and thumb. A nail clipper or small scissors works best.

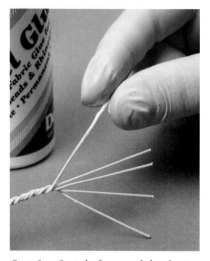

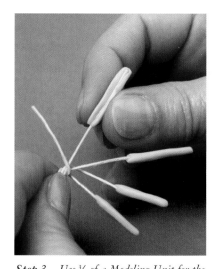

THE STRONG ARMATURE

For figures whose arms are raised this stronger version uses the same floral wire wrapped around a ¹⁄₁₆ inch thick brass rod. For each arm, cut five wires 4 ½ head lengths long. 1 head width from the fingertips, twist the wires together two times and then wrap them tightly around the rod. Use a rod 3 ¾ head lengths long for a woman's arm, 4 head lengths for a man's arm.

Step 2—Coat the finger and thumb wires with vinyl glue (Sobo, Gem Tac, Jewel-it) and let dry. Apply a second coat and let dry again.

Step 3—Use ¾ of a Modeling Unit for the index, middle and ring fingers on a woman's hand, slightly less for the little fingers and more for each thumb. For a man's hand use 1 Modeling Unit, more for the thumb and less for the little fingers. 1 ¼ to 1 ½ units suit plump fingers. Form a tapered rod ½ the mid-width long. Flatten and press firmly around the wire, covering the tip.

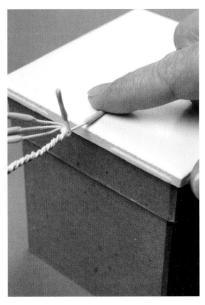

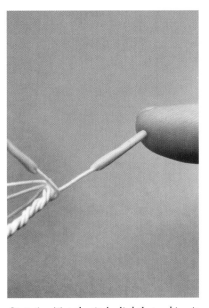

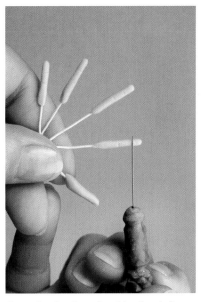

Step 4—One finger at a time gently roll the clay smooth. Fold the other fingers out of the way and work on a smooth, raised surface. A ceramic tile set on a small box or book works well.

Step 5—Test the tip by lightly touching it with your finger. You should feel resistance of the armature wire, but not the wire itself. If there's too much clay at the tip of finger, fold it back or pinch it off, and re-roll the finger clay. If there's too little, stroke the finger to coax more clay over the tip of the wire.

Step 6—On the palm side of each finger, suggest the creases of the joints with the fine needle. The joints divide the fingers into thirds. Each third is roughly equal to twice the width of the finger. Measure from the tip of the finger to mark these creases. Divide the thumb in half.

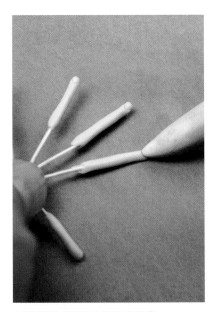

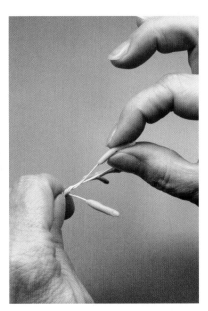

MODELING THE NAILS

Step 7—Lightly stroke the top of the fingers to flatten slightly. Use the small curved tip tool to form the nails, each at least as long as the finger is wide.

Step 8—Use the fine needle to mark the sides and tip of each nail. For a smooth appearance use pressure from the shaft of the needle, not the point.

Step 9—Gently curve each finger, suggesting a relaxed state. From the grand sweep of the arm to slight shrug of the shoulders, most gestures depend on movements at the wrist, elbow, and shoulder to make the point.

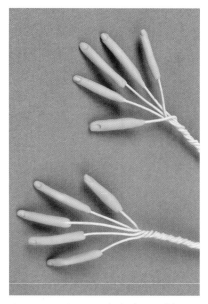

Step 10—Compare the both sets of fingers for symmetry. Do they mirror each other? If so, bake for 20 minutes on a cushion of fiberfill. If not, make corrections.

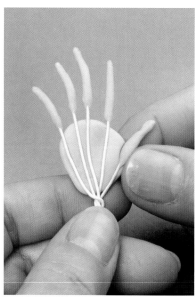

BUILDING THE BASIC HAND

Step 11—Place a flattened oval of clay on the palm. Press firmly and place a second oval on the back of the hand, sandwiching the wires. Use ⅛ of a Base Unit for each oval on a woman's hand, ¼ of a Base unit for each on a man's hand, and ¼ to ½ for a fat figure's hand.

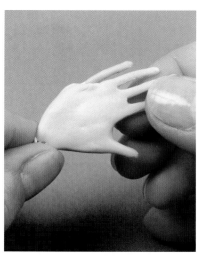

Step 12—Blend the seams and rub clay from the back of the hand onto the fingers and from the palm onto the fingers.

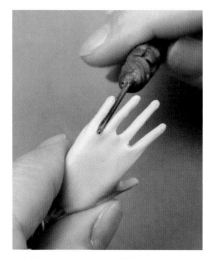

WORKING WITH WEBBING

Step 13—Use the medium knitting needle or the tapestry needle to separate the fingers and model the webbing. The longest finger is slightly less than half the length of the hand. Work alternately on the palm and back of the hand. Stop now and then to blend clay onto the hand and to stroke the sides of the fingers with the large tapestry needle. You'll need to repeat this step as you perfect the hand.

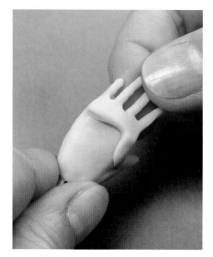

BUILDING UP
THE BACK OF THE HAND

Step 14—Push the thumb down below the horizon of the hand. Place an L-shaped flattened rod made of ½ to ¾ of Modeling Unit on the back of the hand at the base of the fingers.

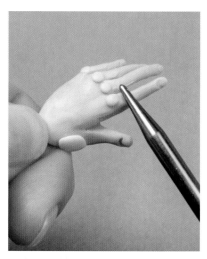

MODELING THE KNUCKLES

Step 15—Add small balls to each knuckle and a flattened rod to the heel of the thumb. Use ⅛ to ¼ of a Modeling Unit for each and blend the seams using the large knitting needle as a roller. Use your finger to soften the knuckles of a fat hand.

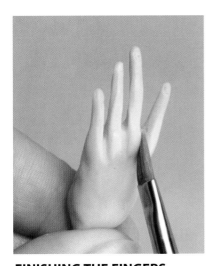

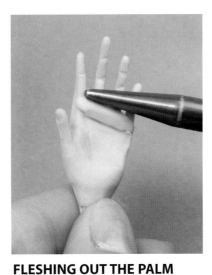

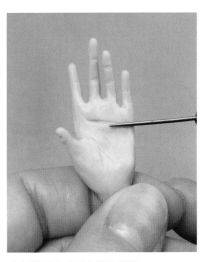

FINISHING THE FINGERS

Step 16—*Pose the fingers by bending them at the knuckles, not at the joints. After posing the fingers, use a soft brush to stroke the back of the hand smooth.*

FLESHING OUT THE PALM

Step 17—*Place a flattened rod, made of ½ of a Modeling Unit, onto the palm of the hand at the base of the fingers. This is the ball of the little finger. Use a large knitting needle to blend the seams and retain this applique's shape.*

A LITTLE PALMISTRY

Step 18—*Use the small tapestry needle to define the lines of the palm. Hold the needle almost parallel to the clay as you score these creases. Use your own hand or the illustration on the pattern guide.*

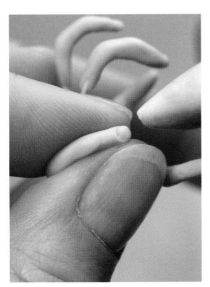

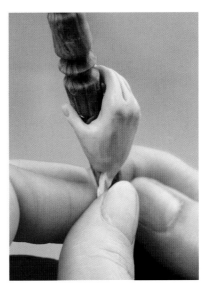

MODELING THE HAND THAT HOLDS

Step A—After marking the lines of the joints, bend the fingers to match the object the hands will hold. You can mold the fingers around the object, but do it with care. Model the joints before you mark the nails and then bake for 20 minutes.

Step B—Model the hand and then set the grip using the object the hand will hold. The hand holding this wizard's staff may need miner repairs after adjusting the fingers and the thumb. The joints may crack, but they can be repaired.

MODELING THE FIST

Step A—*The clenched hand begins with a different armature—two wires, each 9 head lengths long, twisted to leave a loop approximately ½ the mid-width of the head in length. Coat the loops with vinyl glue and let dry. Coat again and let dry.*

Step B—*For a woman's fist, sandwich the loop within two flattened ovals made of 3 Modeling Units. For a man's fist, use 4 Modeling Units for each. Use 5 on a fat hand. Blend the seams, creating a flattened egg with the small end at the wrist. Place your index finger at one side and stroke the top of the egg towards your index finger, forming two flat edges, one vertical and one angled at 45 degrees.*

Step C—*The peak of the angle is the knuckle of the index finger. Turn the hand to place the peak on the right or left, to create a right hand or a left hand. Form a slightly flattened rod and place it flush with the angled edge. This rod will provide the clay for the fingers. Use 2 Modeling Units for a woman's hand, 3 Modeling Units for a man's hand, 3 to 4 on a fat hand. Blend all but the bottom seam.*

Step D—*Use the tapered end of the medium knitting needle to push the "little finger" end in at a slight angle, revealing the heel of the hand.*

Step E—*Suggest the individual fingers with the large tapestry needle. Set the point of the needle on top of the hand at the knuckles where the webbing begins and pivot the needle down to cut the clay. Three equally spaced needle cuts make four fingers.*

Step F—*With the tapestry needle, round off the joints where the fingers fold against the palm.*

Step G—*Emphasize the joints by stroking the fingers down to flatten them slightly.*

Step H—*Push up the index finger.*

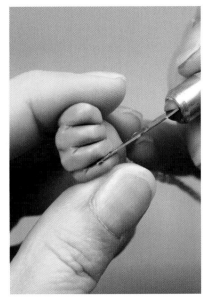

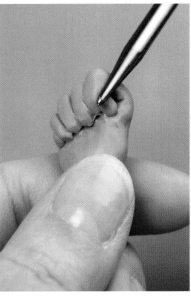

Step I—*Build up the knuckles with four small flattened balls of clay. Use ⅛ of a Modeling Unit for each knuckle on a woman's hand and ¼ of a unit for each knuckle on a man's hand.*

Step J—*Blend the seams onto the back of the hand and then onto the fingers. Use a craft knife to separate any fingers blended together.*

Step K—*The index and the pinkie need special attention; they're visible from the sides. Add the tip to the of the index finger with a small egg of clay made from ⅛ of a Modeling Unit for a man, a little less for a woman, and more for the fat hand. Blend the seams and take care to retain the outline of the tip of the finger..*

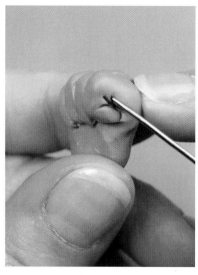

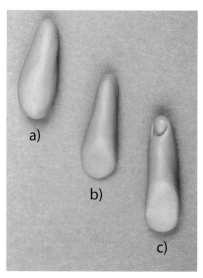

Step L—Add the tip to the little finger with a small egg made from ¹⁄₁₆ of a Modeling Unit, less for a woman and more for a heavier hand. Blend, taking care to retain the outline of the finger tip.

Step M—As the fingers bend, the skin folds in characteristic way. The folds resemble a tree with three branches, and the base of the tree begins at the palm. Use the small tapestry needle to draw the folds in the index and little fingers.

Step N—*a)* Roll 1 Modeling Unit to form an egg. *b)* Flatten the base of the thumb slightly. *c)* Model the nail. Use ¾ of a Modeling unit for a woman's hand and 1 ¼ for a heavier hand.

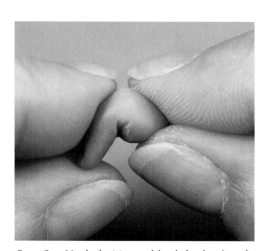

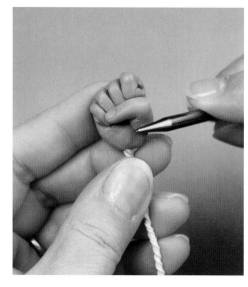

Step P—Place the base of the thumb below the index finger and position the thumb. Blend the base of the thumb only. Finish the fist by suggesting the end of the lifeline near the base of the palm.

Step O—Mark the joint and bend the thumb to the desired pose.

A Pattern for the Female Arm

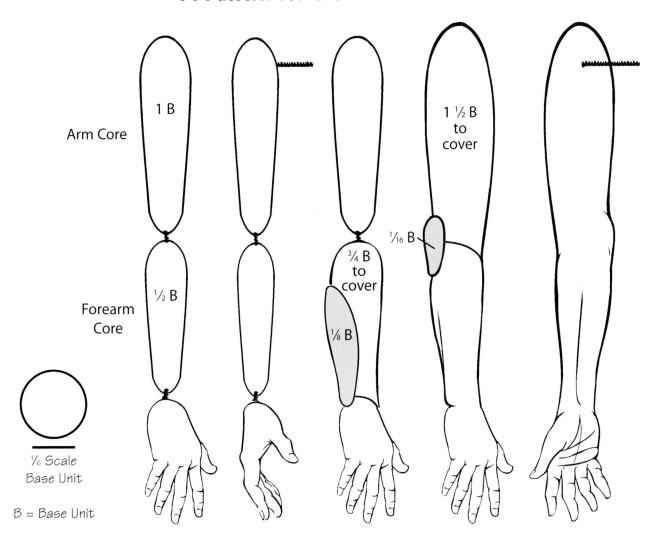

Arm Core

1 B

Forearm
Core

½ B

¾ B
to
cover

⅛ B

1 ½ B
to
cover

1/16 B

1/6 Scale
Base Unit

B = Base Unit

This is the pattern for the female arm. It's smaller and smoother than the male arm, but both the male and female arms use the same size cores and follow many of the same steps. Note the baked clay cores make the arm poseable.

A Pattern for the Male Arm

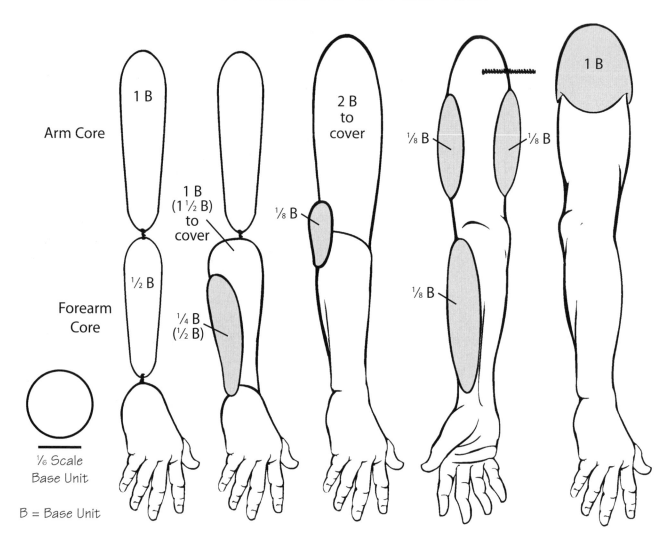

Using more clay to cover the same cores gives you the added flesh for modeling the larger male arm. Using additional appliques gives you the added muscle. If you want to create a very muscular, heroic arm, begin with this pattern and build on it.

Modeling the Arms

Crafting the Cores
Step 19—For each arm, make two clay cores. Use ½ of a Base Unit for each forearm. Form a tapered rod 1 head length long. Use 1 Base Unit for the upper arm and form tapered rod 1 ½ head lengths. They should match the cores in the pattern guide. Split each core almost in half lengthwise.

Step 20—Begin with the forearm. Sandwich the twisted wires in the split clay rod just below the wrist and blend the seams. Do the same with the upper arm, leaving a small gap between the forearm and arm.

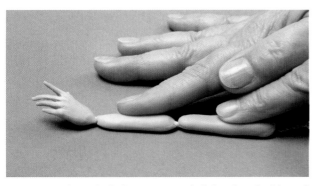

Step 21—Flatten both clay armatures slightly. They should match the cores in the pattern on page 95.

Step 22—The exposed wire at the shoulder should be ¾ to 1 head width long. Bend it at a right angle to the arm.

BUILDING UP THE ARMS

Step 23—Add muscle and flesh to the forearms with ¾ of a Base Unit for each woman's forearm, 1 Base Unit for each man's forearm, and 1 ½ Units for the heavier arm. Form a tapered rod 1 head length long and flatten with a roller. Use 1 ½ Base Units for each woman's upper arm, 2 units for each man's, 2 ¼ for the fat figure's arm. Form a rod 1 ½ head lengths long and flatten with a roller.

NOTE

You'll have no trouble modeling the arms once the core covered armatures have been baked. When you bake them, lay them on a fiberfill cushion palm side up. Bake for 20 minutes at the recommended temperature. Let them cool completely before you add muscle and flesh.

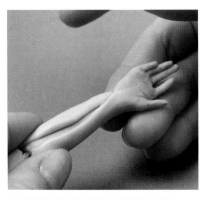

MODELING THE FOREARM

Step 24—Wrap the forearm core so that the seams meet on the under side of the arm, the same side as the palm of the hand. Press firmly and stroke along the length of the seam forearm flattening it slightly. Blend clay onto the hand.

Step 25—Suggest the head of the Ulna, the visible wrist bone, and the muscles of the outer forearm with an elongated egg-shaped applique 1 head width long. Use of ⅛ of a Base Unit on a woman's forearm and ¼ of a Base Unit on a man's forearm, ½ on a heavy forearm. Place the applique on the outside of the arm with the small end at the wrist bone. Blend the seams.

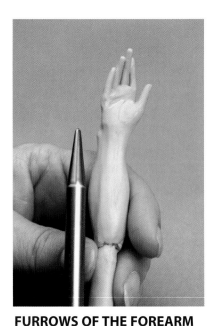

FURROWS OF THE FOREARM

Step 26—Use the medium knitting needle to suggest the Ulnar furrow. It runs from the outside of the wrist bone to the elbow. Use the medium needle to suggest another furrow running from the base of the palm and vanishing at the mid forearm.

MODELING THE UPPER ARM

Step 27—Cover the upper arm with the same wrapping and blending techniques you used on the forearm. Again press firmly and stroke along the length of the arm with enough pressure to assure a smooth surface and a strong bond. Blend to the forearm so that no seams show.

THE ELBOW

Step 28—Place a small egg-shaped applique to model the elbow two head lengths from the tip of the middle finger. Use ¹⁄₁₆ of a Base Unit for a woman's elbow and ⅛ of a unit for a man's, ⅛ to ¼ for the heavy arm.

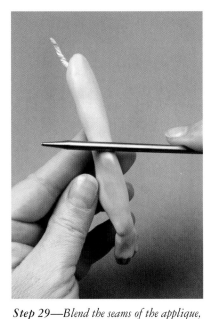

Step 29—Blend the seams of the applique, and then use a medium knitting needle to suggest the elbow joint by pivoting the shaft of the needle across the top of the joint.

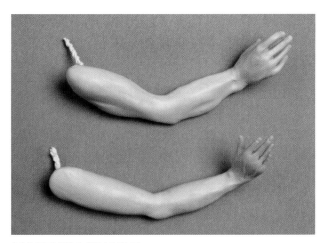

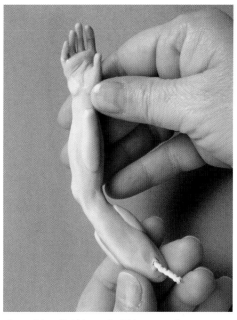

MODELING MUSCLE

Compared to a woman's arm, a man's arm has greater length and width. Using more clay in the fingers and hands, more clay to cover the armatures and more clay in the appliques is only the beginning. Note how additional appliques, each a muscle group, makes the male arm at the top larger and visibly more muscular than the female arm below it.

Step 30—*Build up the Triceps on the outer arm and Biceps on the inner arm with two oval appliques clay. Build up the inner forearm with a flattened rod placed just below the base of the thumb. Use ⅛ of a Base Unit for each applique. To suggest a powerful woman, use 1 Modeling Unit for each applique on a woman's arm.*

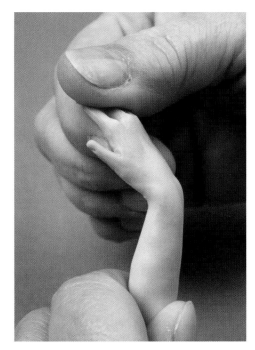

POSING THE ARM AND HAND

Step 31—*Only the wrist and elbow have the potential for pose. You can bend and turn them, but support both the forearm and the hand when you bend the wrist.*

Step 32—*Support the elbow when you bend or turn the arm. Remodel any misshapen joints. Repair any tears by blending the clay rather than patching if possible. Use the tapestry needle to accent folds in the skin at the joints.*

A Pattern for the Heroic Arm

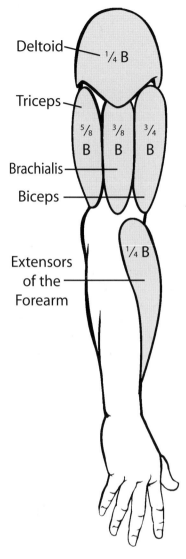

Deltoid — ¼ B

Triceps —

⅝ B ⅜ B ¾ B

Brachialis —

Biceps —

Extensors of the Forearm — ¼ B

Use this drawing as guide for changing the average male arm into the heroic arm. Build the Deltoid with a pie cut shaped applique. Build up the Triceps with an oval applique 1 head length long. Model the Brachialis with a flattened rod 1 head width long and use an oval applique 1 head length long to add to the Biceps. Emphasize the Extensors of the forearm with a flattened rod slightly more than 1 head length long. Note how the Triceps and Biceps wrap around the arm, and the sinuous curve of the Extensor.

⅙ Scale
Base Unit

B = Base Unit

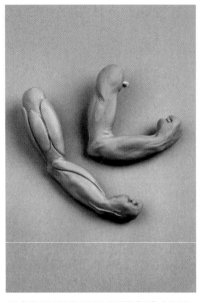

MODELING THE HEROIC ARM

Step A—Attach all of the appliques and then blend the seams using the same techniques you used on the heroic limb. Stroke along the seam lines with your finger. After blending, pose the arm, making any necessary corrections.

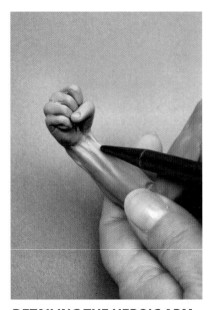

DETAILING THE HEROIC ARM

Step B—Use the tip of the large knitting needle to suggest visible tendons on the palm side of the forearm near the wrist.

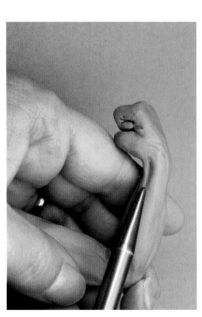

Step C—And near the ball of the thumb.

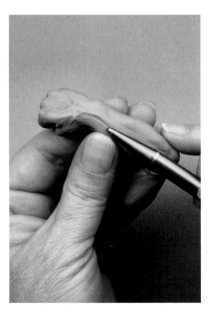

Step D—Tiny threads of clay, lightly blended with the finger or the large knitting needle suggest the prominent veins of the forearm and hand.

Attaching the Arm

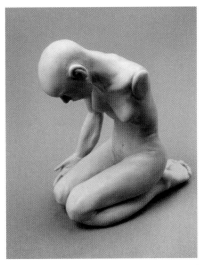

Step 33—Place a flattened oval made of a Base Unit on the shoulder joint. Blend the seams and pierce the socket again with a small knitting needle.

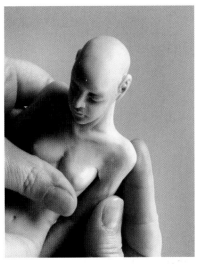

Step 34—Insert the twisted wire into the socket, and push firmly to seat the arm in position. Secure the arm with a flattened oval. This is the Deltoid applique made of ¾ of a Base Unit on a woman's arm, 1 Base Unit on a man's arm and a heavier arm. Blend the seams.

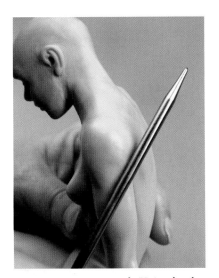

Step 35—Press a gentle V in the clay with the base of the V toward the front of the arm. This is the Deltoid muscle, on a woman or a slack and heavy man a softly defined feature. Soften with your finger.

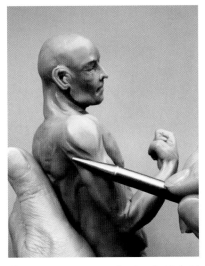

On a man, average or heroic, the Deltoid muscle is prominent, one you'll want to accent.

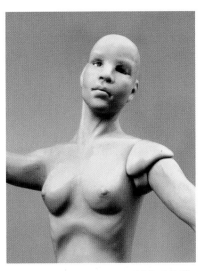

ATTACHING THE RAISED ARM

Step A—Cover the shoulder socket with the ⅛ Base Unit oval applique, blend and pierce the socket. Insert the armature rod in the socket and seat the arm in position. Place a crescent-shaped rod made of ⅛ of a Base Unit beneath the arm. Press firmly. Place the Deltoid applique above the arm. Blend the seams. Use added pressure from your fingers to model the indented arm pit.

Measure for Measure

You've been modeling in the 1:6 scale, ⅙ the size of a life size model. The same techniques will work in any scale. Change the Base Unit, the foil core and the eyes according to scale, and you can create figures in any size. That's the real advantage of measuring the clay. Once you've measured the clay, forget about inches or centimeters. Think in terms relative to the head and face. It's the proportions that matter, not the size. One half the mid-width is still one half the mid-width, and the width of the head is still ⅔ its length.

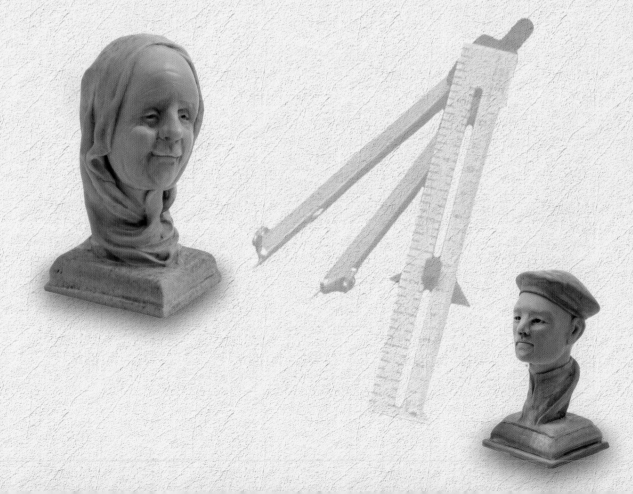

Modeling in Miniature

Good miniature modeling is all about the details. In the ¹⁄₁₂ scale, the miniaturist's scale, those details are very small, so use a good light source. Use a bright light that casts shadows. In those shadows, you'll be able to see the details. Don't be surprised if you find yourself lost in the details. Modeling in miniature is a delight; getting lost is easy.

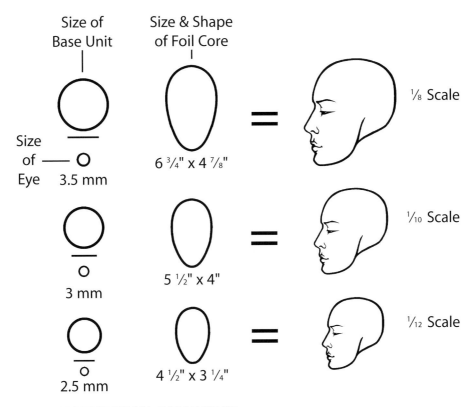

Size of Base Unit

Size & Shape of Foil Core

Size of Eye 3.5 mm

6 ³⁄₄" x 4 ⁷⁄₈"

¹⁄₈ Scale

3 mm

5 ¹⁄₂" x 4"

¹⁄₁₀ Scale

2.5 mm

4 ¹⁄₂" x 3 ¹⁄₄"

¹⁄₁₂ Scale

MODELING THE SMALL SCALE HEAD

This diagram will help you measure the clay, craft the right foil core, create eyes true to size for three smaller scales—¹⁄₈, ¹⁄₁₀, and ¹⁄₁₂. Use the rod method to measure the clay. The numbers below the foil core tell you how much foil to use. For patterns scaled to size, copy the original pattern for the head on page 22 and then reduce it to 75% for the ¹⁄₈ scale, 60% for the ¹⁄₁₀ scale, and 50% for the ¹⁄₁₂ scale. The techniques remain the same.

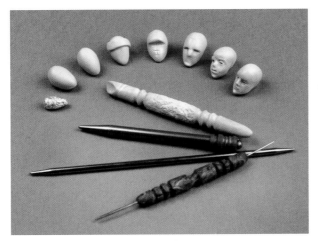

*From foil core to finished face, all of the steps are the same, but **if you have trouble** with a misshapen head, model and then bake the back of the head first. Cover only **half** the core with clay and lightly blend that clay to the foil. Build up the crown and blend and then shape and pinch the chin (page 24). Model the jaw on all sides (page 25) and underneath (page 43). Pierce the base of the head. Bake for 10 minutes. Let cool. A half-modeled, half-baked head will hold its shape while you model the face.*

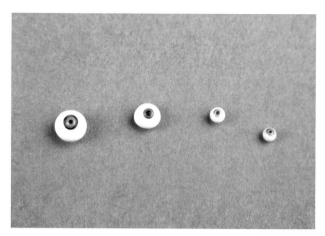

MAKING MINIATURE FOIL CORES

Use your thumb to roll tiny foil cores back and forth in your core mold, and you'll have no trouble making them smooth.

TECHNIQUES FOR TINY EYES

The two eyes on the left are polymer clay. The two smaller eyes are glass "Quilter's Pins." In one box, you'll find a range of sizes from 2.5mm up to 3.5mm.

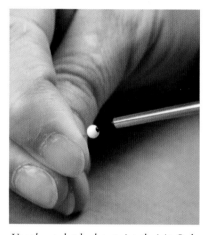

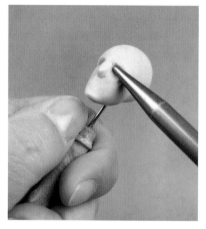

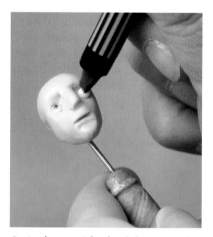

Use the crochet hook to paint the iris. Only the bead of paint should touch the pin, not the tool. Let the paint dry. Dip the eye in varnish. When dry, use the tapestry needle to paint the pupil. Varnish again.

Use the large knitting needle to make a smooth orbit for the eyes. Rotating, or spinning it in place works well in this small space.

Set in the eyes with a hard clean eraser, but use sandpaper, a grinding wheel, or a craft knife to taper the eraser so you can see what you're doing.

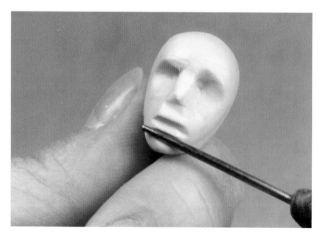

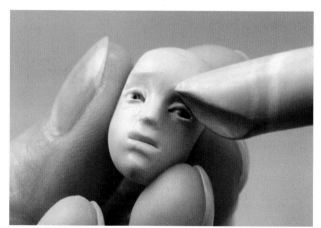

FOLLOW YOUR INSTINCTS

When your modeling instincts tell you to use a smaller tool or to postpone steps till later, follow your instincts. For example use the fine needle tool to make the nostrils and refine the mouth. Model the ears after you attach the head to the body.

BUT NOT ALWAYS

The large curved tip tool is still the tool of choice for modeling the eye lids. Work from the outside to the inside. Use the fine needle to mark a lid-line as a guide for setting the tool in place.

Modeling the Small-Scale Torso

Remember, size doesn't matter; proportion does. Creating the torsos in varying scales uses many of the same techniques. For the very small figures, there are even a few shortcuts.

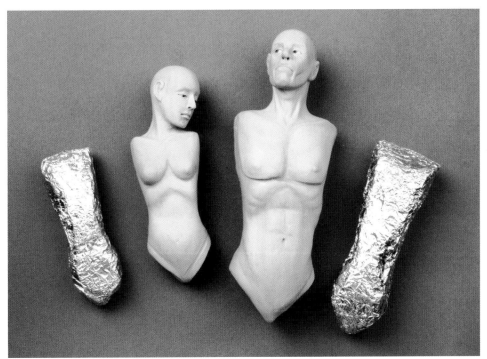

THE ⅛ SCALE TORSO

With hip and chest widths greater than 1 inch, the ⅛ scale body on the left has a foil core similar to the ⅙ scale body on the right. Made in the same way, it's 25% smaller. Because of its length and width, a body this size needs a foil core.

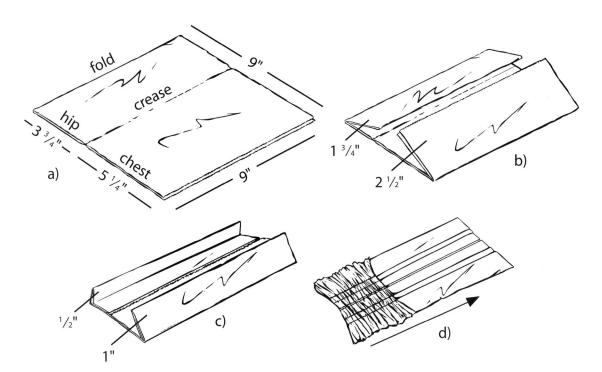

THE ⅛ SCALE BODY CORE

The same central core pattern, reduced for the ⅛ scale figure, uses these measurements: **a)** *Fold an 18" x 9" long sheet of foil in half to make it 9" square. Crease the foil parallel to the fold 3 ¾ inches from one end, the waistline.* **b)** *Fold over 1 ¾ inches of the hip section and 2 ½ inches of the chest section.* **c)** *Fold over ½ inch on the shorter hip section and 1 inch on the longer chest section. The folded sheet should measure roughly 9" x 3 ½".* **d)** *Gather perpendicular to the folds and twist once at the waist. Wrap the core with three 9" x 9" sheets. Gather each sheet to the length of the central core and wrap one at a time.*

The ⅛ Scale Basic Body Pattern

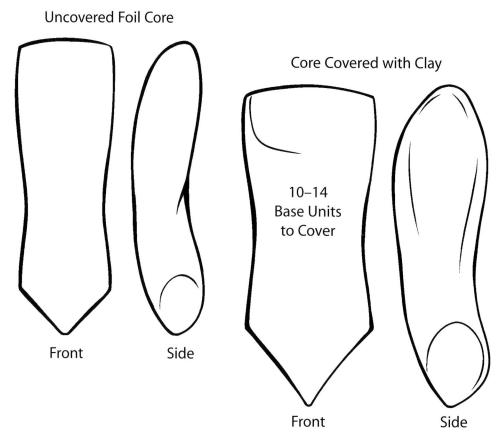

Uncovered Foil Core

Front Side

Core Covered with Clay

10–14
Base Units
to Cover

Front Side

After you've wrapped the central core, formed the hip joints, beveled the shoulders, and arched the back, the core should match this pattern. To cover the core, follow the steps in Part 6. Use 10 Base Units for a slender body, 12 for an average body, and 14 for a stocky body, but don't forget to reduce the Base Unit to the right size.

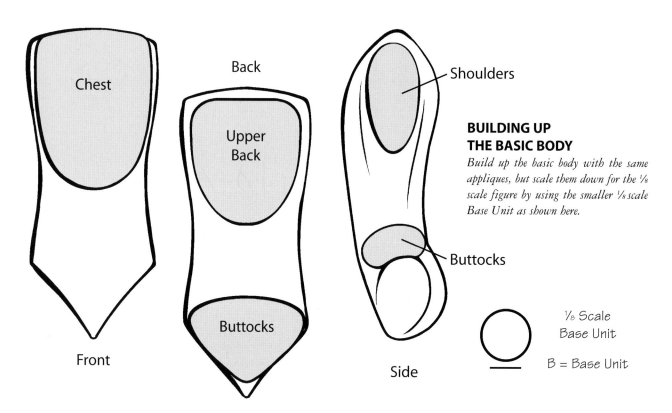

Chest

Back

Upper
Back

Buttocks

Shoulders

Buttocks

Front Side

**BUILDING UP
THE BASIC BODY**

Build up the basic body with the same appliques, but scale them down for the ⅛ scale figure by using the smaller ⅛ scale Base Unit as shown here.

⅛ Scale
Base Unit

B = Base Unit

Modeling the Miniature Torso

You can model the ¹/₁₂ and ¹/₁₀ scale bodies without a foil core by replacing the core with clay. It takes 14 ½ Base Units to replace the foil core and 17 ½ units to create a built up woman's body, 19 ½ to build up a man's body, and 20 ½ to build up a stocky body. With a thickness of less than one inch, a miniature body will bake sufficiently to cure completely and at a short enough baking time to prevent scorching, a problem with some clays. The clay should be very firm. A stiff metal rod, long enough to support the length of the body and attach the head and neck, will give these tiny torsos the strength they need.

The ¹/₁₂ Scale Torso

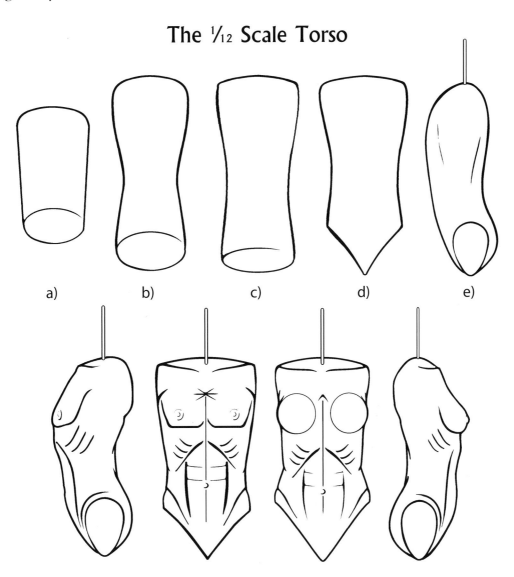

a) b) c) d) e)

A PATTERN FOR THE MINIATURE TORSO

This pattern illustrates how to form the ¹/₁₂ scale body without a foil core and without appliques. Enlarge this pattern 120% to create a torso in the ¹/₁₀ scale.
a) Form a tapered rod 2 head lengths long. b) Shape the rod into an offset hourglass 2 ¾ head lengths. c) Flatten slightly with the palm of your hand.
d) Pinch the base to form the hips. Pinch the shoulders lightly. e) Arch the back and insert a stiff rod 3 ¼ head lengths long. The torso should have this profile.

¹/₁₂ Scale
Base Unit

MODELING A TORSO WITHOUT A CORE

Step 1—Combine the units into a smooth, seamless ball. Roll to form a slightly tapered rod two head lengths long. To begin the waist, place your little finger in the middle of the rod and roll it gently back forth until the rod is 2 ¾ head lengths.

Step 2—Soften and refine the waist by stroking from the waist toward the hips and toward the chest and back.

Step 3—Use the palm of you hand to gently flatten the body. The width (depth) in profile is ¾ the width of the body when viewed from the front or back.

Step 4—Pinch the tapered end to create the fork of the body with one hand. At the same time, gently pinch the shoulders with the other hand and arch the back. The torso should match the scale pattern on page 107.

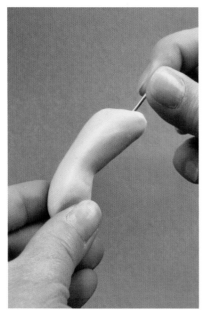

Step 5 — Pierce the body at the neck with the large tapestry needle. With the back arched, insert a stiff metal rod long enough to support the entire body, the neck and the head. The rod should be 3 to 3 ¼ head lengths long.

TIP

Don't forget that landmarks on the front of the body can be used to place landmarks on the back of the body. For example, the base of the shoulder blades is in line with the base of the pectorals and the crest of the buttocks is in line with the navel.

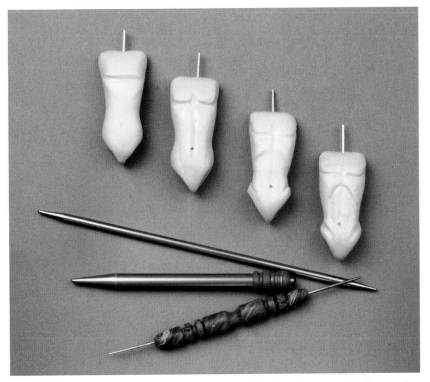

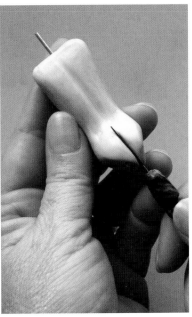

Use the small tapestry needle to model the crease of the buttocks, but follow up by using the medium knitting needle to create the medial furrow.

Whatever the size of the torso, the steps for modeling the landmarks are exactly the same, but you may want to use smaller tools. The large knitting needle makes an excellent roller. The medium knitting needle is great for modeling the muscles. The tapestry needle tool has uses as well.

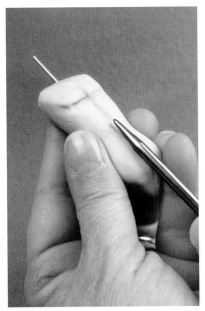

There's no foil core, so don't hold your work too tightly. Cradle it. When you model the chest and abdomen, support the back, and when you model the back, support the chest. If the clay's firm enough, it will have a good memory and hold its shape.

POSING THE MINIATURE BODY

To pose the miniature body, model the straight body first. Remove the spine and then bend the body. Bend the rod in a matching curve. When you reinsert the rod, the channel should remain open. Work slowly, feeling your way. If you feel resistance, pull the rod out and start again.

Add and model the ears after you've attached the head to the torso. Add the head to the body with the same techniques you used for the larger figures. When you finish the torso, pierce the arm and hip sockets with the large tapestry needle. Finish using the same burnishing and baking techniques described on pages 68–69.

Modeling the Miniature Limb

Scaling down changes all three dimensions—the length, the width, and the depth. Adjust the Base Unit and the tools when you create limbs in smaller scales. From establishing and maintaining the proportions to modeling the toenails, the art of modeling in scale means attention to detail.

⅛ Scale Leg Pattern

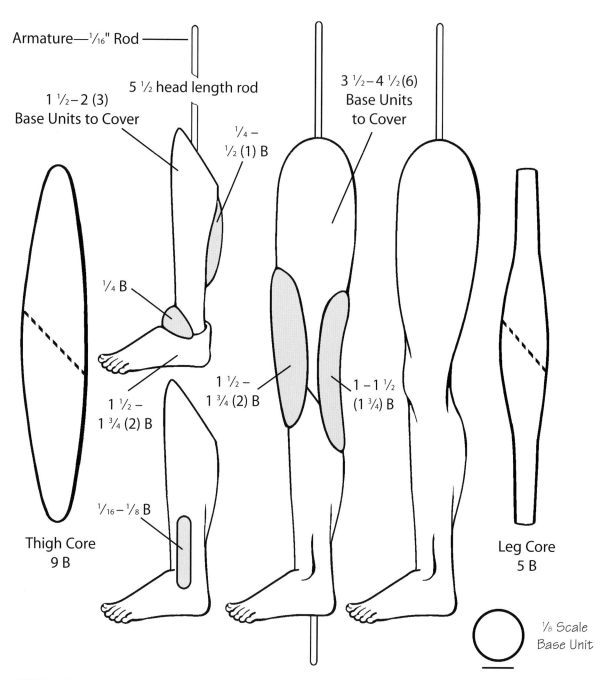

Armature—¹⁄₁₆" Rod

5 ½ head length rod

1 ½– 2 (3)
Base Units to Cover

3 ½–4 ½ (6)
Base Units
to Cover

¼ –
½ (1) B

¼ B

1 ½ –
1 ¾ (2) B

1 ½ –
1 ¾ (2) B

1–1 ½
(1 ¾) B

¹⁄₁₆–⅛ B

Thigh Core
9 B

Leg Core
5 B

⅛ Scale
Base Unit

SMALLER LIMBS, SMALLER CORES

This pattern is your guide for the ⅛ scale figure, but measure the ⅛ scale torso you've created before you begin. Use the distance between the fork of the body and the pit of the stomach as your gauge for modeling the thigh cores. The full limb is as long as the torso, neck and head, shorter for the fat figure.

Taking Advantage of the Scale— Limbs Without Cores

Why use a core at all for tiny such limbs? Aren't they small enough to bake thoroughly? Indeed, they are. The basic shapes are simple, and the steps proceed quickly. To model the thighs, combine the clay needed for the core with the clay necessary to cover it. You can eliminate the Hamstrings applique if you add it to the thigh clay. The same methods prove true for the leg. Combine the core clay, the modeling layer and the clay used to model the calf and you've eliminated another applique. Weld the two together with the knee applique.

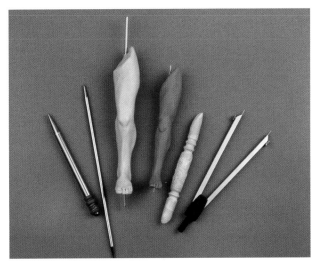

The ⅛ scale limb on the right is only 25% smaller than the ⅙ scale limb. With that miner difference in size, use the same techniques with the same tools. Follow the steps described in Part 6 and keep your measuring gauge handy.

$\frac{1}{12}$ Scale Leg Pattern

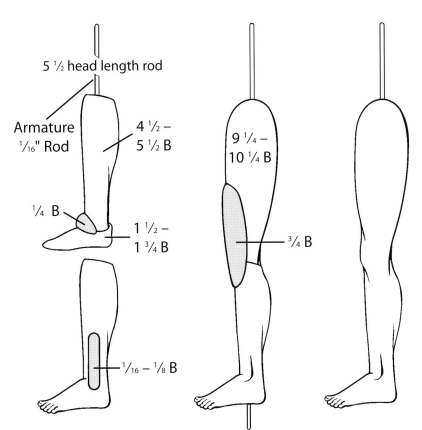

5 ½ head length rod

Armature
$\frac{1}{16}$" Rod

4 ½ –
5 ½ B

$\frac{1}{4}$ B

1 ½ –
1 ¾ B

$\frac{1}{16}$ – $\frac{1}{8}$ B

9 ¼ –
10 ¼ B

$\frac{3}{4}$ B

NOTE

The following series of steps happens quickly, but there's no core to resist a heavy hand, only an armature rod. Hold your work lightly and blend the seams with care. Pause between steps to let the clay cool down. When you blend the seams, use the tool that feels most comfortable. That tool just might be your fingers.

The same pattern again? Not quite. This is a $\frac{1}{12}$ scale limb without cores and with fewer appliques. Success relies on your experience with the original techniques described in Part 6. This pattern shows you how much clay to use. To create a $\frac{1}{10}$ scale limb, enlarge the pattern 120%.

$\frac{1}{12}$ Scale
Base Unit
B = Base Unit

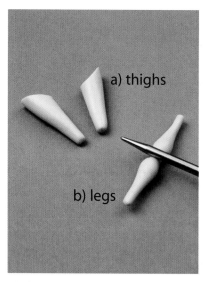

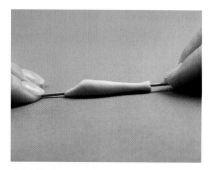

ALIGNING THE SHINBONE

Step 2—Pierce the leg with the small tapestry needle. Thread onto an armature rod. Stroke to correct the length and press the front of the leg lightly against the work surface to align the shinbone.

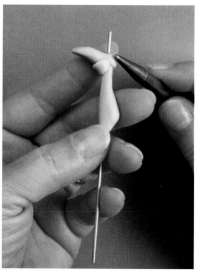

THE BASIC LEG AND THIGH

Step 1—a) For matching thighs, roll the clay into a bi-cone 3 ½ head lengths long. Cut in the center at 45 degrees. Use 18 units for a male figure, 17 for a female. b) For matching legs, roll a modified bi-cone almost 3 ½ head lengths long. Use a medium knitting needle to taper the center of the master leg. Cut in half. Use 10 units for a pair of male legs, 8 ½ for a female.

ATTACHING THE FOOT

Step 3—Wait to model the tiny toes on ¹⁄₁₀ and ¹⁄₁₂ scale feet. Attach a partially modeled foot (no toes) with the dorsal arch applique. Support the foot while you blend the seams. Lightly stroke from the heel onto the calf, and from dorsal applique onto the leg and onto the foot.

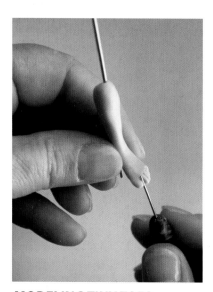

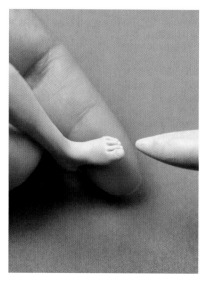

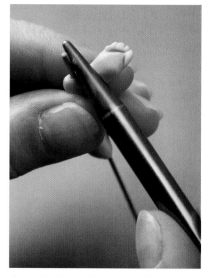

MODELING TINY TOES

Step 4—To model the toes use the same techniques described on pages 76–77 in Part 6. Use the fine needle tool to mark the toes. Use the small tapestry needle to further separate them. Pivot the needle over the edge of each cleft to round the tips of the toes.

Step 5—The small curved tip tool will even create nails scaled to this small size. Finish the sides of the nails with the fine needle tool.

Step 6—Don't forget to model the sole of the foot, especially the arch on the instep and the angled grooves beneath the toes. These features affect the top of the foot in noticeable ways.

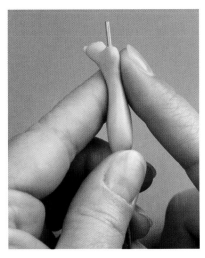

SHAPELY CALF

Step 7—*After you model the toes, stroke the back of the leg at each side of the leg to form the Achilles Tendon and build up the Gastrocnemius. Work from the ankle region toward the calf.*

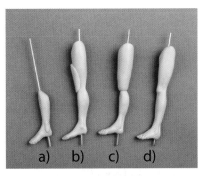

a) b) c) d)

PUTTING THE LIMB TOGETHER

Step 8—a) Add the ankles and blend. Use ¹⁄₁₆ of a Base Unit for a woman's ankles and ⅛ for a man's ankles. b) With the leg and foot finished, thread the thigh onto the armature rod. c) Blend the seams at the knee joint. Build up the Quadriceps and knee with an applique made of ½ a Base Unit. d) Model the knee, the Quadriceps Tendon, the Sartorious with the medium knitting needle. Light pressure is what you need, especially on the Quadriceps Tendon above the knee.

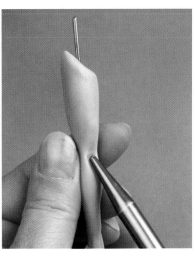

THE HOLLOW OF THE KNEE

Step 9—*Form the Hollow of the knee with the tip of the large knitting needle. Roll it and back and forth to create the hollow.*

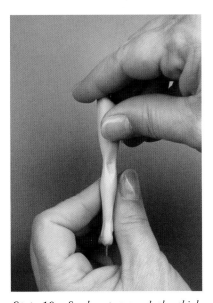

Step 10—Stroke up toward the thigh with your finger to soften the hollow.

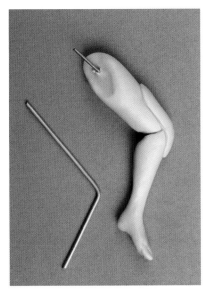

THE SMALL BENT LIMB

Model the leg and foot on an armature rod already bent to the desired pose. Pierce the thigh and thread it onto the rod. Blend the seams and model the knee with the techniques described on page 83.

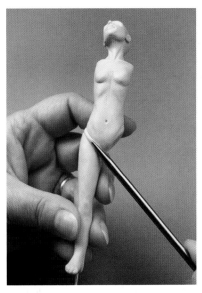

ATTACHING THE LIMBS

Step 11—*Attach the limbs with the same techniques you used for the larger ⅙ scale figures on page 82 of Part 6. Apply a thin oval, made of ¼ Base Unit to the hip joint and blend. Insert the armature rod into the socket in the hip joint and blend the seams, stroking from the thigh onto the torso. Secure and build up each of the buttocks with oval appliques of 1 Base Unit each for the female figure, ½ each for the male figure. For figures this small, this lightweight, you don't need glue, but you may wish to partially bake the figure for 20 minutes after you add the first leg, and then bake again after you've added the second leg.*

Modeling the ⅛ Scale Hand and Arm

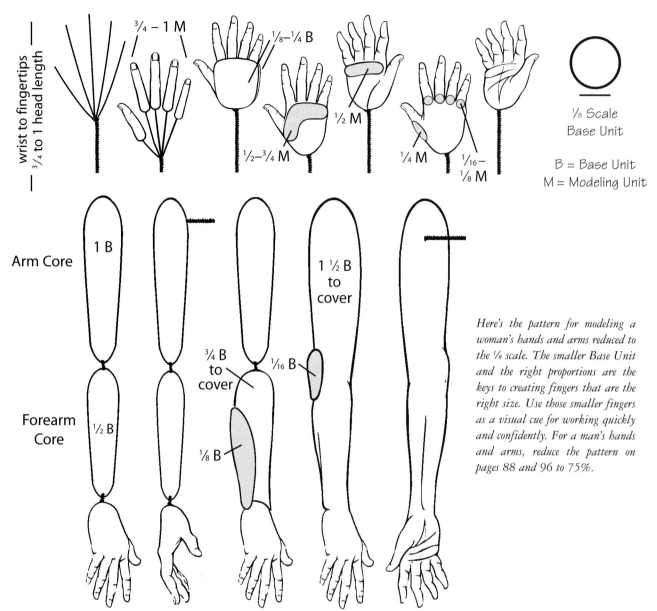

wrist to fingertips — ¾ to 1 head length

¾ – 1 M

⅛ – ¼ B

½ – ¾ M

½ M

¼ M

¹⁄₁₆ – ⅛ M

⅛ Scale
Base Unit

B = Base Unit
M = Modeling Unit

Arm Core

1 B

1 ½ B
to
cover

Forearm
Core

½ B

¾ B
to
cover

¹⁄₁₆ B

⅛ B

Here's the pattern for modeling a woman's hands and arms reduced to the ⅛ scale. The smaller Base Unit and the right proportions are the keys to creating fingers that are the right size. Use those smaller fingers as a visual cue for working quickly and confidently. For a man's hands and arms, reduce the pattern on pages 88 and 96 to 75%.

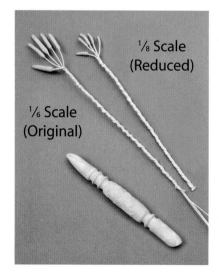

⅙ Scale
(Original)

⅛ Scale
(Reduced)

Compare the smaller ⅛ scale fingers to the larger ⅙ scale set and you understand the importance of measuring according to scale, especially when you realize the ⅛ scale arm and hand uses the same gauge cloth covered wire. From the fingertips to the shoulders, every step, stroke, and tool remains the same for the ⅛ scale hand and arm. Follow the steps described in Part 7, and check your measurements every step of the way.

NOTE

Whatever the size, hands and arms benefit from a strong but flexible armature. Whatever the size, the artist benefits from modeling over baked clay cores. Unlike the legs, this is not a time to take shortcuts.

The ¹⁄₁₂ Hand and Arm

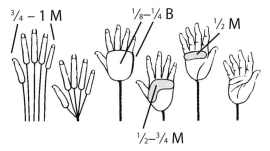

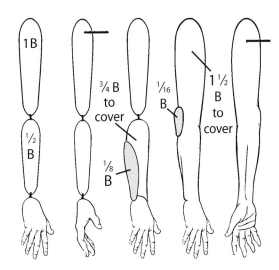

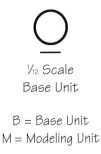

³⁄₄ – 1 M ¹⁄₈–¹⁄₄ B ¹⁄₂ M ¹⁄₂–³⁄₄ M

1B ³⁄₄ B to cover ¹⁄₁₆ B 1 ½ B to cover ¹⁄₂ B ¹⁄₈ B

¹⁄₁₂ Scale Base Unit

B = Base Unit
M = Modeling Unit

Here's the pattern for modeling the hands and arms in miniature, but there is a difference. The ¹⁄₁₂ scale hands are so tiny it's easier to model each finger separately, bake the fingers, and then assemble the hand. That's the only difference between this scale and the ¹⁄₈ scale on the facing page. At this scale, knuckles are an artistic choice. Enlarge this pattern 120% for a ¹⁄₁₀ scale reference.

Step 1—*Use 10 strands of 24 to 28 gauge beading wire, 4 ½ head lengths long. Treat the wire with vinyl glue. Tint the glue with flesh-colored acrylic paint.*

Step 2—*Don't twist the wires together. Model each finger separately by folding the clay over the wire and rolling it between your fingers and then on a ceramic tile.*

Step 3—*Use the small curved tip tool to mark the nails. Use the fine needle to mark the sides of the nails. Bake the fingers and thumbs on fiberfill for 20 minutes*

Step 4—*Arrange the fingers and thumb. Hold firmly and twist the wires together at the wrist. Now, follow steps described in Part 7 to model the hands and arms.*

Repair hairline cracks by brushing back and forth over the crack with acetone. After the acetone dries, apply a tiny disc of clay and brush smooth with diluent.

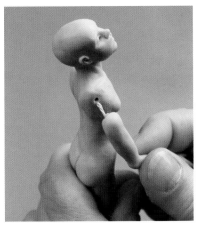

When you add the arms to the body, use your fingers to blend the deltoid applique, and finish with the tools you find most comfortable for this scale.

Costumes of Clay

"Clothes," said Mark Twain, "make the man." They also make the mannequin A costumed sculpture makes a statement of time and place. Ideally, creating such a figure is a planned part of the whole, but some of the best costumes are afterthoughts, inspired by the sculptures themselves.

CREATING CLAY CLOTH

Costumes of clay begin with clay that has the look of cloth. There are a variety of techniques that create this kind of optical illusion. Special blends of clay—pearlescent or fiber rich—add satin-like sheen or visual softness. Molds add cloth-like textures, while paints and powders highlight molded textures for startling effects

SOURCES OF TEXTURE

Fabric molds begin with a source. Scraps of lace, fabric remnants are obvious sources of texture, but wire mesh, a scrubbing pad and the odd sock cuff have all generated wonderful faux fabrics and fabric molds. Make a mold from wire mesh to create the look of diamond pin-tucked embroidery. The scrubbing pad makes a believable suede. A mold of the pad produces nappy cloth. Molds made from sock cuffs, with their tight ribbing, resemble miniature knits.

CREATING A
TEXTURE MOLD BY HAND

A blend of 3 parts Fimo Mix Quick to 1 part Prēmo or 1 part Kato Polyclay makes for a durable texture mold. Roll a thin clay sheet and place it on a ceramic tile. Soak the fabric sample in water, blot and press it firmly on the clay sheet. Roll once slowly and evenly. Peel away the fabric and bake the mold for 20 minutes. Molding several trims on a single sheet of clay saves time and effort. Trim and bake for 20 minutes.

CREATING A
TEXTURE MOLD BY MACHINE

Use a pasta machine to capture impressions of heavily textured or knitted fabrics. Roll the clay slightly thicker than the cloth. Wet the fabric and lay it on top of the clay sheet. Set the pasta machine so that it grips both the clay and fabric. Roll through the machine. Peel the cloth from the clay. Lay the clay on a tile or baking dish. Trim and bake for 20 minutes.

CREATING A
TEXTURED PANEL MOLD

Panel molds have the appearance of trimmed fabric. Lay a piece of wet lace or trim on the clay sheet and top it with piece wet fabric. Press firmly and then roll carefully to impress both textures into the clay. Peel away the fabric and lace. Trim the mold and bake. To use a pasta machine, fuse the trim to the fabric with fabric glue or fusible webbing and then create the mold.

THE FREEHAND EMBROIDERY MOLD

Create the look of embroidery by drawing in the clay with a stylus or tapestry needle. A dimple makes a flower center. Surround it with petals made of three or more lines drawn closely together. A spiral will make a rose. Add vines, stems with long curving strokes, and leaves with short, sharp strokes. Don't outline. Fill in. Bake for 20 minutes.

MOLDING CLAY FABRIC BY HAND

Step 1—To use a fabric mold, wet the mold to prevent the unbaked clay from sticking. Roll a thin sheet of clay the same size of the mold or larger. Lay the clay sheet on the mold, cover with a sheet of wax paper and burnish firmly with your fingers. Impress every aspect of the mold into the clay before you finish with a roller.

Step 2—The clay will adhere to the waxed paper. Use the paper to peel the clay cloth from the mold. Peel the "cloth" from the waxed paper and lay it on a paper towel to dry before you highlight with paint or powder.

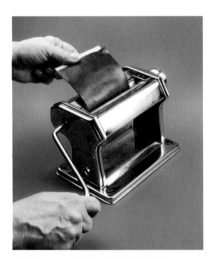

MOLDING CLAY FABRIC BY MACHINE

To use a mold with the pasta machine, wet the mold thoroughly and lay the clay sheet on top. Roll both through the pasta machine at a setting just slightly larger than the thickness of the mold. Peel off the clay sheet, trim and lay on a paper towel to dry.

HIGHLIGHTING THE PAINT

You can paint, stencil, stamp, and silk-screen unbaked clay to make a variety of fabrics. Combine paint with texture and the texture comes alive. Use a cosmetic sponge to dry brush acrylic paint onto the raised surface of the clay cloth and the texture will stand out, even white paint on white clay. Don't wet the sponge, just dab it in the paint and blot it. Gently graze the surface with the sponge. When the paint dries, you'll be able to drape or press the clay in place without damaging the design.

HIGHLIGHTING WITH POWDER

This clay cloth, a blend of red and gold clay, has the look of satin and the texture of tiny flowers made with the freehand mold. Bronze tinted mica powder brushed lightly over the clay adheres to the raised texture, but leaves the untextured clay with its original color and sheen. Like painted clay, you can manipulate this sheet. You can also flatten it with a roller. The mica powder will remain in its original pattern. The finished result appears embroidered with gold thread.

Dressing the Sculpture

How much Clay?

It can take almost as much clay to costume a figure as to model the figure itself. To create a loose fitting shirt or bodice of a dress, have half as much clay on hand as you used to cover the core. When it comes to modeling trousers, have on hand one and half times the amount of clay needed to cover each core. Long skirts, coats and capes can use two to three times as much. A lot of clay, yes, but oh, so much fun.

The Well-Dressed Limb

These fellows illustrate two possible techniques, methods determined by the color you choose. The fat fellow on the left shows you how to work with hard-to-keep-clean, light colored stockings or tights—model the entire limb in the light color and add shoes and pants after baking. The thin fellow on the right illustrates a similar shortcut. Legs modeled in gray and feet modeled in brown. Note the wrinkles in the gray cloth and the softness of the color, a blend of gray clay and brown Granitex. Note, too, the shoe-shaped foot and the creases in the brown clay leather.

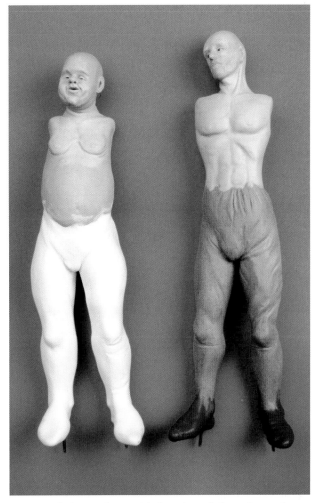

Begin at the bottom, begin with the socks and shoes, then work your way up and out, baking to protect your work as you proceed. Save time and steps by using colored clay to model the limb that wears stockings, tights, leggings or trousers.

WRINKLES AND FOLDS

This detail adds interest to the stocking covered leg. Pivot the medium or small knitting needle in an arcing motion across the limb, using just enough pressure to raise a "wrinkle" in the clay.

Leggings and trousers deserve extra wrinkles and folds. Place wrinkles where they're most likely to occur, where the limb bends or stretched fabric will sag. Note the small cod piece of clay. Made of $1/16$ of a Base Unit, it adds a necessary touch of realism to the male figure.

The Well-Shod Foot

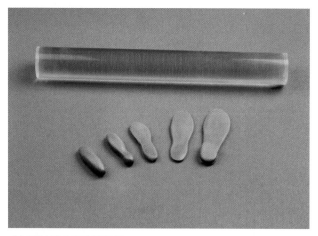

A TOUCH OF SOLE

For the dainty slipper, use ¼ of a Base Unit for each sole. Use a ½ a Base Unit to make each boot sole, and full Base Unit to make the thick sole of the clog. Roll the clay to form a rod, half the length of the foot. Roll the rod beneath your little finger to turn the rod into a drumstick shape. and then flatten the drumstick with your fingers. Finish with a roller until the sole is the right size.

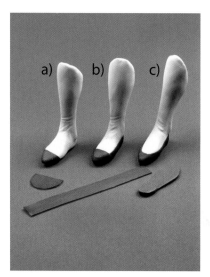

THE SLIPPER

*The dainty slipper has 3 pieces. The uppers are two thin sheets of clay—the half round "toe box" and a thin strip long enough to wrap around the length of the foot. The sole is thin. **a)** Wrap the toe box and seal the clay to the bottom of the foot. **b)** Wrap the strip around the base of the foot and blend it to the toe box and the bottom of the foot. **c)** Trim the uppers with a craft knife to create the style of slipper you wish, and press the sole in place. All shoes follow this same order of assembly.*

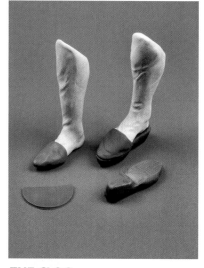

THE CLOG

The clog has a thicker half round toe box and a thicker sole. Blending and trimming aren't necessary. Use this same pattern and wood grained clay (peek ahead to crafting clay hair on page 132) to make wooden shoes. Blend the toe box to the sole if you do make wooden shoes.

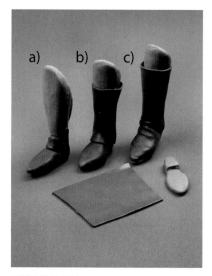

THE BOOT

***a)** The boot completely covers the foot; model the foot using clay the color of the boot. Use that same boot colored clay to secure the foot to the leg and to model the ankles. **b)** Finish the boot by wrapping the leg with a sheet of clay three times as wide as the leg. **c)** Blend the seam and press the sole in place.*

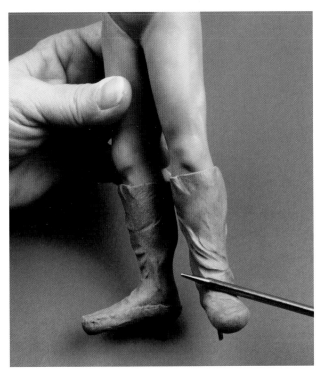

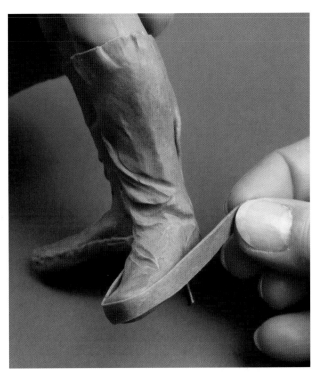

THE HIGH MOCCASIN

Step 1—*A variation of the boot, this is the high moccasin. It begins with a toe box, followed by a sheet of clay three times as wide as the leg. Use the medium knitting needle to create folds in the suede, a blend of light brown clay and black Granitex.*

Step 2—*Wrap a thin strip around the base of the foot and press in place, but don't blend the strip.*

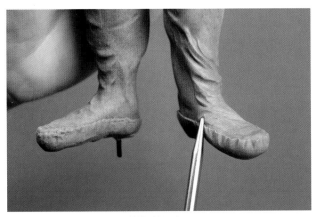

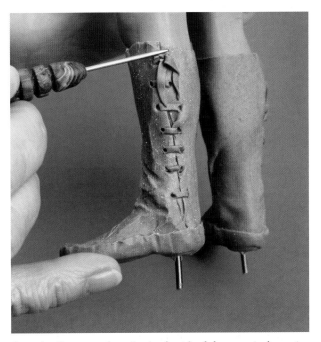

Step 3—*Use pressure from the knitting needle to make the moccasin appear stitched by pressing small indentations along the edge of the strip at regular intervals.*

THE GLOVED HAND

To model the gloved hand, use the same method you would use to model stockings and tights. Model a hand using clay the color of the glove. Omit the finger nails and focus on wrinkles and folds. Model the forearm in the same glove color.

Step 4—*Suggest and opening in the side of the moccasin by scoring it with a tapestry needle. Press across the opening at regular intervals and place tiny flat strips of clay, the laces, on these indentations. Use the tapestry needle to poke the ends of the laces into the clay and suggest eyelets in the leather. Bake the figure fully propped for twenty minutes, or use heat gun for the twenty to thirty minutes. Let the figure cool completely before the next step.*

Pantaloons, Knickers, Trousers and Leggings

PANTALOONS

Step 1—*This technique, called rod and drape, makes realistic pantaloons. Wrap a thin strip around the waist, a waist band, and a thin strip around each thigh, cuffs for the pantaloons. Place small rods around the legs, long enough to just fit between the waist and the cuff. Press firmly into place.*

Step 2—*Roll thin sheets of clay, and cut into strips just wide enough to stretch from the waistband to the cuffs. Gather the tops and use a knitting needle to press them in place at the waistband. One by one drape the sheets down over the rods, carefully pressing them in place, and gathering at the cuffs as needed. Use three or four gathered strips for each leg. Hide the seams by folding the edge of the strip under. When you press it in place, the folded edge will look like a gather and not a seam. Use the knitting needle to blend the gathered edges to the waist band and cuffs.*

Step B—*These clay sheets are thin enough to show the shape of the leg, yet thick enough to create wrinkles and folds. Make gathers by pressing the tip of the knitting needle into the clay at the waistband and cuffs. Because of the powerful pigments in the red clay, this fellow will bake again for 20 minutes before any more garments are added.*

KNICKERS

Step A—*A second possibility for this fellow is knickers. They begin with a waist band and cuffs, followed by a series of sheets of clay, long enough to stretch between the waistband and cuffs.*

> ### TIP
> Stop and wash your hands frequently when working with colored clays. A mixture of alcohol and diluent brushed on and wiped off with a clean brush or paper towel will remove the red stains from this fellow's white stockings.

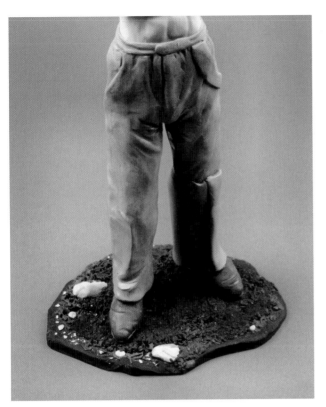

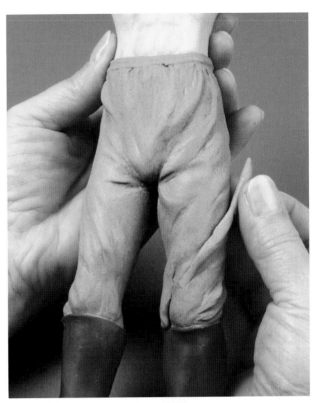

TROUSERS

This is one possibility for the gray legged man—trousers. Wrap and blend a sheet of clay a little more than three times as wide as the leg, and long enough to extend from the top of the knee to the ankle. The clay should thick enough to safely hold its shape and the crease you give it in the front and back. Add a button or zipper fly front with a strip of clay, a separate waistband and a pockets if you wish. Bake for 30 to 40 minutes according to the thickness of the clay.

LOOSE LEGGINGS

A second possibility—loose leggings made by adding more wrinkles and folds made with rods of clay to this fully baked figure. Bake the leggings for 30 minutes.

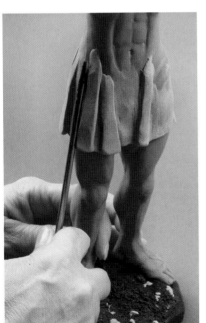

THE WEDGED SKIRT

Step 1—*Tapered rods of equal length, flattened and pressed in place are the first steps to creating this short kilt. This wedge construction is ideal for short garments such as this.*

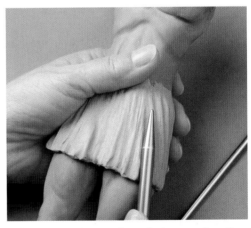

Step 2—*Use pressure from the large and medium knitting needle to model a series of pleats reminiscent of an Egyptian cotton popular during the age of the Roman Republic. All this garment needs is a waistband. A twisted strip of the same clay cloth wrapped around the waist will make the kilt appear held in place by a cord, hidden beneath the folds. Because of the thickness of the clay, this figure will bake for 40 minutes.*

Two Simple Shirts

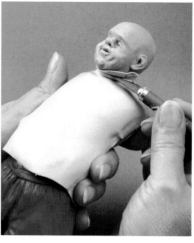

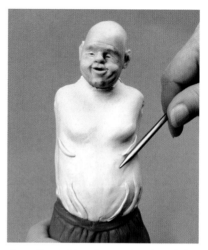

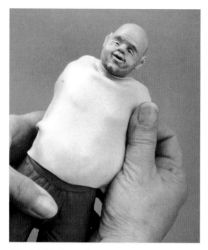

FITTED BUTTON FRONT

Step A—*Begin the fitted shirt with two thin sheets of clay, each as wide as the torso and the desired shirt length. Stretch one sheet across the chest so that it fits firmly against the body. Press to remove air bubbles. Do the same to the back. Blend the seams at the side and trim.*

Step B—*Trim the neckline with a craft knife.*

Step C—*Add gathers with rods and clay and arcing tools strokes. Blend, working to create a seamless appearance.*

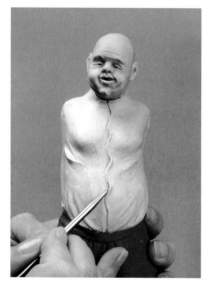

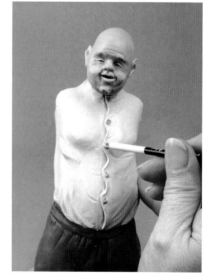

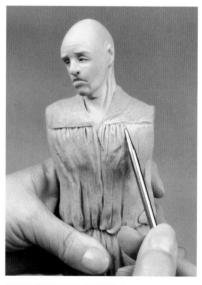

Step D—*Use the knitting needle to press a straight placket from the neckline to the waist. For added character, use the tip of the knitting needle to raise the placket at regular intervals. Simply move the needle from side to side to raise the edge. Now the shirt appears tight. It needs buttons.*

Step E—*Loosely blended balls of brown and tan clay pressed in place with the end of a paint brush look like wood buttons. Poking two holes in each button is an added detail easily done with a needle eye cut in half. Adding his arms already covered with sleeves, is the next step. It's also a simple task, one you've seen.*

THE BELTED TUNIC

Wedge construction above and below the waist makes this shirt look full and belted. The yoke line was pressed into the clay with a knitting needle. Strokes with the knitting needle created the smaller folds and blended the larger wedges. A knife cut made the simple V opening at the neckline.

The Lace and Satin Dress

Step A—*Rather than use a single gathered sheet, use several sheets to build up the skirt in layers with a technique called Draping. Gather one end of the clay sheet. Stretch the gathered end to make the cloth thinner where you will blend it to the body. The folded edges look like natural gathers in the fabric.*

Step B—*This is the third and final layer of fabric. When using this technique, press each layer firmly onto the previous layer for added strength.*

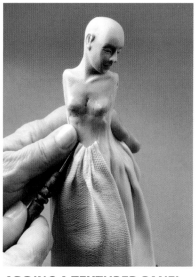

ADDING A TEXTURED PANEL

Step C—*This lace panel made from a mold was painted to accentuated the lace. It's the finishing touch for this skirt. It was gathered and then V cut at the waist to preserved the lace pattern that stretching would have destroyed. Very thin sheets of clay like this one need to be pressed firmly against the skirting beneath it. Press down and do not stroke across the clay or you'll lose the molded pattern.*

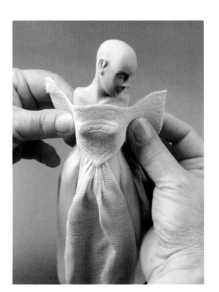

A SIMPLE BODICE

Step D—*The bodice for this dress was cut from the decorative border of clay lace identical to the lace panel on the front the dress. Its design takes advantage of the scalloped edge of the lace. V cut at the waist, it will match the same V cut on the lace panel of the skirt. Lightly wrap the bodice around the torso and then press in place.*

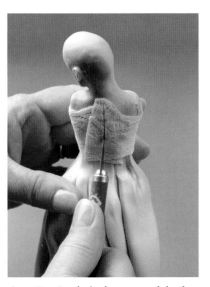

Step E—*On the back, use a craft knife to cut through the overlapping pieces. Lift and remove the top and bottom cut ends and the seams will match.*

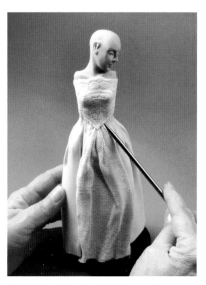

Step F—*Use the knitting and tapestry needles to finish the waist of the dress. Press additional gathers in the skirt, but take care with the lace panel.*

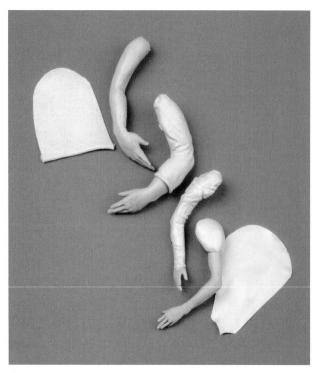

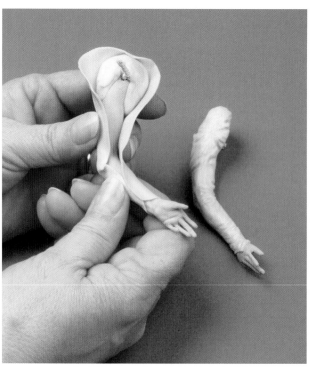

A SLEEVE IS A SLEEVE

Whether it's a tight fitting sleeve for a large ⅙ scale sculpture, or a fancy Leg of Mutton sleeve for a smaller ⅛ scale figure, a sleeve is a sleeve, and the techniques are similar. So, too, are the simply cut patterns for both sleeves.

THE LEG OF MUTTON SLEEVE

Step 1—To make the leg of mutton sleeve, roll a ball of clay from one Base unit and cut it in half. Each half attached to the baked arm becomes the foundation for the large puffed cap of the sleeve. Wrap the teardrop-shaped sleeve around the arm so that the seams meet on the underside of the arm. Blend the seams.

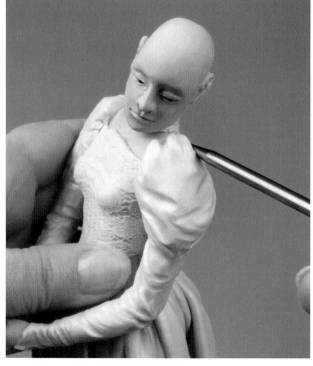

Step 2—Use the medium knitting needle to press wrinkles and folds into the clay. Use the tapestry needle to create finer wrinkles and folds.

ATTACHING THE COSTUMED ARM

Step 3—Insert the armature wire into the socket and press the arm against the body. Accent gathers at the shoulders with the knitting and tapestry needle. Use this technique to attach any costumed arm.

Dressing the Seated Figure

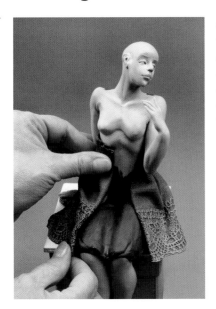

Step 1—*Support the skirt of a seated figure with three wedges of clay—one between the knees and on each side of the body. Gather and stretch 6 to 8 thin sheets of clay fabric. Press in place above the waist. To create a fitted appearance, shave excess clay from the torso with a craft knife and rub smooth.*

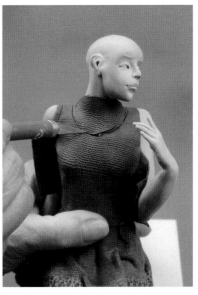

Step 2—*Treat the bodice as you would a fitted shirt. Press a sheet of clay on the torso, covering the front and then the back. Blend the seams. Trim the neck and shoulder lines with a craft knife.*

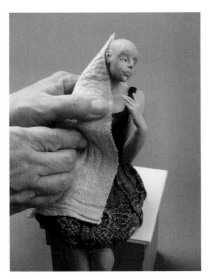

Step 3—*Not all fabrics produce the same result as a mold, but many can and will replace lost texture. Use your fingernail or a knitting needle to stroke folds in the clay fabric through the genuine fabric.*

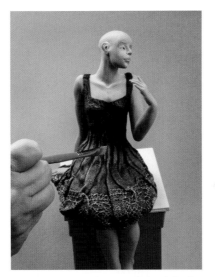

Step 4—*Restore the painted finish by dry brushing the clay cloth. Brighten the lace trim. Bake at the recommended temperature for 30 minutes.*

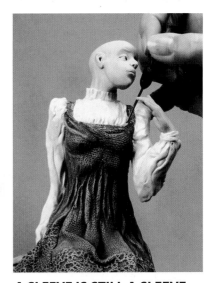

A SLEEVE IS STILL A SLEEVE

Baking the skirt and bodice makes adding sleeves and finishing the costume a much easier task, especially when you're using more than one color. The visible blouse is rod and drape construction and the sleeves are also rod and drape. The large and small tapestry needle makes quick work of the tucks and gathers at the shoulder seams and on the bodice.

The Buckskin Gown

Step A—Fabric stiffener tinted with brown acrylic paint will make this already stiff buckram durable enough to serve as an armature for a wind blown dress. Made of a circle with an X cut in the center, the buckram is soft while wet, but you can play with the draping design as it dries. A soda bottle filled with water for weight serves as the form for shaping this armature. Different bottles will create different draping effects. Dish detergent and many shampoo bottles have shoulders and make good forms for coats and capes. Large soda bottles make hoop skirts.

Step B—The same circle of cloth, eased over the legs and glued to the torso with instant glue, now receives a final shaping and coat of vinyl glue so the clay will adhere. The ragged hem line, made with a small scissors suits the windblown buckskin dress this figure will wear.

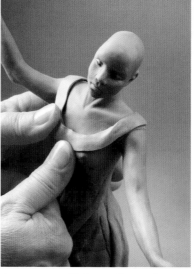

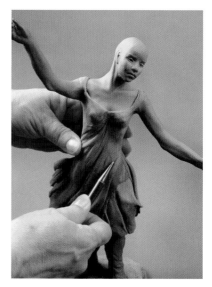

Step C—Two different blends of light brown clay, with a little Black Granitex added to each, make a realistic buckskin. Use a roller to press torn sheets of the clay together. Press the "buckskin" sheets firmly against the armature cloth, making sure there are no air bubbles. Begin at the hem line and work your way up to an imaginary neckline, or draw one with a colored pencil. Blend the clay firmly to the torso.

Step D—Establish a neckline with a strip of clay and blend it the rest of the dress.

Step E—Accent the wind blown look with long arcing strokes of the medium and large knitting needle. Use your fingers or a brush to soften the edges left by the knitting needles. Add a few gathered sheets and stretch to make the clay thinner where you blend it to the bodice. Let some of the ragged edges show.

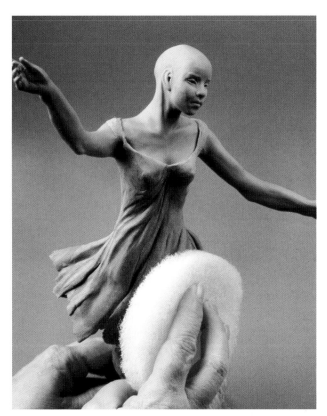

Step F—Press a scrubbing pad against the clay to add a buckskin texture.

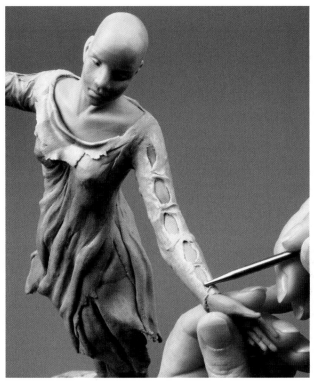

Step H—Seal the sleeve seams at regular intervals and use curving strokes of the knitting needle to push clay to the side, highlighting the ladder worked sleeve. Add strips of lacing. The collar is one long, torn scrap, folded and pressed in place.

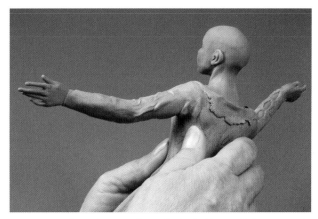

Step G—These sleeves will match the ladder work lacing on the high moccasins. Wrap the sleeve so that the seams meet on the top of the arm, and press the clay firmly against the arm. The clay is so thin it wrinkles easily, a nice effect, but clay that thin is fragile. Press it firmly against the arm and use the knitting and tapestry needles to model wrinkles and folds.

NOTE

Too tall to stand in the oven, this figure will bake laying on a thick cushion of fiberfill. Stuffing additional fiberfill between the wind blown dress and her legs will protect the costume and the figure, but this additional fiberfill will insulate the clay. Add another twenty minutes to the baking time to insure the clay cures. Use wet paper towels to protect the exposed figure from scorching.

Finishing Touches

We're colorful people. We bloom with youth and blush with modesty, simply because we're alive. Make your sculptures bloom. With the first hint of color, the first dab of paint, they will begin to come to life. With the last details, you'll wonder if they've entered your world or you've entered theirs.

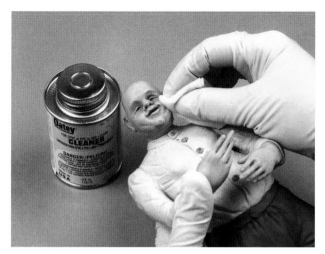

BEFORE YOU PAINT

The first touches of paint often reveal flaws. Despite careful work, nicks and scratches occur, often where you've worked the hardest, on the face. Use that first touch of paint as tool for discovery. Apply a thin wash of water mixable oils and let it dry. Paint will flow into those flaws and highlight them. Use acetone to remove the paint and the flaws. It will soften the baked clay. Apply it with a soft brush or soft paper towel. Use adequate ventilation, wear protective gloves, and wipe or brush carefully. Those nicks and scratches will disappear. So too will hairline cracks. Don't let the acetone pool or set on the clay too long or it will etch the clay and you'll have to remove the etching. When the acetone evaporates, you're ready to bring your sculptures to life.

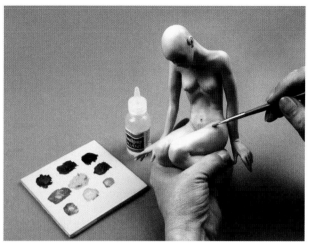

USING WATER MIXABLE OILS

Use a dry brush technique and a wide soft brush to add rosy hints of color where the blood flow is rich or close to the surface of the skin—the thighs, the calves, the belly, the buttocks, the outer arms, the elbows, the soles of the feet, and the nipples. When the paint loses its sheen, lightly brush the surface with diluent. Dip the tip of the brush in diluent and then wipe it on a paper towel; a little goes a long way. The color will remain and the brush strokes disappear as the diluent soaks into the clay.

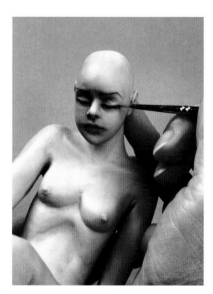

FACE PAINTING

Use a small brush to accent shadows around the eyes and nose. Try a blend of Cobalt Blue with Crimson for a warm tone. For soft lashes and soft brows, the paint should be thick enough to control and thin enough for painting fine lines, and, of course, match the desired hair color. Notice how the opaque clay now appears translucent?

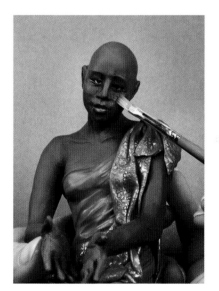

HIGHLIGHTING DARK-TONED SKIN

A blend of Crimson and Raw Umber highlights this dark lady's cheeks, while a blend of Crimson and Raw Sienna color her lips. Soft shadows around the eyes come from a blend of Raw Umber, Crimson and Cobalt Blue.

NOTE: BODY PAINTING

Acrylics have been the paint of choice for most artists who work in polymer clay, but try water mixable oils. The refined oils are compatible with the clay when mixed with water. They blend beautifully and leave no hard edges. Mix a pallet of flesh tones and blushes. Add a bit of Raw Sienna to White, and the tiniest touch of Crimson to create a range of flesh tones from shadowy to rosy to one exactly matching the skin tone of your sculpture. Thin the paint with water, not oil, and apply it sparingly. Though it takes longer to dry, this paint is forgiving, but once dry, is permanent.

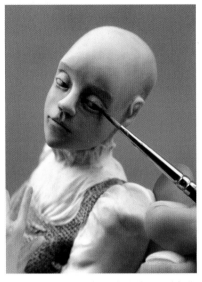

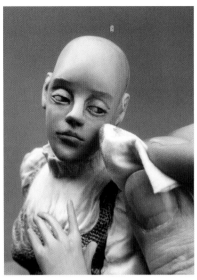

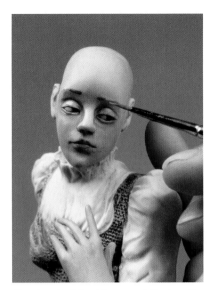

THE PALE COMPLEXION

Pale by comparison, scant shadows around the eyes applied with a small brush are all this lady needs. A fine line, carefully applied at the inside edge of the lid, highlighted the lashes.

Pale pink, a blend of flesh and a bit of crimson applied with a brush and blotted with a paper towel will add a soft bloom to pale cheeks.

For sharply defined brows and lips, acrylics and a fine brush do the job. Fast drying, they work with the water mixable oils. A blend of White, Raw Sienna, and Alizarin Crimson tinted her lips while a blend of Raw Sienna and Raw Umber tinted her brows. When it comes to painting brows, paint the most difficult brow first. If you're right handed, paint the right brow, or the one on the left as it faces you. If you're left handed, paint the brow on the right as it faces you.

Crowning Glory

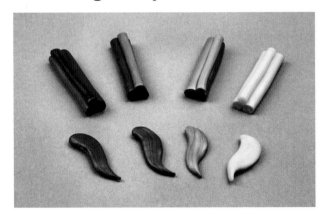

CREATING THE GRAINED BLEND

Step 1—Create a grained blend of colors with a touch of metallic clay to add realism to sculpted hair. For each hair color, thoroughly mix one dark and one light value. Mix equal parts of the two to create a middle value. Use a metallic clay to create the light value. For example, create black hair with one rod of Black, one rod of 4 parts Black & 1 part Copper, and one rod of a combination of the two. Brown Hair: one rod of Burnt Umber, one rod of 4 parts Raw Sienna and 1 part Gold, and a third rod combining the two. Titian hair: use one rod of Raw Sienna, one rod of 3 parts Yellow and 1 part Gold, and a blend for the third rod. White hair is the exception. Use one rod of 1 part Pearl White and 1 part Translucent, one rod of 1 part Translucent and $1/16$ part gold, and rod of Translucent.

Step 2—Stack the three rods and roll it rapidly between your palms to form one long rod.

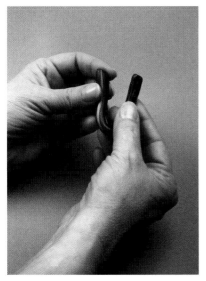

Step 3—*Fold the rod in half. Roll the folded rod between your palms. Continue rolling and folding 8 times. It should resemble a grained log, and look a great deal like wood.*

Step 4—*Flatten the rod with a roller, rolling with the grain. Flatten it slightly for thick hair styles and thin for hair that lays close to the head.*

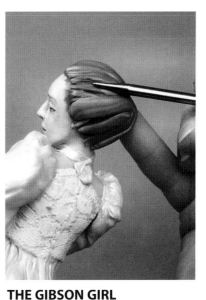

THE GIBSON GIRL

Step A—*This simple style uses wedges of grained clay, made by stretching short, thick strips to a point. Press the wedges on the crown, with flat edge just above the hair line. Use the medium knitting needle to stroke the clay toward the crown, blending the wedges together and establishing the upswept style.*

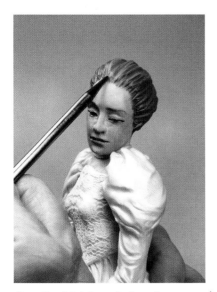

Step B—*Lightly stroke from the crown to soften the hairline all around the head.*

Step C—*Use the hair stamp to add fine texture. Moisten the stamp with water and pivot it across the hair, from the hairline toward the crown.*

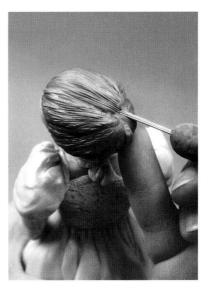

Step D—*Finish detailing the hair fine texture with the comb. Watch for cross hatched lines and comb them out. You'll find the fine and bent needle tools work very well at the base of the scalp and near the ears.*

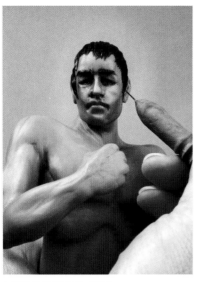

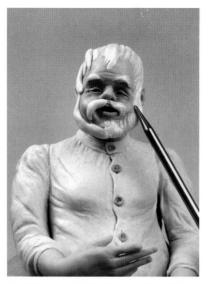

THE ROMAN CUT

Short hair lies close to the head, but the techniques for this style have a lot in common with the Gibson Girl. Build up the crown with thin rods tapered at both ends. Radiate the rods from the center crown toward the hair line, and curl the ends to frame the face. Stroke with a knitting needle to establish the wave and style, and then use the stamp and finish texturing with the comb. Instead of painted brows, this man has clay brows, made from tiny rods of clay.

SHORT, THICK AND BEARDED

Similar to the Roman cut, thick tapered rods radiate from the crown and frame the fat fellow's face. Smaller rods help to develop his beard. Use the knitting needle to blend the rods of clay. Stroke from the beard onto the face so that the growth appears natural. Finish with the stamp, the comb and fine needle. Use tiny rods for the brows and the fine needle to add texture.

Combining Clay and Fiber

Sisal twine, a natural fiber with a lovely sheen can add a new dimension to the reality you've created, hair that looks real, hair that's both clay and fiber. Slightly heavier than human hair or mohair, this fiber has the advantage of matching the textured clay hair created by the stamp and comb, enabling you to combine materials and methods.

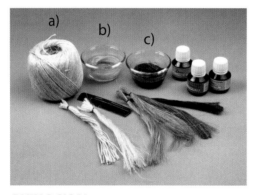

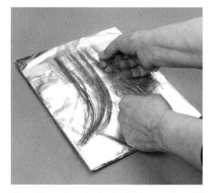

DYING SISAL

Step 1—a) Cut fifteen to twenty strands of sisal cord into 6-inch lengths, and tie them together at one end with button thread, creating a hank of sisal. b) Soak in water to separate the fibers and comb. c) Dye the hanks with fabric dye, rinse, and hang to dry, or iron the hanks between clean paper towels. Alcohol based silk dyes, such as Dupont work well. The clay blends were made to match three of these hanks, the Titian, Brown, and Black. With a little experimentation, you'll have no trouble creating a clay blend for blond hair, or one that matches natural sisal.

Step 2—Varnish the dyed fibers and you'll be able to model straight hair, short curly hair, or long locks and embed them in the clay. Cover cardboard with foil, and lay a strip of masking tape across one end. Add a second strip of masking tape, sticky side up, looping the ends so the tape stays in place. Press the fibers onto the sticky tape and secure with a third piece of masking tape.

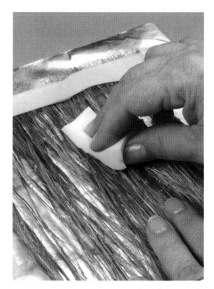

Step 3—*Use a sponge or a brush to apply satin or gloss acrylic varnish to the fibers. This is a sticky venture. Some of the fibers will stick to each other. Comb through again. Before the varnish dries, peel off the second (the sticky side up) masking tape. All of the varnished fibers will stay secured between two pieces of tape. Use a clothespin or a bulldog clip and hang the hair to dry.*

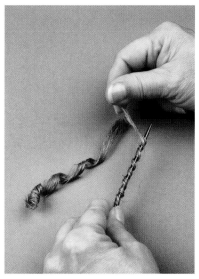

Step 4—*You'll want separate strands and narrow locks of straight, stiff hair, some as wide as a ¼ inch, but most narrower. Play with it. Peel off a lock and wrap it around a thin metal rod or a tapestry needle to make a curls. The thinner the rod or needle, the tighter the curl. Suddenly, it looks like hair.*

Combining Sisal and Clay

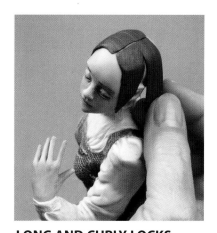

LONG AND CURLY LOCKS

Step A—*Thin strips of brown grained clay are the beginning for this simple style. Notice how the thin strips of clay define the style before the fiber has been added? You can define any style with clay. Part it on the side, in the middle, or even add bangs.*

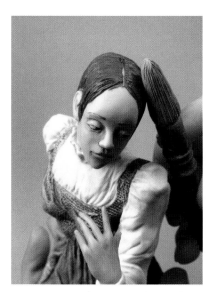

Step B—*Use the stamp to begin adding texture. A few careful strokes with the tapestry needle will renew the part in her hair.*

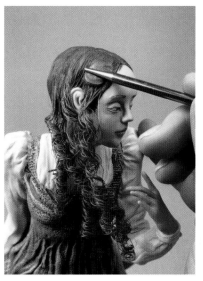

Step C—*Curl the locks but leave about ½ of and inch or more uncurled. One lock at a time, imbed the straight ends of the locks into the clay. Press it into the clay and cover with a thin, small patch of grained clay. Use a knitting needle as a roller to blend the patch of clay to the crown clay.*

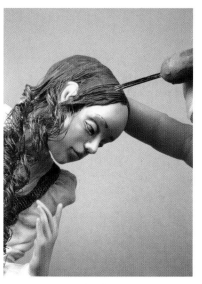

Step D—*Use the three needle comb to blend the sisal extension to the clay. Comb through the sisal up toward the clay crown so that the fibers align with the fine lines in the clay. Work your way around the crown, embedding hair near the base of the scalp and above it. Use all your tools, the stamp, the comb, and the fine needle tools to create a seamless blend of hair and fiber. Pay attention to the hairline and the hair near the ears.*

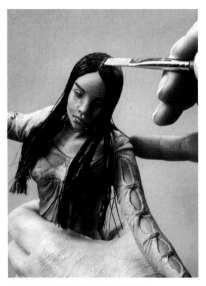

LONG, STRAIGHT HAIR

Step 1—The same techniques used to make curly locks apply to long straight hair—imbed, patch, blend, and texture. After you've combed the clay and fiber, use a clean brush and diluent to soften any ragged edges. Brush the clay with the grain of the hair.

Step 2—When you bake the figure, the varnish will soften. Take advantage of this property to finish the hair style and control any fly away locks that don't hang naturally. Press the locks close to the body and carefully wrap the pressed locks and body with a strip of aluminum foil. Bake the figure for 20 to 30 minutes depending on the thickness of the unbaked clay.

SHORT AND CURLY

Step A—Thin strips of clay are the beginning of this hair style. Press them firmly into the clay and use a knitting needle to draw tiny spirals in the clay, most importantly near the hairline. Work to create tiny, wispy curls.

Step B—Wrap long, narrow locks around thin rod to create a long tight curl. You will need ten or more of the curly locks. Use a tapestry needle to imbed the locks in the clay every ⅛ of an inch or so. Lay the locks in a random wavy pattern so that it looks like many short curls rather than a long one. If you have trouble making the curl adhere to the clay just where you want it. Add a tiny drop of instant glue to the clay and press the curl in place with a tooth pick.

THE GIBSON GIRL
AND SHINING GLORY

Step 1—You can imbed fiber into a thick upswept style and change the look completely. Remember the grain of the clay hair determines how you imbed the fiber. Always embed the locks with patches like this one, patches that flow with the established hairstyle.

Step 2—After baking, apply varnish with a soft brush and brush with the grain. While you're varnishing, use the small brush to add a gleam to the eyes and a shine to the lips and finger nails.

Solid Ground

Your work is more than a sculpture, it's your singular vision. Create a world based on that vision, solid ground for your sculpture. Suggest the fragment of a room with a wooden plaque covered with polymer clay. A loose and streaky blend of clay, sanded smooth and buffed after baking, resembles marble. Dusky colored clay mixed with Granitex or Fimo Stone, textured with crumpled foil, looks like stone. Or suggest the world where your sculpture resides.

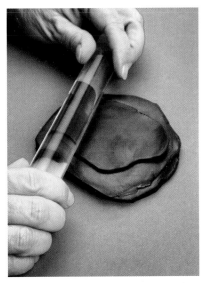

Step 1—*Create an outdoor environment with stacked sheets of earthy clay, a blend of brown and black. This method lets you build up a foundation thicker where the figure will stand. ¼ of an inch at the edges, this bit of ground is ¾ of an inch thick where the figure will stand. That's enough depth to support a heavy 12-inch tall figure.*

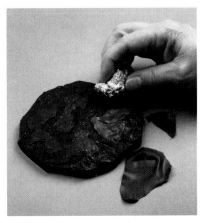

Step 2—*Press thin scraps of dark or mottled green clay on the base and use crumpled foil to give the base an earthy texture.*

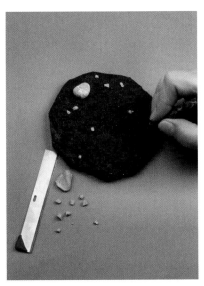

Step 3—*Add rocks of gray clay marbled with translucent or white. Blend a bit of Fimo Stone or Granitex for more realism. Use a tapestry needle to turn the green clay into mossy ground by drawing a series in spirals and interlocking figure eights in the clay. A drawing technique called scumbling, it will create raised and ragged edges of green growth.*

Step 4—*Do this step on a bakeable surface. Moisten the feet of the figure. Hold the figure firmly and press it into the clay, seating the armature rods deep into the base and the feet in the clay ground. Carefully remove the figure and bake the base for about an hour and twenty minutes.*

Step 5—*When the base is thoroughly cool, set it on a ceramic tile and apply PVC cement to the footprint and the feet. Stand the figure in the base and clamp the figure in place with a heavy rubber band that wraps around the tile as well as the feet and base. The glue will set up in an hour, and cure fully in 24 hours.*

A Touch of Fantasy

The fantasy sculpture is my hallmark. Fairies are my stock in trade, and here is how I make fairy wings. After years of hand drawing and painting wings on velum or acetate, I now use my computer and my inkjet printer.

MAKING FAIRY WINGS

Step A—*Use this image to make Monarch fairies or butterflies. If you use a color copier, print two matching copies in the size you desire, onto archival paper. If you have the tools (a scanner, computer, graphics program, and printer) scan the wings at a the highest setting possible without producing a "pixilated" image. Save the image as a TIFF. Use a graphics program such as Paint Shop Pro or Photoshop to print the wings at 720 dpi or higher in the size you desire. Print two matching copies onto archival paper or a good translucent inkjet vellum such as Strathmore.*

Step B—*Let the ink dry for two hours or more. Cut out the wings and apply a permanent glue stick to the unprinted side of one of each wing. Leave the corner of the wing where it attaches to the fairy unglued.*

Step C—*Hold a matched set up to the light, align the edges and press the two wings together.*

Step D—*Make four eye pins out of a thin brass rod as long as ⅓ to ½ the depth of the fairy's torso. Open the unglued corner of the wings and carefully brush a small amount vinyl glue onto one wing. Insert the loop of the eye pin and press the wings together, securing the loop in place. Let dry.*

ADDING DIMENSION TO THE WINGS

Step E—*Place a wing on a soft folded paper towel and cover it with a sheet of clear vinyl. to minimize scarring. The vinyl from a food storage bag works well. Use the medium knitting needle to score along the vein lines of each wing. Don't use too much pressure, just enough to emboss the vein. Take care to emboss a right and left pair of wings.*

Step F—*Turn the wing over, replace the vinyl sheet, and use a large knitting needle to outline the scaled part of the wings. Work next to but not on the vein lines. Finish by embossing the entire scaled area. Use firm, straight strokes and never cross the vein lines. Do this on each wing.*

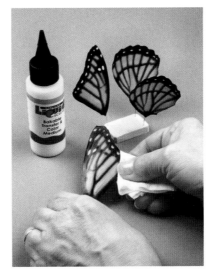

Step G—*Make the wings waterproof with Translucent Liquid Sculpey or Clear Genesis Matte Medium, a polymer heat set paint. Brush both sides of the wings and then wipe off the liquid polymer with a soft towel. This will leave a thin but effective film. Set the eye pins into the eye stand and bake the wings for 15 to 20 minutes*

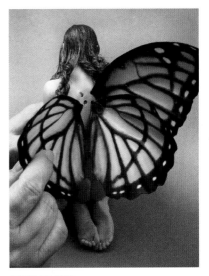

THE FAIRY

Drill four holes in the upper back of the fairy. Set them in a slight V pattern, with the base of the V pointing down. Check each wing one at a time to make certain the hole is deep enough and the eye pin is not too long. Add drop of instant glue into the wing socket and insert the eye pin and seat the wing. Insert the wings on one side and then the other, beginning with the bottom wing first. Let the glue dry before proceeding to the next wing.

The Last Details

Every sculpture needs a special touch, an enchantment to catch the eye and capture the heart. Tiny wings are at the heart of the little monarch, the last detail for this sculpture. No eye pins, but instant glue holds all four wings together at the insertion point. The butterfly's body is a rod of clay, flattened and folded over the base of the wings. The antennae are beading wire, painted black. Instant glue holds the butterfly nestled in the gathers on this young lady's sleeve.

Father Christmas now holds several scrolls. Liquid polymer clay protects the names of boy's and girl's names copied from a baby book and printed with an ink jet printer in a tiny but fancy font. His green suspenders, are simply two strips of clay, but they add an extra bit of color that visually unites the figure with the base. The freehand flower texture mold and bronze powder created the cross brace for his suspenders.

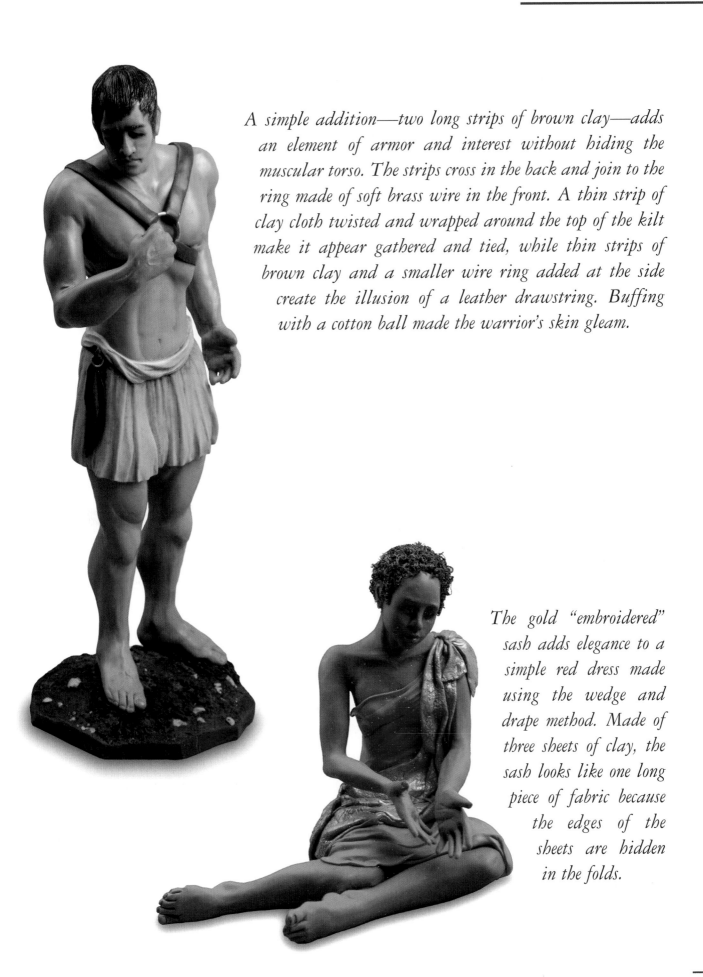

A simple addition—two long strips of brown clay—adds an element of armor and interest without hiding the muscular torso. The strips cross in the back and join to the ring made of soft brass wire in the front. A thin strip of clay cloth twisted and wrapped around the top of the kilt make it appear gathered and tied, while thin strips of brown clay and a smaller wire ring added at the side create the illusion of a leather drawstring. Buffing with a cotton ball made the warrior's skin gleam.

The gold "embroidered" sash adds elegance to a simple red dress made using the wedge and drape method. Made of three sheets of clay, the sash looks like one long piece of fabric because the edges of the sheets are hidden in the folds.

The bear claw necklace draws the eye toward the large Wind Dancer's face. Each claw was made of a tiny tapered rod curved over a large knitting needle and then baked. Tweezers held each claw in place until instant glue took hold, about 20 seconds.

Half the size of the original, the miniature Wind Dancer wears a buckskin gown cut from the same clay cloth, a crown sisal hair cut from the same hank and detailed with the same tools. The only additional tool was a magnifying visor. The sleeves were modeled on baked arms, and the arms added to a figure wearing a fully baked gown. This miniature has no bear claw necklace; her size and the details in the sleeves are enough to draw the eye.

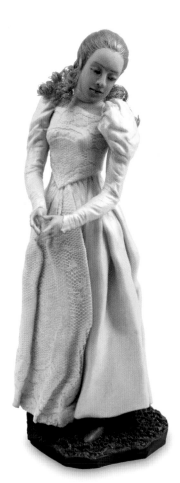

A light buffing with cotton highlighted the satin of the Gibson Girl's white dress. For clays such as this, buffing, rather than varnish, is the key to preserving the pearlescent sheen.

Resources

Books

Drawings and photographs of the human form cover my studio walls. My personal library has grown. These are books you might find helpful:

Books on Figurative Sculpting

Modeling and Sculpting the Human Figure, Edouard Lanteri, Dover Publications, 1985.
Modeling the Head in Clay, Bruno Lucchesi, Margit Malmstrom (Contributor), Watson-Guptill Publications, 1996.
Modeling the Figure in Clay, Bruno Lucchesi, Margit Malmstrom (Contributor), Watson-Guptill Publications, 1996.
Modeling a Likeness in Clay, Daisy Grubbs, Watson-Guptill Publications, 1982.
The Portrait in Clay, Peter Rubino, Watson-Guptill Publications, 1997.

Books on Polymer Clay Sculpting Technique

Fantastic Figures: Ideas and Techniques Using the New Clays, Susanna Oroyan, C & T Publications, 1994.
Family and Friends in Polymer Clay, Maureen Carlson, North Light Books, 2000.
How to Make Clay Characters, Maureen Carlson, North Light Books, 1997.

Books on Anatomy

Anatomy for the Artist, Jeno Barcsay, Metro Books, 2001
Anatomy for the Artist, by Sarah Simblet, John Davis (Photographer), DK Publishing; (1st edition), 2001.
Artistic Anatomy, Dr. Paul Richer, Robert Beverly Hale, Watson-Guptill Publications, 1986.
Dynamic Anatomy, Burne Hogarth, Watson-Guptill Publications, 1990.
A Handbook of Anatomy for the Art Student, Arthur Thompson, Dover Publications (5th edition), 1929.
An Atlas of Anatomy for Artists, Fritz Schider, Dover Publications (3rd edition), 1981.
Atlas of Human Anatomy for the Artist, Steven Rodgers Peck, Oxford University Press, 1997.

Supplies

When you can't find the supplies you need, go to the source. Contact the manufacturers listed below to find a retailer near you that carries their products.

- *The Clay Factory Ltd.*, manufacturer of Cernit • http://www.cernit.de/ • info@cernit.de
- *Du-kit*, manufacturer of Du-kit Polymer Clay • http://www.dukit.co.nz/ • sales@dukit.co.nz
- *Eberhard Faber GmbH*, manufacturer of Fimo clays; distributed by Staedtler, Inc. • http://www.staedtler-usa.com/ • customerservice@staedtler-usa.com
- *Golden Artist Colors, Inc.*, manufacturer of Golden Acrylics • http://www.goldenpaints.com/ • goldenart@goldenpaints.com
- *Havo b.v.*, manufacturer of Creall-therm • http://www.havo.com/default.htm • info@havo.com
- *K&S Engineering*, manufacturer of brass rods, brass and aluminum tubing • http://www.ksmetals.com/ • ksmetals2@aol.com
- *Modelene* • http://www.modelene.com.au/ • enquiries@paperplace.com.au
- *Polyform Products Company*, manufacturer of Sculpey products • http://www.sculpey.com/ • info@sculpey.com
- *Van Aken International*, manufacturer of Kato Polyclays • http://www.vanaken.com/ • va_info@vanaken.com
- *Winsor & Newton*, manufacturer of Artisan Water Mixable Oils and Finity and Galeria Acrylics • http://www.winsornewton.com/ • U.S. email: usatechhelp@colart.co.uk • EU email: uktechhelp@colart.co.uk

Further Information

Spend time on the World Wide Web. You'll find information on figure sculpting techniques and polymer clay in newsgroups and chatrooms where you can question the experts and share knowledge. Look for work done by Jodi and Richard Creager, Maureen Carlson, Kim Jelly, Clay Moore, Randy Bowen, the Shiflett Brothers, Chuck Needham, Gabe Perna, Casey Love, Shawn Nagle, Dan Perez, Andy Bergholtz, Steve Wang, Martin Canale, Pablo Viggiano, Kim Graham, Jill Willich, Gabriel Marquez, Mark Newman, Claudio Setti, and Tony Cipriano—all professional sculptors, all remarkable artists who work in polymer clay. You can even visit my Website, Elvenwork, at http://www.elvenwork.com

Index

Age, facial variations, 42
Armatures, general, 18
 Arms, 97
 Baked clay core, arms, 97
 Baked clay core, legs, 72
 Hands, 88
 Head and face, 23
 Leg core, 72
 Scaling, 110
 Shaping, 51
 Torso, central core, 50
Arms & Hands, general, 87
 Armature, 88
 Baked clay core, 96
 Attaching arms, 101
 Forearm, modeling, 98
 Heroic arm, modeling, 100
 Posing arms, 99
 Upper arm, modeling, 98
Attaching Elements
 Arms, 101
 Head, 62
 Legs, 82, 113
 Sockets, forming, 68
 Wings, 139

Back
 Backbone, 63
 Building up, 56
 Finishing touches, 61
 Landmarks, 49
 Modeling, 60
 Shoulder blades, 60
Baking tools, 19
Baking, when to, 69
Baking, standing & seated figure, 85
Bases, display, 137
Beards, sculpting, 134
Body, painting, 131
Breasts, 58
Burnishing, 68
Buttocks, 61

Calf and ankle, 78, 113
Cheeks, 38
Chest, general, 56
 Finishing Touches, 58
Chin, 38
Clay, see Polymer Clay
Clothing & costumes, general, 117
 Dressing figures, 119
 Fabric texture molds, 1117
 Freehand texture molds, 118
 Highlighting, 118
 Modeling methods, 118
 Panel molds, 117
 Pants, 122
 Shoes, 120
 Skirts, 123
 Sleeves & shirts, 126
Collar bones, modeling, 62
Cores
 Arm, 97
 ⅛ Scale, 114
 ¹⁄₁₀, ¹⁄₁₂ Scale, 115
 Fat body, 66
 Feet, 76
 Fingers, 88
 Fingers, ¹⁄₁₀, ¹⁄₁₂ Scale, 114
 Foil, 23, 50
 Forearm, 97
 Heroic body, 64
 Heroic leg, 81

Cores (cont)
 Leg & foot, 72
 Torso, 50
Display bases, 137
Dressing figures, 119

Ears, 44
Ethnic variations, head & face, 31
Eyes, 27
 Age, variations, 42
 Brows, 35
 Closed, 35
 Expressions, 33
 Lids, 34
 Orbits & Sockets, 27
 Positioning, Sizing, Painting, 28
 Refinements, 33
 Rescaling, 104

Face, age variations, 42
Face, ethnic variations, 33
Face, painting, 131
Facial features, 26
 Cheeks, modeling, 39
 Chin, shaping, 39
 Eyes, sizing & positioning, 28
 Facial angle, 26
 Facial plane, mapping, 25
 Mouth, basic, 27
 Nose, basic, 26
Fantasy, wings, 138
Feet, modeling, 76
Fingers, modeling, 89, 92
 ¹⁄₁₀, ¹⁄₁₂ Scaling, 11-6
Finishes, basics, 19
Foil Cores, 50

Gallery, completed sculptures, 140
Gloves, 121

Hair, sculpting, 132
 Beard, 134
 Fiber & clay (long), 134
 Gibson girl (upswept), 133
 Roman cut (short), 134
Hands, modeling & posing, 91
 ⅛ scaling, 114
 ¹⁄₁₀, ¹⁄₁₂ scaling, 115
Head, attaching, 62
Head, posing, 63
Head & Face, 21
 Armature, 23
 Cheeks, 38
 Chin, 38
 Ears, modeling, 44
 Eyes, 27
 Brows, 35
 Closed, 35
 Expressions, 33
 Lids, 34
 Refinements, 33
 Ethnic variations, 33
 Facial plane, 25
 Jaw, 25
 Magic Squares, 21
 Mouth, 36
 Expressions, creating, 36
 Grin & laugh, 41
 Open, 41
 Teeth, forming, 41
 Neck, modeling, 43
 Nose, basic, 26
 Modeling, 37

Head & face, nose, modeling (cont)
 Variations, 37
 Proportioning, 21
 Skull, 24
 Rescaling, 103
 Wrinkles & lines, 42
Hips, 56

Jaw, shaping, 25

Landmarks
 Arms & hands, 87
 Back, 49
 Head, 21
 Leg & foot, 71
 Torso, 47
Leaching, polymer clay, 9
Leg & foot
 Ankle & calf, 78, 113
 Attaching to torso, 82, 113
 Cores, baked, 72
 Heroic leg, 81
 Landmarks, 71
 Muscles & tendons, 78
 Posing, 83
 Scaling, 111

Mapping, torso, 47
Miniatures, modeling, 103
 Arm, 114
 Finishing techniques, 142
 Head, 103
 Leg, 110
 Posing, 109
 Torso, 107
Modeling, basics, 10
Molds, fabric, 117
Mouth, 27
 Basic modeling, 36
 Expressions, 36
 Grin & laugh, 41
 Open wide, 41
 Teeth, 41
Muscles/Tendons, leg & foot, 78

Neck, modeling, 43
 Refining jaw, 43
Nose, basic, 26
 Modeling, 37
 Variations, 38

Painting figures, 131
Pants, 122
Pelvic girdle, 57
Polymer clay
 Brands, 06
 Conditioning & leaching, 9
 Measuring, 12
 Mixing flesh tones, 8
 Safety, 9
 Specialty clays, 7
Posing
 Arms, 99
 Hands, 91
 Head, 63
 Legs & feet, 82
 Miniature torso, 109
 Torso, 59
Proportioning
 Clay, 11
 Figures, basics, 12
 Head & face, 21
 Magic squares, head & face, 21

Ribcage, modeling, 57

Scaling, basics, 103
 Eyes, 104
 Hands & arms, ⅛ scale, 114
 Hands & arms, ¹⁄₁₀, ¹⁄₁₂ scale, 115
 Head, 103
 Fingers, ¹⁄₁₀, ¹⁄₁₂ scale, 115
 Foil cores, general, 105
 Legs, ⅛ scale, 110
 Legs, ¹⁄₁₀, ¹⁄₁₂ scale, 111
Shapes, modeling basics, 11
Shirts, 124
Shoes, 120
Shoulders, building up, 56
Shoulder blades, 60
Skin, 68
Skirts, 123
Skull, shaping, 24
Sleeves, 126
Smoothing techniques, 68

Teeth, 41
Toes, 76, 112
Tools, essentials, 13
 Baking, 19
 Curved tip tool, 16
 Eyeball mold, 18
 Finishing tools, 19
 Foil core tool, 17
 Hair stamp tool, 17
 Handles, 14
 Miniature modeling tools, 109
 Needle tools, 15
 Sculpting stand, 18
 Strengthening, 18

Torso, 47
 ⅛ scale, 105
 ¹⁄₁₀, ¹⁄₁₂ scale, 107
 Armature, central core, 51
 Back, landmarks, 49
 Modeling, 60
 Finishing, 61
 Breasts & nipples, 58
 Building up, 56
 Buttocks, 61
 Chest, finishing, 58
 Chest & abdomen, landmarks, 47
 Collar bones, 62
 Covering with clay, 54
 Fat torso, 66
 Heroic torso, 64
 Landmarks, modeling, 56
 Mapping, 47
 Miniature, 105
 Pelvic girdle, 57
 Posing, 59
 Posing, miniatures, 109
 Ribcage, 6-27
 Shoulder blades, 60

Wings, 138
 Attaching, 139